**Transmutations of Horror
in Late Twentieth Century Art**

Edited by Christoph Grunenberg

The Institute of Contemporary Art
Boston

The MIT Press
Cambridge, Massachusetts
London, England

First MIT Press edition, 1997
© 1997 The Institute of Contemporary Art, Boston

Library of Congress Catalog Card Number: 97-71212
ISBN 0-262-07184-3

The Institute of Contemporary Art, Boston
April 24 - July 6, 1997

Exhibition organized by The Institute of Contemporary Art, Boston
Curated by Christoph Grunenberg
Assisted by Marcella Beccaria
Video produced and directed by Branka Bogdanov

Book and jacket design by Jeannet Leendertse

This book was set in Bell Gothic, Digital ICG, and Melior and was
printed and bound by Snoeck-Ducaju & Zoon, Ghent, Belgium.

The Institute of Contemporary Art
955 Boylston Street, Boston, MA 02115-3194
Tel. (617) 266 5152
Fax. (617) 266 4021

MASSACHUSETTS CULTURAL COUNCIL

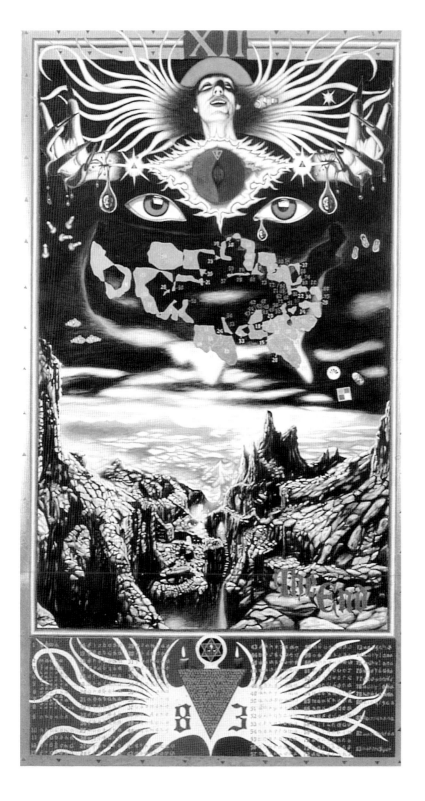

Pieter Schoolwerth

Thee 83 Altered States ov Americka:
Chapter 12, 1995-96
Colored pencil and paint pen on paper
Collection of Tim Nye, New York

Contents

Milena Kalinovska

Director's Foreword

> In the last days, the comet dominates the sky as it does a billion night-
> mares. Its nucleus is bright enough to stand out in broad daylight, and
> by night its foggy milk-white nucleus and bridal-veil tail make for one
> of the prettiest things humans have ever seen in the sky, and one of the
> last.

In the January 27, 1997 issue of *The New Yorker*, Timothy Ferris describes the "unlikely yet not so unlikely" end of human civilization and, through his writing, allows us to imagine what watching that catastrophe might be like. He provides us with the "facts"—but the anxiety is our own. It is the article that we have been waiting for as the end of the millennium draws closer and a proliferation of disturbing books, bizarre films, and grotesque art only reconfirms our fears for the future. We are not totally irrational. Looking back, the balance sheet as it appears at the end of the century is not much help. The enormity of "evil" deeds seems to haunt our psyche as if to reaffirm that even the "progress" we have made—let us say on the technical side—has caught up with us on a human level.

Gothic, curated by Christoph Grunenberg, has the same effect as the end of the century inferno. He has gathered a group of artists who represent a movement that has been gaining in strength, especially over the past five years. These artists, nourished by uncomfortable realities, capture, in a "Gothic" manner, metaphors for the extremes that keep haunting us. What we fear most, and what these artists depict, is indeed ourselves. The possibility of the irrational, uncontrollable circumstances that face us allows for an aesthetic development that signifies our discomfort and disorientation.

I would like to thank Christoph Grunenberg for his insight into an important tendency in contemporary art; his dedication to the project; the imagination with which he selected the artists and writers, edited the publication, and organized additional programming. I am most grateful to all who have made this exhibition and its accompanying publication and programs possible.

I would especially like to acknowledge and express my gratitude to the artists for their major contributions to this exhibition with work that reflects on the turbulent times we live in.

Christoph Grunenberg

Acknowledgments

1997 marks the centenary of the publication of Bram Stoker's *Dracula* and the bicentenary of Mary Wollstonecraft Shelley's birth. We are pleased to present *Gothic* in Boston, birthplace of Edgar Allan Poe, one of the greatest masters of the macabre and pathological, and home of an indigenous tradition of the New England Gothic. *Gothic* presents contemporary art that displays a strong pre-millennial fascination with the dark and uncanny side of the human psyche and attempts to locate it within the context of a revival of a Gothic sensibility in many cultures today.

Above all, *Gothic* has benefited from the enthusiastic response of the artists to the exhibition and their generosity in sharing information and ideas. We are particularly pleased that so many of them felt inspired to create new works or site-specific installations for The ICA and would like to thank all of them for their efforts and energy invested in this project. Our warmest thanks also go to the authors of this book: Dennis Cooper, John Gianvito, James Hannaham, Patrick McGrath, Joyce Carol Oates, Shawn Rosenheim, Csaba Toth, and Anne Williams, for their excellent contributions elucidating from many different angles the notion of the Gothic in art, literature, film, and music.

Gothic and its accompanying publication have benefited much from the discussions, exchange of ideas and advice from The ICA's Curatorial Department. I would like to express my warmest thanks to Marcella Beccaria, Curatorial Assistant, who has accompanied the project from the beginning with great devotion and efficiency, coordinating the multitudinous threads of the exhibition and this book while pursuing research and coming up with new ideas and directions. Lia Gangitano, Assistant Curator and Registrar, generously shared her views and recommendations, helped with the selection of the *Film and Video Series*, and contributed invaluable editorial advice. Ulrike Unfug, Curatorial Intern, with resolute persistence and utmost efficiency, handled the many requests for photographic material for the text illustrations of the catalogue. Thomas Conley Rollins, Jr. proved an invaluable Research Intern, who for many months carried books between Cambridge and The ICA. He also compiled the Selected Bibliography in this book. Martina Pachmanová, under great time pressure, efficiently compiled and edited the Selected Biographies of the Artists. Additionally, Curatorial Interns Nicole Noseworthy and Emily O'Shea helped with research at the early stages of the exhibition. Many thanks also to Tim

Obetz, Exhibitions Manager, and the installation crew who, as always, made a demanding installation possible and helped to realize complex site-specific works.

We are most grateful to Branka Bogdanov, ICA Video Producer/Curator, for her instructive and imaginative introductory video. The video combines interviews with artists, writers, critics, scholars, and art historians with views of works of art and excerpts from film and music, creatively illustrating the many aspects of the Gothic in contemporary culture. I also would like to thank her and especially John Gianvito, Guest Curator of the Harvard Film Archive and catalogue author, for co-curating the *Gothic Film and Video Series*, which presents historical and contemporary examples of "horror and terror" on film. Video Intern Kerry Zucker was instrumental in obtaining films, prints, and stills for this series. The Goethe-Institute, Boston again provided invaluable assistance and support for this series.

Milena Kalinovska, James Sachs Plaut Director of The ICA, has been especially encouraging and supportive since she first heard about *Gothic*. I am extremely grateful for her enthusiasm. Pat Kramer, Director of Development and Communications, and Susan Weiss, former Grantwriter at The ICA, were instrumental in securing funding for this ambitious project. We would like to thank them, as well as the following staff members: Joanne Barrett for her active Public Relations work for this exhibition; Laura Brown for the Educational Programming and the DocentTeens for their many tours; Nicola Rinne for her innovative marketing of *Gothic*; as well as Naomi Arin, Rosemary Clarke, Kara Keller, Mara Kampe, June Mattioli, Chris McCarthy, and the Gallery Staff.

We are particularly grateful to the lenders who so generously agreed to part with their works for an extended period: Eileen and Michael Cohen, New York; Vicki and Kent Logan, San Francisco; Selma and Josef Vandermolen, Ghent, Belgium; Nina and Frank Moore, New York; Tim Nye, New York; Gian Enzo Sperone, New York; Thea Westreich, Art Advisory Services, New York; as well as private collectors who prefer to remain anonymous.

The ICA would like to extend its thanks to the galleries that agreed to lend works of art, to their staffs, and to the artists' assistants for all their time, help and support: Galleria Guido Carbone, Turin; Paula Cooper, Alissa Friedman and Lucien Terras, Paula Cooper Gallery, New York; Richard Desroche, CRG Gallery, New York; Claudia Carson, Robert Gober Studio, New York; Judy Ann Goldman Fine Art, Boston; Jay Gorney and Rodney Hill, Jay Gorney Modern Art, New York; Carol Greene, Greene Naftali Inc., New York; Rafael Jablonka, Jochen Link

and Birgit Müller, Jablonka Galerie, Cologne; Alexis Hall, Mike Kelley Studio, Los Angeles; Xavier LaBoulbenne, New York; Barry Barker and Pilar Corries, Lisson Gallery, London; Roland Augustine and Michelle Maccarone, Luhring Augustine Gallery, New York; Bruce Hackney, David McKee Gallery, New York; Ben Barzone, Jeff Gauntt, and Tom Heman, Metro Pictures, New York; Victoria Miro and Clare Rowe, Victoria Miro Gallery, London; Dan Cooney, Tony Oursler Studio, New York; Patrick Painter Editions, Vancouver; Friedrich Petzel and Susan Cohen, Friedrich Petzel Gallery, New York; Shaun Caley and Stuart Regen, Regen Projects, Los Angeles; Annabella Johnson, Jack Tilton Gallery, New York; Annushka Shany, White Cube, London; Brent Sikkema, Wooster Gardens, New York; and Glenn Scott Wright and Andrew Silewicz, Glenn Scott Wright Contemporary Art, London.

Many other individuals generously helped with their advice and expertise, including Gabriele Beccaria, La Stampa, Turin; Kate Bush, ICA, London; Rachel Buff and Joe Austin, Bowling Green University, Bowling Green, Ohio; Lisa Graziose-Corrin, The Contemporary, Baltimore; Hard Candy Inc., Beverly Hills; Jürgen Keil, Goethe-Institute, Boston; Shaun Kelly, Boston; Colin de Land, American Fine Arts, Co., New York; Ewa Lajer-Burcharth, Harvard University, Cambridge, Massachusetts; Michael McInnis, Primal Media, Boston; Kathleen Merrill, Lannan Foundation Art Program Director, Los Angeles; Gillian Levine, Boston Creative Music Alliance; Karen Moss, Walker Art Center, Minneapolis; Riccardi, Boston; Bethany Shorb, Boston; Jennifer Smith, Boston; Robert Storr, Museum of Modern Art, New York; Samantha Tsao, Thread Waxing Space, New York; Urban Decay; and Mark Weintraub, Massachusetts Cultural Council, Boston. We are most grateful to them. For helping us with the research and for supplying reproductions we would like to thank Fern Bayer, Toronto; Bloom Gallery, Amsterdam; British Fashion Council; Richard Stark and Lynn Sable, Chrome Hearts, Los Angeles; Mike Leahy, Cambridge, Massachusetts; Terry Geesken, Museum of Modern Art Film Stills Archive, New York; Thierry Mugler, Paris; Fred H. Berger and Paul Hart, *Propaganda* magazine; and Erik Lukas, Visages RPS, Inc., Los Angeles.

I also would like to express my appreciation and gratitude for the enthusiastic support *Gothic* received from The ICA Board of Trustees Exhibition Committee and would like to thank especially Charlene Engelhard, Kenneth L. Freed, Marjory Jacobson, Annette Lemieux, Ellen Poss, Lucille Spagnulo, and Lois Torf for their generous advice and ideas.

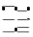

We are pleased to collaborate again with The MIT Press on this ambitious publication. Roger Conover at The MIT Press demonstrated great interest in the project from the beginning and the amicable cooperation with him has made this publication possible. Many thanks are due to Jeannet Leendertse for steering us away from preconceived ideas and providing the exceptional design of this book. Susan Clark expertly read and checked the manuscripts, assuring the accuracy of the texts. We would also like to thank Geert Verfaillie, Michael Sakkalli, and Patrick Snoeck of Snoeck, Ducaju & Zoon in Ghent, Belgium, for coordinating the production and printing of *Gothic* in a most professional and timely manner.

This exhibition and its programs have been made possible by the generous support from the Boston Globe Foundation; Arthur F. Blanchard Trust; Boston Safe Deposit & Trust Company, Trustee; Boston Safe Neighborhoods Youth Fund; Branta Foundation; Charles Engelhard Foundation; Kapor Family Foundation; Lannan Foundation; Massachusetts Cultural Council, a state agency; Nathaniel Saltonstall Arts Fund; Bessie Pappas Charitable Foundation, Inc.; David Harold Stoneman Fund; and ICA members and patrons.

In-kind support provided by the Phoenix Media/Communications Group, Sonesta International Hotels Corporation, TANK, and Tower Records.

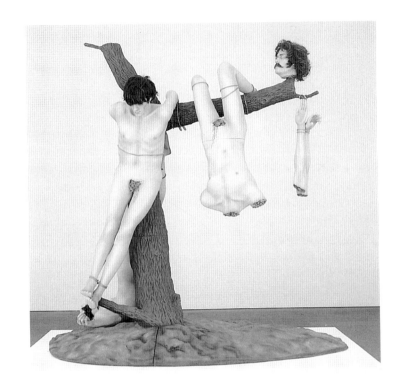

Dinos and Jake Chapman

Great Deeds Against the Dead, 1994
Fiberglass, resin and paint
Courtesy Victoria Miro Gallery, London

Unsolved Mysteries

Gothic Tales from Frankenstein to the Hair-Eating Doll

CHRISTOPH GRUNENBERG

> Black is boundless, the imagination races in the dark. Vivid dreams careering
> through the night. Goya's bats with goblin faces chuckle in the dark.
>
> Derek Jarman, "Black Arts"[1]

I still vividly remember watching for the first time the classic Hammer Films
version of *Dracula* (1958, directed by Terence Fisher) on television—a young
teenager, alone in my dark bedroom and with everyone else in the house asleep.
The film intensely excited but also greatly disturbed me. Though I did not
believe in vampires, the suspense of the struggle between Count Dracula and
Dr. Van Helsing (portrayed by the always composed and imperturbable Peter
Cushing—the representative of reason) seemed at times unbearable. In the final
scene, as the stake is driven through the vampire's heart and Dracula is killed,
the tension was not relieved. I spent a restless night, too agitated and frightened
to fall asleep, too suspicious of the monsters and horrors lurking in the unknown
and expecting me in my dreams. What, by today's standards, seems like a harm-
less production then captured my adolescent imagination. In my mind, Dracula
became real enough to produce a hair-raising adrenaline rush and quickening of

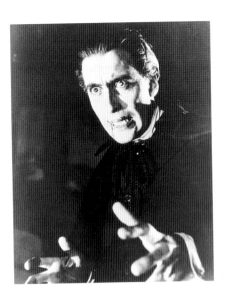

Christopher Lee in Terence Fisher's
Dracula, Great Britain 1958

heartbeat. My midnight encounter with one of the central figures of Gothic fiction caused intense "pleasurable pain," as Edgar Allan Poe described the sensation aroused by accounts of human and natural disasters, and I was only too willing to be terrified and titillated.

Gothic Revival

'T is the tempestuous loveliness of terror

Percy Shelley, "On the Medusa of Leonardo da Vinci," 1819[2]

The desire to be entertained, challenged, shocked, and to indulge in the most intense and stimulating sensations that ensue in the encounter with the emotional extremes of delight and terror seldom seem more pronounced than today. As the end of the millennium approaches, the fascination with the dark side of the human imagination is once again rampant, indicating a full-blown resurgence of a "Gothic" sensibility in contemporary art and culture. In a review of the 1996 film season, Janet Maslin in the *New York Times* discerned that "a mordant outlook along with chilly detachment and often pitch-black humor, was the year's most pervasive force."[3] Hardly a week goes by without the release of a movie or book exploring supernatural events, encounters with aliens and other monsters, particularly gruesome murders, or characters with mysterious spiritual and physical powers. An obsession with the paranormal and fantastic, evil and distorted deeds and minds, first explored in the Gothic novel more than two hundred years ago, once again occupies a central place in the popular imagination: "A Gothic spirit much like Poe's now infuses a great deal of our film and popular fiction—and other, less predictable zones of the culture as well," as the writer Mark Edmundson recently ascertained.[4]

CHRISTOPH GRUNENBERG

We are living in particularly dire times—in a Gothic period of fear, horror, moral disintegration, and indulgence in perverse pleasures. "Gothic" has become the *quid pro quo* for somber and disturbing moods, sites, events and cultural by-products of latter-day America: from "Gothic capitalism," to the "*Day of the Locust* 'Gothic'" of Los Angeles, to "Ghetto-Gothic" (the title of Melvin Van Peebles rap album dealing with "socially-relevant issues" such as domestic violence), to the "Southern Gothic" of true crime in small-town Texas as described in the best-seller *Midnight in the Garden of Good and Evil*, to the *Batman* films' "dime store gothic gloom," to the definition of the TV dramas *X-Files* and *Millennium* as "mod-gothic melodramas," or *Melrose Place* as a "gothic serial for the cyberage," and finally to the ubiquitous "American Gothic," embracing everything from daytime TV talkshows to O. J. Simpson, Satanic ritual murders, Timothy McVeigh's New York state hometown and the television series of the same name.[5] A predilection for the Gothic has deeply affected all areas of contemporary life—from "high" literature to "schlock" science fiction, mystery, and romance novels; penetrating art, architecture, design, fashion and graphic design; to be found in advertisements and on record covers; present in popular music of today as in the revival of Gregorian chants and medieval hymns; and, most pronounced, making its daily appearance in film and television, where an obsession with sex, crime and the proclivities of twisted yet clever serial killers has developed into one of the most popular categories in mainstream entertainment.

In literature, the so-called "New Gothic" has been proliferating in American and British fiction: "Though no longer shackled to the conventional props of the genre, the themes that fuel these pieces—horror, madness, monstrosity, death, disease, terror, evil, and weird sexuality—strongly manifest a gothic sensibility."[6] Many contemporary visual artists share a common aesthetic, a

Spadechair, 1995
Leather, sterling silver, ebony
Designed by Richard Stark
Courtesy Chrome Hearts, Los Angeles

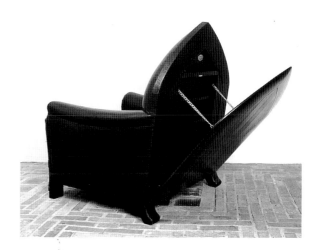

preference for crude, fragmentary, and contorted forms which are employed to produce effects of horror as well as amazement. Moreover, some artists use a detached and controlled formal language to transmute images of excessive and gruesome violence, nevertheless achieving an equally disconcerting impact. In architecture and the decorative arts, the neo-Gothic style of the eighteenth and nineteenth centuries is experiencing its first major renewal of interest since the 60s and 70s, while contemporary architects and designers reinvent medieval ornaments for an enthusiastic audience relishing romanticized notions of the past.[7] Chrome Hearts of Los Angeles offers heavy metal jewelry in sterling silver with medieval motifs as well as exquisitely crafted armchairs with pointed forms and drawbridge-like backs. Less nostalgically, Deconstructivist architecture reflects the dematerialized and fragmented structures of Gothic cathedrals as well as "the urge for transcendence, for overcoming the weight and opacity of architecture."[8]

The subculture of Goth rock, its distinct dress code and lifestyle predate the current revival of a manifestly Gothic aesthetic and disposition by almost two decades, its members remaining devoted in their enchantment with death, the macabre and otherworldly. The Goths' romantic look with its strong inclination towards black was successfully appropriated by mainstream fashion several years ago. A dark, Gothic manner continues to distinguish street and *haute couture* fashion with an emphatic bent towards the "glamorously deathly, an avant-garde look that presents a borderline case where the next step could involve illustrating the very face of death."[9] Today the Gothic in fashion and design has become mass marketable, available courtesy of singer/actor turned designer Cher, whose *Sanctuary* catalogue offers jewelry, fashion, as well as heavy yet comfortable medievalized furniture. Even mainstream advertising for Mastercard, Hewlett-Packard or Cadillac, for example, has dared to turn "barbaric," presenting Gothic mini-dramas featuring haunted castles and frightful monsters in TV commercials.

In addition, the Gothic has long been popular in film and television not only with respect to content but also in formal terms. David Cronenberg and Peter Greenaway pioneered the introduction of metaphysical dramas with a distinct mordant and grotesque aesthetic, while David Lynch emphasized the strange and bizarre by placing it within the context of apparent normality. More recently, the "crumbling, back-door-satanic urbanscape" of the thriller *Seven* (1995, David Fincher) has shaped the look of a whole series of Hollywood movies and television series, such as *The X-Files* and *Millennium*. Exploring the full range of supernatural incidents from religious miracles, aliens, UFOs, and serial killers (with occasional references to real events), these TV series combine

"gruesome horrors… and a lush, becalmed spirit of voyeurism so pure and intent that it borders on a trance state."[10] The ubiquity of the cultural phenomenon of the Gothic continues in the newest media: the computer games *Myst* or *Obsidian* explore the romantic and industrial Gothic respectively in animated, comic-style versions of fairy tales; on the Internet an endless range of specialized Gothic sites with telling titles such *Hallowmas* ("a non-profit creative literary web-zine devoted to art, poetry and fiction and creative non-fiction that characterizes the darker elements of life: the melancholic, the horrible, the bitter"), *Belfry* (a guide to morbid places including the "Gothic Guide to Hollywood" and the "Museum of the Macabre"), *Gallery of the Bizarre* ("Necro-Erotic Cyberworks series. A blend of primal past and cyber-gothic future"), *Greshie's Melencholic Presumption*, one of numerous music sites, *Chapel of Sorrows*, a guide to the local "Gothic/Darkwave/Industrial scene in Charlotte, NC," plus information on Gothic Weddings, Bed & Breakfasts, or interest groups advocating the return of *American Gothic* on television.

Apocalypse Now or Never

> "Twenty oh-oh"—"a nervous name for what is sure to be nervous year."
>
> Hayes B. Jacobs in The New Yorker, 1963[11]

Eternal night seems to have fallen over the world and dark is the most fashionable color in the autumn of the century. Though few expect the world to end with the turn of the millennium, a true *fin de siècle* spirit of cultural pessimism and spiritual *malaise* permeates society today. For many, the millennium is just a welcome opportunity for an especially extravagant New Year's Eve celebration. However, "despite our blithe frontal-lobe plans for the occasion," evidence is mounting that the end is coming: Chernobyl, global warming, predictions of huge meteorites destroying the earth, the "frenzy of interest in Buddhism," angel mania, the "mystery explosion in the Australian outback," and so on. "Come to think of it, we've spent the entire half century working on a mass case of repressed millennial jitters, and it's getting harder and harder to ignore the symptoms."[12] In the cyclical end-of-year round-up of prophecies, supermarket tabloids announce the apocalypse while, at the same time, historians discuss *The End of History* (Francis Fukayama) and philosophers (Arthur Danto) lament *The End of Art*. Others have known all along, including Southern Baptists, Pentecostals, Branch Davidians, and other religious fundamentalists, New Age prophets, radical environmentalists, and computer geeks (fearing a monumental crash caused by the change of date or from viruses), who all expect a day of reckoning on December 31, 1999.[13] As utopia makes way for dystopian gloom

and doom, the deluge of trend publications of the 70s reveling in grand schemes and futuristic predictions for the twenty-first century has been surpassed by an abundance of "the end is nigh" literature. The incertitude and apprehensiveness seem so pervasive that even the exact date of the beginning of the next millennium is debated by scientists (1999, 2000 or 2001?).

Pre-millennial despair extends beyond the realm of philosophical and scientific speculation and has long invaded everyday life as reports on the incalculable dangers of urban life, random crime, freak accidents, and hidden health hazards constantly remind us. The proliferation of serial killers in print and on film (it is getting so crowded these days that one expects mad murderers lurking behind every corner) hints at society's deepest fears: to be the next random victim at the mercy of a powerful, highly intelligent and utterly deranged individual. The fascination might be explained with the mass murderer's ruthless fulfillment of his (rarely her) deepest sexual desires and repressions, his reckless violation of laws and brazen mockery of authority. A disquieting correlation has been established between the right of independence, as embodied in the American Constitution, and the fact that three out of four serial killers live in the United States: "A cultural emphasis on individual freedom makes choosing evil a lively option," as John Updike recently stated.[14]

The serial killer is emblematic of the essential *Doppelgänger* nature of the modern individual: at once enlightened, liberated and emancipated but also regulated and constrained by narrow normative social codes, economic necessities and competitive pressures to consume. Mark Seltzer, in his analysis of serial killers, established "an internal connection between what might be called an addiction to self-making or self-transformation and these maladies of agency and pathologies of will or motive..."[15] Serial killers "embody" the disturbing tension between the respectable citizens' secret aspiration toward and at the same time deep anxiety over losing control and entering a realm where logic, reason and common sense no longer operate. "The reason people are hermetically sealed in their homes is that they are worshiping the glass tit of fear, which is telling them the world is too scary to go out in."[16] We seem to be destined to worry through the next millennium as the absurd dangers of modern life have turned even the safe refuge of suburbia and home into a battlefield: the innocent domain of the nursery is invaded by "hair-eating dolls," chomping on unsuspecting children's locks; an increasing number of people are abducted by aliens; and vampiric goatsuckers roam the landscapes of Puerto Rico.[17] The world is out of joint and the only way to cope seems to adopt a deeply fatalistic and cynical outlook or to seek solace in traditional values and beliefs that might

reestablish a state we used to call "normality." America is in search of a long lost paradise which, for many, can only be found in some nostalgic reconstruction of a past that never was.

American Gothic

> Robert Bork: "God's plan made a hopeful beginning
> But man spoiled his chances by sinning
> We trust that the story
> Will end with God's glory
> But at present the other side's winning."
>
> Ben Wattenberg: "Gomorrah, Gomorrah, I love you, Gomorrah. You're always a day away."
>
> From a discussion between Robert Bork and Ben Wattenberg on "Regulating the Future: The New Industrial Policy," American Enterprise Institute, Washington, D.C., December 1996[18]

In the recurrent cultural debates that ripple through American society, the lines between opponents are usually clearly defined: on the one hand, the "liberal" cultural pessimists, drawing a dark picture of approaching social disintegration, chaos and disaster; on the other, the conservative forces who, despite their despair about the contemporary state of morality, promote an optimistic vision of the future. While the radicals of yesterday are deeply disoriented after the final demise of Communism in the Eastern bloc and continually absorbed in futile theoretical battles, the "Right" (with all its contradictions, diverse factions and subgroups) possesses one decisive advantage: adhering to its firm beliefs, traditional standards, and clearly outlined agenda, it remains confident and hopeful. Fundamentalist religious groups and the so-called New Right crusade for a safe and secure America, for the

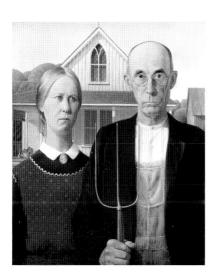

Grant Wood
American Gothic, 1930
Oil on beaverboard
The Art Institute of Chicago
Friends of American Art Collection

education of decent, healthy and respectable citizens, for physical and material restraint, for traditional family values, for a law-abiding and God-fearing people, for a nation that is proud and strong without getting too involved in the problems of other, faraway countries.

Since the Reagan 80s, American society has been increasingly dominated by narrowly defined middle-of-the-road values. The big battles are now being fought in the field of "high" and "low" popular culture. Fundamentalist groups have attempted to ban from TV screens, from the covers and pages of magazines, and the shelves of record and video stores everything that disturbs the uncompromising doctrine of an imaginary nuclear family, the dream of a caring, non-violent society, the Puritan repugnance of sex (or better even: no sex at all— "Just Say No!") and an obsessive preoccupation with physical and mental cleanliness. Fostering the delusion of a uniform society of common ideals and morals, the conservative backlash with its agenda of moral reconstruction has been successful in forcing the introduction of the V-chip for televisions and the cleansing of offensive, sexually explicit, or violence-evoking language and scenes from CDs and videos.[19] The exclusion of artists, museums, and galleries from already slashed federally funded grants continues to impoverish the cultural landscape and creative diversity. The advocates of moderation continue to condemn anything as abnormal and deviant that even vaguely smells of excess: no smoking, no alcohol, no sex, no more passion, and definitely no more fun! The abhorrence of corporeal pleasures, luxury, superfluous decoration or waste continues to define the perimeters of permissiveness in America. It is Satan who reveals himself in false splendor, grotesque exaggeration and insolent ostentation. "We are in the midst of one of those periodic moments of repression, when the culture, descended from the Puritans, imposes its hysterical visions and enforces its guilty constraints on society, legislating moral judgments under the guise of public health, all the while enlarging the power of surveillance and the reach of censorship to achieve a general restriction of freedom."[20]

The United States of the 1990s seem to be entering a second Victorian age, with all its aberrations of restrictive social codes, moral terrorism, sanctimonious ideals and double standards. The country is deluged by a titanic flood of extra strong moral disinfectant, flushing away the grime and filth from the minds of corrupted children, perverted adolescents, and adults with bad consciences. "Where are the disastrous miscalculations, the squandered opportunities, the wrong turns that made life so picaresque and hairy?" asked writer James Atlas recently bemoaning the decline of bohemian culture and its substitution by business and marketing motives. And, he continued: "The fact that certain

indulgences have been proscribed for health reasons may help to explain the institutionalized hostility to pleasure in our culture."[21] The again much quoted Book of Revelation confirms the warning (more than just metaphorically) of unchastity and carnal indulgence: "Behold, I come as a thief. Blessed is he that watcheth, and keepeth his garments, lest he walks naked, and they see his shame." (16:15). Adaptable to our media culture with its emphasis on the visual, the Bible explicitly invokes "the shame of bodily exposure: the 'thief' is constructed as a voyeur, as one who may 'see' that which should not be seen."[22] The solution to this problem and many others is the popular "Brown-Paper-Bag-Strategy": It's all right to do it as long as no one knows about it. Nudity, explicit sexual content, or violence in movies, television, art, music, magazines, computer games, or on the Internet have by no means decreased—it is just the access to the media that transports the message of evil and moral degeneration that has been curtailed. Quite possibly, the latest regulation of private lives might have an adverse affect, as filmmaker and well-known exploiter of life's more bizarre sides, John Waters has observed: "Now, dirty language seems to be a really big thing in all of our lives. We've lived through when you couldn't even say 'fuck' in the movies or anything. And now, pretty soon you'll be able to say it on national television—as soon as they put those V-chips in."[23] Who is to be protected? Children, adolescents, and less moral, responsible and discriminating citizens than us? Or we ourselves from our own dirty fantasies and deviant desires? The "purification" of the American imagination is epitomized in one of the formerly most Gothic sites of New York: Times Square, where filth, sex, cheap entertainment, unregulated capitalist enterprise, and advertisement on the grandest scale used to collide in an anarchic cacophony of oversized proportions—enacting the "terminal orchestration of the Romantic," as the architect Rem Koolhaas has described it. Times Square is symptomatic of the Disneyfication of American culture and its inexorable contradictions: "the leap from sick but energetic authenticity straight into the embalmed cheer of Disney has an intolerable perversity.... A coalition of moralists, planners, and a nostalgia-driven entertainment giant expelling, as if in some Biblical sense, the unwanted from the city... it hardly seems a good omen for Manhattan's continuing relevance in the twenty-first century."[24]

As history has proven again and again, the more restrictively the standards of permissiveness are defined and the more rigidly they are enforced, the greater becomes the fascination with the unknown, the desire to taste the forbidden fruit—and the more ingenious become the methods and tricks of those who seek to circumvent the rules and restrictions. "Who has not," Edgar Allan Poe asked, "a hundred times, found himself committing a vile or silly action, for no other

reason than because he knows he should *not*? Have we not a perpetual inclination, in the teeth of our best judgment to violate which is *Law*, merely because we understand it to be such?"[25] The recent campaigns for implementation of standards of propriety and decency in entertainment have revealed, above all, a morally disoriented and deeply divided society whose solutions are either hypocritical compromises or authoritative intrusions into personal space. The ghosts of the Gothic have returned and are haunting the American soul with their images and ideas: "Unsentimental, enraged by gentility and high-mindedness, skeptical about any progress in any form, the Gothic mind is antithetical to all smiling American faiths. A nation of ideals, America has also been, not surprisingly, a nation of hard disillusionment, with a fiercely reactive Gothic imagination," as Mark Edmundson describes in his the article on "American Gothic."[26]

The Seven Deadly Sins: A Morality Play

John Waters	So happy Ash Wednesday, the first day of Lent. Don't you think Catholics always feel a little dirty?
Mike Kelley	Yeah, I think they do. It's bred into them.
John Waters	Exactly. And I think sex will always be a little better because it is dirty. You can never really escape that, no matter how healthy you get.
Mike Kelley	Yeah, it's true. It charges everything.
John Waters	So actually I am perversely glad that I was raised Catholic even though I think it screwed me up.
Mike Kelley	Oh yeah, definitely. That's for sure.

John Waters, Mike Kelley, "The Dirty Boys"[27]

After decades of rationalizing murder, crime and violence, the concept of evil is experiencing a maybe not so surprising comeback in ethics, once again a trendy branch of philosophy, as well as being ubiquitous in the more entertaining manifestations of fashion and popular culture: "In our metaphysical frustration, the

scandalously old-fashioned idea of evil enjoys a revived chic, noticeable in the self-mutilations of young glamour-seekers and the somber, zombified, Mapplethorpesque cast of fashion photography."[28] The popular nail polish Hard Candy is available in various metallic shades with such evocative names as "Porno," "Pimp," or "Greed," while Urban Decay offers "Slut" and "Acid Rain." Poppy features "Seven Deadly Sins" lipstick, advertised with the slogan: "Explore your dark side! ... A sin to suit every mood." MTV investigates teenagers' understanding of the seven deadly sins today while Hollywood glee-fully toys with ever more shocking displays of malevolence and malignancy, uncovering categories of evil supposedly long laid to rest. In the extreme psy-chological thriller *Seven*, for example, a highly methodical and controlled serial killer leaves clues including quotations from Milton's *Paradise Lost* ("Long is the way and hard that leads out of hell to light") as he cruelly punishes those who have committed one of the seven deadly sins.

The current Gothic mood, as much as it has become a commercially exploited fashion and entertainment phenomenon, is symptomatic of a continuing spiri-tual emptiness at the end of century. The media's obsession with grotesque depictions of death, decay, and disease, and the public's eager consumption of them, reveals a metaphorical vacuum and the need for a convincing substitute for obsolete moral and religious categories. "As we lose touch with the idea of evil, we seem to need more and more vivid representations of it—as it were a drug whose potency diminishes with each use," Andrew Delbanco points out in his recent book, *The Death of Satan: How Americans Have lost the Sense of Evil.*[29] Evil has proven an elusive category as religious, psychoanalytical, biolog-ical and philosophical explanations fail to grasp or explain its nature and ori-gins. In the past, the dark and fantastic products of the mind were perceived as manifestations of the inexplicable workings of the Devil. Psychoanalysis attempted to rationalize the enigma of horror as the result of childhood trauma, paranoia, subconscious desires, and a plethora of neuroses, phobias, and mental disorders. "Our culture is now in crisis," Delbanco continues, "because evil remains an inescapable experience for all of us, while we no longer have a

Mike Kelley

Apology (from Australiana), 1984
Acrylic on paper
Collection of Louisiana Museum,
Humlebaek, Denmark
Courtesy of the Artist and Jablonka
Galerie, Cologne

symbolic language for describing it.... It leaves us in our obligatory silence, with a punishing question: 'How,' in the words of one literary critic, 'is the imagination to compass things for which it can find no law, no aesthetic purpose or aesthetic resolution?'"[30]

Science, technology, and psychoanalysis have turned bad, and help today seems only available from far, far away—be it from outer space or the innermost depths of the human psyche. Browsing through any bookstore today, one will find the most space taken up by those genres pertaining, in the widest sense, to the unknown and spiritual: extensive sections of Mystery novels, with expanding subdivisions of True Crime, usually located not far away from Science Fiction and Fantasy, or the ever increasing selection of inspirational, New Age and Self Help books next to the Occult and Supernatural, which have developed into independent categories. The necessity to believe in something is reflected in the flourishing of these weak substitute faiths. Entertainment has replaced religion and ideology as the primary source of moral guidance and for representations of evil. "The Manichaean image of a universe at war—light versus darkness, with disguise and espionage rampant—retains terrific and inspirational force."[31] Gothic fairy tales such as the exemplary *Star Wars* (1977, significantly re-released in 1997), based on archetypal myths, the mastering of identity crises and oedipal conflicts, nowadays provide the essential ideological and normative framework. Director George Lucas, more preacher than artist, explains: "It seemed to me that there was no longer a lot of mythology in our society—the kind of stories we tell ourselves and our children, which is the way our heritage is passed down. Westerns used to provide that, but there weren't Westerns anymore.... I wanted it [*Star Wars*] to be a traditional moral study, to have some sort of palpable precepts in it that children could understand. There is always a lesson to be learned. Where do these lessons come from? Traditionally, we get them from church, the family, art, and in the modern world we get them from media—from movies."[32]

Harrinson Ford in Ridley Scott's
Blade Runner, USA 1982

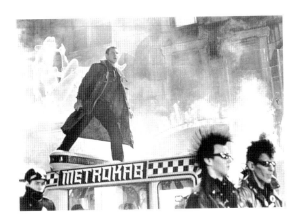

The Future is History

> ... 5 BILLION PEOPLE WILL DIE FROM A DEADLY VIRUS IN 1997 ...
> ... THE SURVIVORS WILL ABANDON THE SURFACE OF THE PLANET ...
> ... ONCE AGAIN ANIMALS WILL RULE THE WORLD ...
>
> Excerpts from interview with clinically diagnosed paranoid schizophrenic
> April 12, 1990—Baltimore County Hospital
>
> Opening epigraph from *Twelve Monkeys*, 1995

The first installment of *Star Wars*, one of the most popular films ever, established science fiction as a mainstream, guaranteed blockbuster genre. In true early postmodernist fashion the series started with *Episode IV: A New Hope* and will continue in 1999 with a "Prequel," exploring the past of the epitome of evil, Darth Vader. The uplifting tone, optimistic narrative and futuristic aesthetic of the first three *Star Wars* films will, apparently, darken considerably in the next three chapters, as Lucas continues to turn the future into past: "The scripts to the three films that I'm finishing now are a lot darker than the second three, because they are about the fall from grace. The first movie is pretty innocent, but it goes downhill from there, because it's more of a tragic story—that's built into it."[33] As the *fin de siècle* moves toward its climactic conclusion, the utopian fairy tales of the 70s are being superseded by dark distopyan dramas. Interestingly enough, the Biblical Book of Revelation has also advanced to a most frequently consulted and quoted source. In *Twelve Monkeys* (1995, Terry Gilliam), psychoanalyst Dr. Kathlyn Railly (Madeleine Stowe) discovers that the biblical prophecies, which she herself outlines in a museum lecture on "Apocalyptic Visions," are true and that most of the world's population will be ravaged by a deadly virus in 1997. It looks like the future may hold some bad surprises.

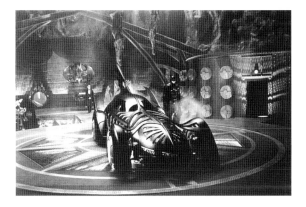

Joel Schumacher
Batman Forever, USA 1995

The numerous filmic explorations of the 60s and 70s of negative utopian societies and totalitarian surveillance states consistently imagined the future as a squeaky-clean, sterile and decontaminated world inhabited by brainwashed and emotionally castrated individuals (including, for example, *THX 1138* of 1970, George Lucas' first film). Since the early 80s, the optimism of the futuristic high-tech look in science fiction films has been reversed into a dark vision of the future as a post-apocalyptic, technological wasteland. *Blade Runner* (1982, Ridley Scott), *Terminator 2* (1991, James Cameron), *Batman* (1989, Tim Burton), *Strange Days* (1995, Kathryn Bigelow), and particularly Terry Gilliam's films *Brazil* (1985) and most recently *Twelve Monkeys*, take place in anarchistic metropolises resonating "with our fears of our mismanaged future, environmental and social entropy, and our perceived inability to control our destiny."[34] Usually situated in some distant point in the future, the urban settings present an amalgam of pre-war Times Square and contemporary Shibuya Square in Tokyo (*Blade Runner* and *Strange Days*), Depression America or England as redesigned by a megalomaniac architect (*Brazil* and *Batman Forever*), or dismal 1950s suburban Paris (*Delicatessen*, 1990, Jean-Pierre Jeunet; a parody on the genre and its heroes—with a circus clown and the French obsession with food at the center of the plot). The most pertinent model for this aesthetic of doom can be found in the jagged Gothic cityscape of *Metropolis* (1926, Fritz Lang). The recent flood of Gothic doomsday spectacles share the retrospective histrionics of the Gothic novels' fascination with the Middle Ages, sustaining "a nostalgic relish for a lost era of romance and adventure, for a world that, if barbaric, was, from the perspective of the eighteenth century, also ordered."[35] "The

Terry Gilliam
Brazil, Great Britain 1985

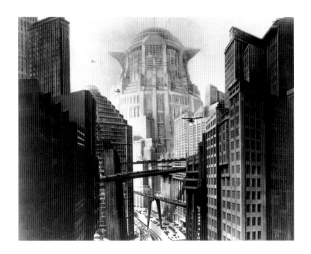

Fritz Lang
Metropolis, Germany 1929

Future is History," the subtitle of *Twelve Monkeys* announces—and never has the future looked so much like the past.

The sterile and antiseptic environments of the third industrial revolution have been surpassed by the eternal night of desolate megalopolises, dramatically lit interiors of old factories, blast furnaces and the heavy, monumentally towering machinery celebrating the heroics of industry. In the future, computers exist predominantly as instruments of surveillance, control, regulation, or torture, employed by "Big Brother" governments upheld by myriad and impenetrable bureaucracies (*Brazil)* or omnipotent and unfathomable corporations ("The Company" in *Alien*, 1979, Ridley Scott). Evoking the original *Frankenstein's* infatuation with industrial progress (1931, James Whale), contemporary Orwellian dramas sentimentally relish the physicality of corporal labor and the male eroticism of technology concentrated in the fetishistic representation of elaborate instruments, mechanical apparatuses and intricate contrivances. Computers, machines, and technology have gone bad before, as HAL, the computer with the evil personality in *2001: A Space Odyssey* (1968, Stanley Kubrick). In the 80s and 90s, however, the monsters of technology created by man are no longer contained in clean boxes with blinking lights and dematerialized mechanical voices, but again occupy "gothicized" bodies as cyborgs, aliens, and endless variations on the mythical figures of the Golem, Frankenstein, or Dracula: "Like the bolt through the neck of Frankenstein's monster in the modern horror film, the technology of monstrosity is written on the human body."[36] As in the interrogation scenes of *Twelve Monkeys*, human being and machine become indistinguishable, technology as the agent of hegemonic power swallowing, demobilizing, surveilling, and torturing the individual.[37]

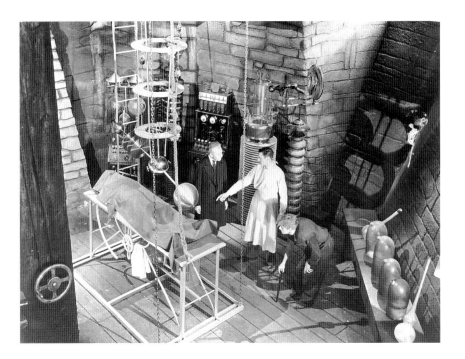

James Whale
Frankenstein, USA 1931

The industrial Gothic of contemporary film and fiction reflects an increasing weariness about the alienating power of technology and its disastrous social consequences: "downsizing," the closing of whole branches of production, permanent unemployment, and the disruption of families and communities. The aesthetic of industrial manufacture speaks of disillusion with the promises of high technology while simultaneously projecting a romantic notion of pre-alienated work, job security, and identification with and fulfillment in the productive process. The Draculas of today are greedy corporations, automation, corrupt parties and politicians who deliberately erode the foundations of the welfare state. Capitalism is like a vampire "sucking the blood of living labor," to follow Marx's famous analogy, not unlike the ultimate Gothic monster in *Alien*—part reptile, part robot with its metallic skin and retractable steel teeth dripping and drooling with gooey saliva.[38] *Alien* has been called "a scathing critique of capitalism, depicting alienated workers savaged by both the pitiless Company which regards them as expendable, and the Company's double, the pitiless Alien, which regards them as prey." However, the film also "undercuts its own Marxist critique with a recuperative feminist narrative of triumphant individualism, the

audience cheering as Ripley, the modern woman, defeats the Alien with tech-
nology, savvy, weaponry, and pluck."[39] Despite the fact that the sole survivor
and eventual victor is female (Sigourney Weaver), the plot follows along the
conventional lines of the confrontation of the "maiden" or "virgin" (in the final
showdown Ripley wears a white space suit), who is saved by her purity and
innocence (as a pre-climactic teaser she saves a cat in a daring, altruistic move).
Alien, like so many horror and science fiction films of the last decades, is dri-
ven by both despair over the disintegration of traditional production processes
and postindustrialist nostalgia for the recent past with its illusory promise of
stable and homogenous social structure.[40]

Opposition to progress and profits is futile and only the Nietzschean super-
heroes of Hollywood can defeat the mega-corporations and conspiring govern-
ments—and, these days, even they fail occasionally. In the final sequence of
Brazil, the (anti-)hero retreats from the prospect of torment by the technocratic
bureaucrat into madness, taking the only escape left. The mad scientist epito-
mizes the late twentieth-century ambivalence towards progress, science, tech-
nology, industry and capitalist culture.[41] And, as fiction becomes fact, the
Unabomber presents the latest twist in the continuing revival and transforma-
tion of archetypal Gothic characters. Like Frankenstein, he is at first fascinated
by science only to be disillusioned by its alienating and dehumanizing force. He

Bruce Willis in Terry Gilliam's
Twelve Monkeys, USA 1995

has learned the lesson of fateful interference with nature and the violation of the privilege of creation. Disenchanted by reason and common sense, he leads a cruel crusade against his old ideals and dreams, as if acting out a sequel to *Frankenstein*, with the Swiss Alps and Arctic desert supplanted by the Montana wilderness.

The Topology of Horror

> Q: "Who are you?"
> A: "The question is *where* am I."
>
> Trailer for Wes Craven's film *Scream*, 1996

Since Horace Walpole's *The Castle of Otranto,* the geographical and architectural setting is one of the key elements in establishing a mood of suspense, anticipation, and terror. The Gothic is concomitantly bound to the place of evil, the *locus horribilis* where monsters reside, the victims are tortured and then devoured, and where unforgettable crimes have taken place. A true Gothic work "should combine a fearful sense of inheritance in time with a claustrophobic sense of enclosure in space, these two dimensions reinforcing one another to produce an impression of sickening descent into disintegration."[42] In the Gothic world it rains without end and eternal night prevails, as in Gothic cult films such as *The Crow* (1994, Alex Proyas) or in the TV series *The X-Files* "where the low ceilings and low, damp skies keep a lid on a lingering fog that mildews and wilts the corners of every image with free-floating dread. Even the sunlight looks a little ill."[43]

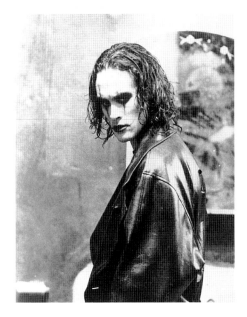

Brandon Lee in Alex Proyas'
The Crow, USA 1994

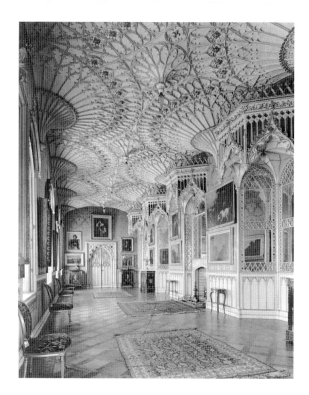

Horace Walpole
Strawberry Hill, Long Gallery, 1749-76
Twickenham, England

It was the successful evocation of the atmosphere of a medieval environment in
architecture that led to what has become known as the first Gothic novel and
one of the most influential books of the later eighteenth century. The architec-
ture of Horace Walpole's Strawberry Hill, credited as the first "true" Gothic
Revival domestic building (based on the study of specific examples of medieval
Gothic architecture), was, in his own words, "more the work of fancy than imi-
tation."[44] Despite its inspiration by authentic sources, Strawberry Hill shares
with the Gothic novel its theatricality and reliance on dramatic effects: "With all
its shadowed 'gloomth,' narrow passages, stained-glass windows, and ribbed
vaults, there is not a single instance of Gothic structure in the building." The
pointed vaults and windows, the compound piers and columns, the intricately
ornamented walls, doors, and the fan vault of the Long Gallery all exhibit the
"make-believe of a stage set."[45]

The Gothic resides naturally in the landscape of terror, nurtured by the uncom-
fortable relationship of the human character and the natural environment. In
Romantic literature and art the individual and nature no longer coexist in
organic harmony, as proposed by the eighteenth century pastoral ideal, but men
and women are aroused and terrified by the wild and uncontrollable tempera-
ment of nature. The ambiguous aesthetic category of the sublime has defined the

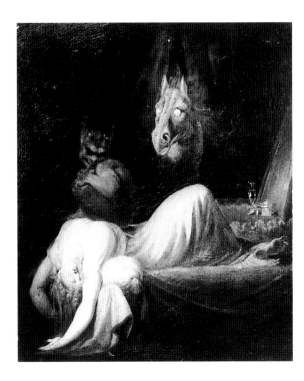

Henry Fuseli
The Nightmare, 1790
Oil on canvas
Goethe-Haus, Frankfurt am Main

elements that produce "astonishment" and "that state of the soul, in which all emotions are suspended, with some degree of horror," as "obscurity," "vastness," or "greatness of dimension," "infinity," "darkness," and "rugged and broken surface."[46] Gothic tales are set in Northern countries, in the picturesquely uncultivated landscapes and dismal climates of Scotland, Germany, the Alps, or New England. Eternal drizzle, violent thunderstorms, high winds uprooting old cartilaginous trees, and sudden floods thrilled readers and spectators of the eighteenth and nineteenth centuries. The natural milieu and artificial objects function—in the sense of the Romantic "pathetic fallacy"—as a mirror to the moods and character of tormented and passionate souls. The perception of exteriority is radically transformed by a change in the state of mind as triggered, for example, by the protagonist's encounter with a stranger in Henry James' *The Turn of the Screw:*

> The place, moreover, in the strangest way in the world, had, on the instant, and by the very fact of its appearance, become a solitude.... It was as if, while I took in—what I did take in—all the rest of the scene had been stricken with death. I can hear again, as I write, the intense hush in which the sounds of the evening dropped. The rooks stopped cawing in the golden sky, and the friendly hour lost, for the minute, all its voice. But there was no other change in nature, unless indeed it were a change that I saw with a stranger sharpness.[47]

ostersize Copy Machine, 1996
ixed media
llection of Eileen and Michael Cohen,
ew York

Julie Becker

Postersize Copy Machine (detail), 1996
Mixed media
Collection of Eileen and Michael Cohen,
New York

 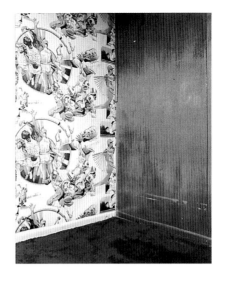

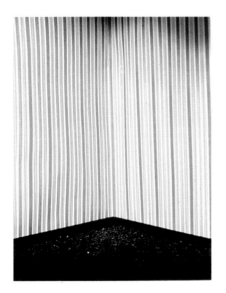 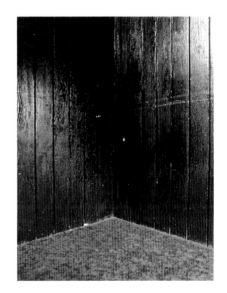

Interior Corner #1, 1993
C-print
Courtesy Regen Projects, Los Angeles

Interior Corner #7, 1993
C-print
Private Collection, Courtesy Thea
Westreich, Art Advisory Services,
New York

Interior Corner #8, 1993
C-print
Private Collection, Courtesy Thea
Westreich, Art Advisory Services,
New York

Interior Corner #10, 1993
C-print
Collection Nina and Frank Moore,
New York

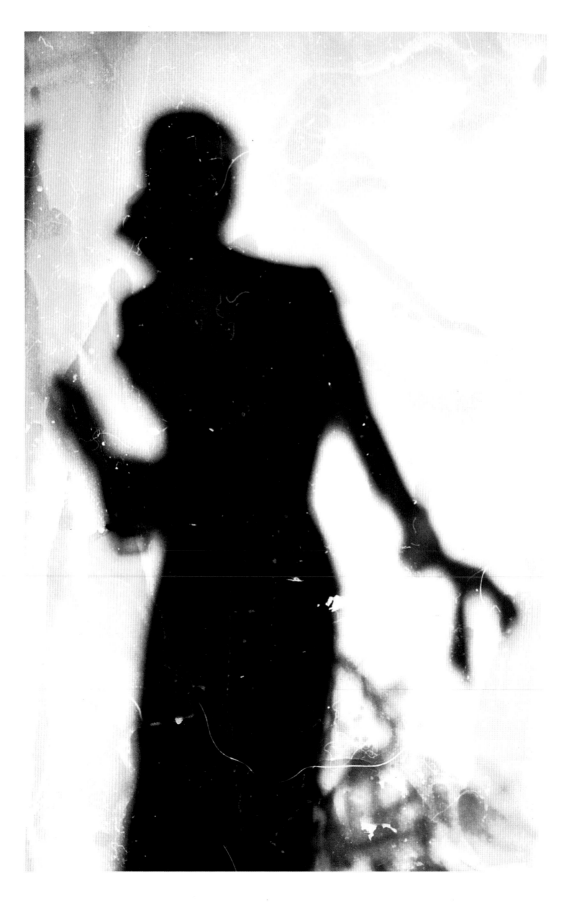

Monica Carocci

Untitled, 1995
Black and white photograph
Courtesy Galleria Guido Carbone,
Turin

Untitled, 1995
Black and white photograph
Courtesy Galleria Guido Carbone,
Turin

Monica Carocci

Untitled, 1995
Black and white photograph
Courtesy Galleria Guido Carbone, Turin

Untitled, 1995
Black and white photograph
Courtesy Galleria Guido Carbone, Turin

Dinos and Jake Chapman

Cyber-iconic Man (detail), 1996
Mixed media
Courtesy Victoria Miro Gallery, London

Dinos and Jake Chapman

Excess Energy Expenditure Page
(Unholy Enema), 1997
Mixed media on paper
Courtesy Victoria Miro Gallery, London

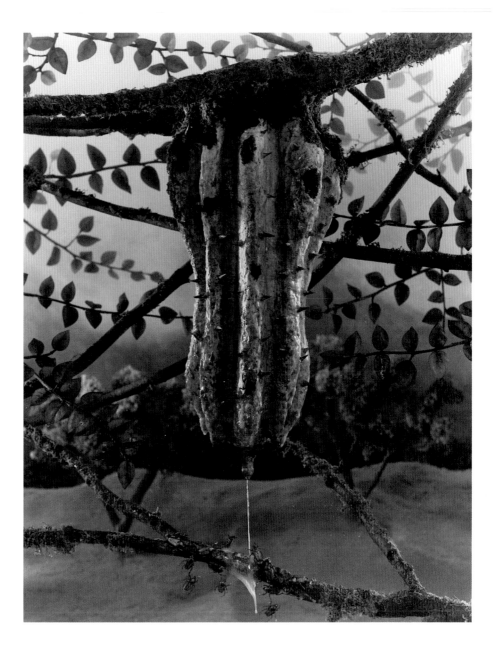

Gregory Crewdson

Untitled, 1994
C-print
Courtesy of the Artist and Luhring
Augustine Gallery, New York

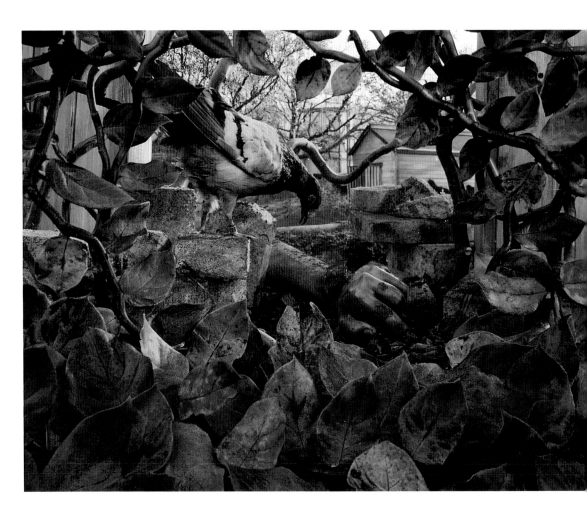

Gregory Crewdson

Untitled, 1996
C-print
Courtesy of the Artist and Luhring
Augustine Gallery, New York

Untitled, 1994
C-print
Courtesy of the Artist and Luhring
Augustine Gallery, New York

Untitled, 1996
C-print
Courtesy of the Artist and Luhring
Augustine Gallery, New York

Keith Edmier

Blister, 1995
Acrylic, polyvinyl, wax
Collection of Friedrich Petzel Gallery,
New York

Nowhere (Insideout), 1995
Resin
Courtesy of the Artist and Friedrich Petzel
Gallery, New York

James Elaine

Swan Lake, 1995
Steel, decorative iron work, glass, anti-
freeze, and freeze-dried calf rib cages
Courtesy of the Artist, New York

Reflecting Pool, 1994
Ribbon mahogany wood and collected
alarm clocks
Courtesy of the Artist, New York

Sign for the Dying Salon, 1995
Steel, decorative iron work, stained glass
Courtesy of the Artist, New York

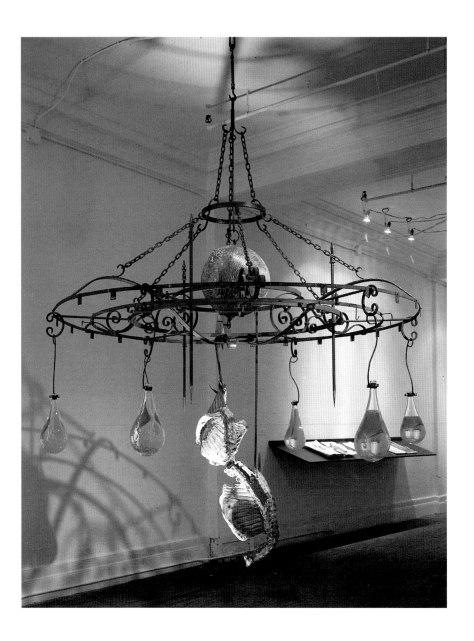

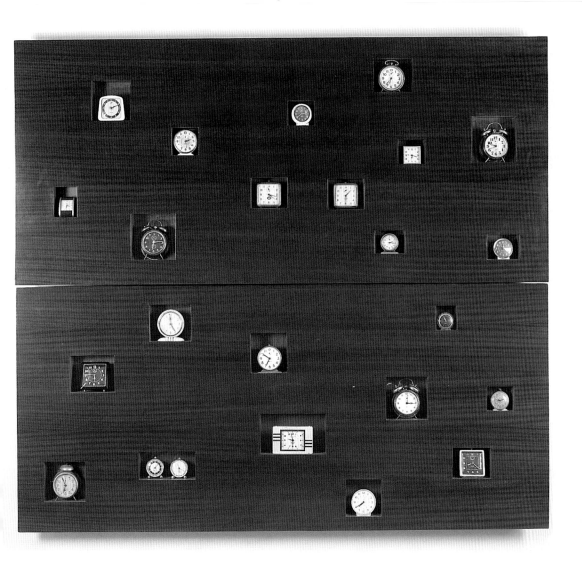

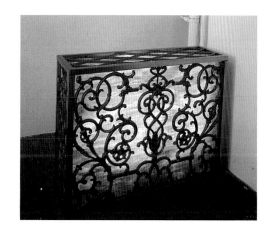

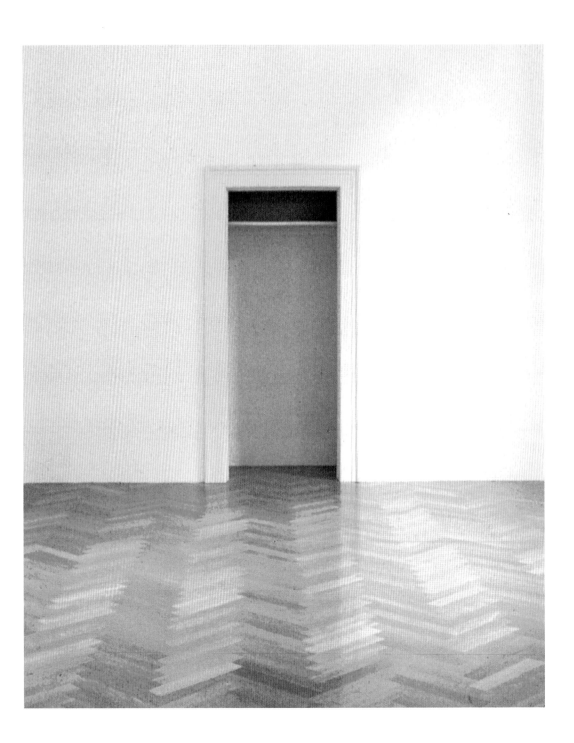

Robert Gober

Untitled (Closet), 1989
Wood, plaster, enamel paint
Collection of Selma and Josef Vandermolen,
Ghent, Belgium

The fascination with castles and other medieval ecclesiastical and secular buildings in early Gothic novels, indicated in many of the works' titles, gave the genre its name. The lonely, disintegrating and abandoned house in a bleak landscape with its haunted and dark interior filled with an abundance of heavy furniture and decoration, pregnant with history and memories, makes its appearance later in the development of the genre and constitutes the most popular Gothic *topos* of the nineteenth and twentieth centuries. Edgar Allan Poe's masterful setting of the scene in the opening paragraph of *The Fall of the House of Usher* still stands as the pinnacle of the production of an uncanny atmosphere: "During the whole of a dull, dark and soundless day in the autumn of the year, when the clouds hung oppressively low in the heavens, I had been passing alone, on horseback, through a singularly dreary tract of country; and at length found myself, as the shades of the evening drew on, within view of the melancholy House of Usher." This sight produces in the writer a feeling of "insufferable gloom," and "an iciness, a sinking, a sickening of the heart—an unredeemed dreariness of thought which no goading of the imagination could torture into aught of the sublime."[48] The notion of the uncanny has been described as "aesthetically an outgrowth of the Burkean sublime, a domesticated version of absolute terror."[49] The invasion of the private and secure sphere of the home by some unknown evil force exemplifies the conflict between interior and exterior world, between individual and society, and between the intra- and intersubjective. Ultimately, the uncanny describes the return of repressed events, memories, and fantasies—the encounter with one's own most intimate fears, as Freud described it: "It may be true that the uncanny is something which is secretly familiar, which has undergone repression and then returned from it…"[50] The house functions as a matrix for memory and the exploration of its hidden rooms, forbidden spaces, locked doors, closet, and cupboards (a standard theme in Gothic fiction as in *film noir*) summons to consciousness displaced and undigested experiences and dreams.

The contemporary Gothic is no longer exclusively at home in medieval castles, neo-Gothic homes, or isolated New England villages; the uncanny today surfaces in strange and bizarre American landscapes, in dark urban nightscapes, abandoned parking lots, factories, warehouses, and other remnants of postindustrial culture as well as in the suburban sprawl of apparent normality and peace. The only place where the uncanny has rarely felt at home is in the manifestations of Modernist architecture which are too bright, too clean and too transparent for the ghosts and memories of the subconscious to hide and unexpectantly resurface in moments of shock and surprise. Over the last decades, the last refuge of

the middle class has become the preferred site for encounters with strangers, serial killers, and the supernatural. Since George Romero's *Night of the Living Dead* (1968) horror has been situated in everyday suburban and small-town America. The film thrives on the painful contrast between the peaceful community and the ordinariness of its characters. Shot in black and white, "the result is a flat murky ambiance which is perfect for the ramshackle American gothic landscape where the events occur."[51] Throughout the 70s and 80s films such as *Carrie* (1976, Brian de Palma), *A Nightmare on Elm Street* (1984, Wes Craven), *Poltergeist* (1982, Tobe Hooper), and the *Halloween* (1978, John Carpenter) and *Friday the 13th* (1980, Sean S. Cunningham) series have situated the bloody clash of the normal and pathological into a pastoral and idyllic America, ignorant of social, urban, or technological change. On television the strange and wondrous world of David Lynch's *Twin Peaks*, located somewhere in the American heartland, was instrumental in utilizing the absurd-grotesque as an expression of the permanent conflict of illogical and subconscious processes and the demand for rationality and order in the material world. The intrusive presence of alien monsters and mad serial killers in the homes of ordinary Americans further signifies the disintegration the bourgeois institution of the nuclear family: "Rather than serving bourgeois patriarchy as a place of refuge from the social upheavals of the last two decades (many of which have been initiated by the young and women), the family has become the site of them—and now serves as a sign of their representation."[52] Economic realities, demographic changes, and the break-up of traditional gender roles are "the monsters" that have descended on common citizens since the late 60s. As Judith Halberstam has pointed out, the Gothic monsters that threaten and terrify us are never "unitary but always an aggregate of race, class, and gender."[53] Dracula, and his many mutations, stand for the "deviant and criminal, the other against whom the normal and lawful, the marriageable and the heterosexual can be known and quantified.... Dracula, in other words, is a composite of otherness that manifests the horror essential to dark, foreign, and perverse bodies."[54]

Goth and the Dilemma of Style

> We merely present the audience with a mirror so they can see themselves. People need to connect with something that represents how they feel. I'm not on some moral crusade to do that in particular, but... everything is coming apart at the seams, and I'm just here to record for posterity.
>
> Marilyn Manson, 1996[55]

In 1992, a California high school student was suspended for wearing a sweat shirt with Old English type because of its association with gang culture.[56] We are accustomed to find Gothic and Old English type on gravestones, in nineteenth-century books, on official documents such as the American Constitution, in old-fashioned *New Yorker* advertisements, or associate it with any product declaring a venerable tradition, respectability and trustworthiness (as the names of newspapers). Over the last years, the Gothic type has advanced from an indicator of the dull and boring to the ultra-hip, infiltrating mainstream design and advertising: "Imagine, a type style that began in an ascetic cloister now signifies both an urban street gang and State power.... Alternative work feeds the mainstream, its daring diluted through assimilation."[57] Gothic typeface as a stylistic signifier took the well-known route from shocking subcultural attribute to

Thierry Mugler
Fall/Winter Collection, 1988
Courtesy Thierry Mugler, Paris

Thierry Mugler
Fall/Winter Collection, 1990-91
Courtesy Thierry Mugler, Paris

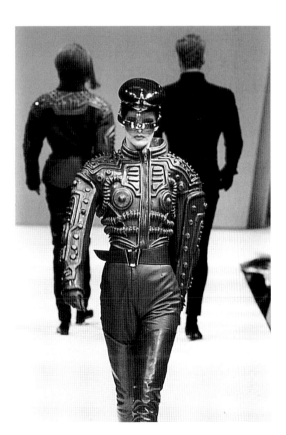

defused mainstream fashion statement via the customary stages of appropriation and transformation by youth culture, eventual discovery by astute designers, followed by the ascent from "low" to "high," respectively from underground to commercial culture until plunging to its certain death through overexposure. In recent years, stylistic elements of Goth have turned up in the fashion of such top couturiers as Thierry Mugler, Claude Montana, Jean-Paul Gaultier, John Galliano, or Alexander McQueen. While Goth managed to exist relatively undetected by the mainstream for over a decade, by the late 80s and early 90s models attired in the romantic or industrial Gothic look and appropriate makeup appeared on the catwalks of international fashion shows. The matching accessories, especially jewelry with medieval crosses or occult signs, were available from exclusive designers such as Christian Lacroix. At the end of mainstream appropriation inevitably stood commercial exploitation and semantic exhaus-

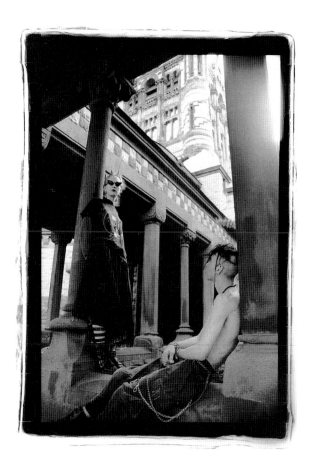

Bethany Shorb
Jeff and Amalia, Trinity Church, Boston,
Fall 1996
Silver print
Courtesy of the Artist, Boston

Shaun Kelly
DeLynn and Peter, March 12, 1997
Color photograph
Courtesy of Club Man Ray, Cambridge,
Massachusetts

tion, reducing stylistic idioms to innocuous mass-market caricatures devoid of their original subversive power and meaning. They became, as Dick Hebdige defined the process, "frozen": "Once removed from their private contexts by the small entrepreneurs and big fashion interests who produce them on a mass scale, they become codified, made comprehensible, rendered at once public property and profitable merchandise. In this way, the two forms of incorporation (the semantic/ideological and the 'real'/commercial) can be said to converge on the commodity form."[58]

Goth music and subculture first surfaced in the late 70s and early 80s in London, emerging from and in opposition to Punk, the New Romantic, and Glam Rock (with the monsters of rock Led Zeppelin, Kiss, Alice Cooper, and David Bowie as additional ancestors), further characterized by an active interest in the Gothic novel, Neo-Gothic architecture, and classic horror films. Anticipating the apocalyptic mood that would capture the public in the 90s, Goths dressed in a "profusion of black velvets, lace, fishnets and leather tinged with scarlet or purple, accessorized with tightly laced corsets, gloves, precarious stilettos and silver jewelry depicting religious and occult themes."[59] The dyed black hair, white makeup and dark lipstick completed the classic look that gave the often androgynous Goths their reputation for death worship and preference for the more macabre and mordant aspects of life. Deeply romantic, well read, and cultishly devoted to their musical heroes and lifestyle, the Goth scene, unlike most other subcultural styles, has displayed a remarkable staying power. By no means a homogenous group, Goths keep on reinventing themselves, currently branching out into the less atmospheric industrial music and adapting to its predilection for leather, metal, S&M and bondage. Occasionally (and mostly inaccurately) associated with Satanism, teenage suicides and vampiric rituals, Goth has been implicated in "moral panic attacks" frequently directed at youth subcultures.[60] Flirting with evil is, however, an integral part of the culture of Goth. Nine Inch Nails' Trent Reznor's New Orleans home features "the actual door of the Tate mansion on which the Manson family once scrawled the words 'PIG'," while newcomer Marilyn Manson ("Satan's Cheerleader" according to *Spin* magazine) unites the extremes of sex goddess and mass murderer in its name: "The world is totally screwed up, and that's the way I want it.... Good and evil, beauty and ugliness, hate and love, all rolled up into one."[61] Marilyn Manson's nightmarish videos ("Sweet Dreams" or "Tourniquet") exaggerate the current industrial or techno-Goth aesthetic of decay and decomposition, locating the distorted and mutilated body in the center of a postapocalyptic stage set shifting from natural history museum to lunatic asylum and rundown motel room.

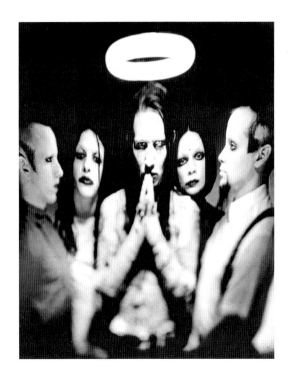

Marilyn Manson
Courtesy nothing, Los Angeles

Retinal Fetish[62]

> I beheld in full frightful vividness the inconceivable, indescribable, and unmentionable monstrosity which had by its simple appearance changed a merry company to a herd of delirious fugitives.

> I cannot even hint what it was like, for it was a compound of all that is unclean, uncanny, unwelcome, abnormal, and detestable. It was the ghoulish shade of decay, antiquity, and dissolution; the putrid dripping eidolon of inwholesome revelation, the awful baring of that which the merciful earth should always hide.

> H. P. Lovecraft, "The Outsider"[63]

In the eighteenth century, "Gothic" denoted "barbarous" and "primitive," derived from the low estimate of medieval architecture and its disproportionate emphasis on vertical movement, crude and abundant ornamentation, and dramatic light effects. John Ruskin—"always speaking as a Goth"—established in the nineteenth century that "the characteristics or moral elements of the Gothic are the following, placed in the order of their importance: 1. Savageness. 2. Changefulness. 3. Naturalism. 4. Grotesqueness. 5. Rigidity. 6. Redundance." Reversing the negative connotation of these attributes, Ruskin encouraged his contemporaries to "examine once more those ugly goblins, and formless monsters, and stern statues, anatomiless and rigid; but do not mock at them, for they

are signs of life and liberty who struck the stone."[64] Though tinted by a deeply romanticized notion of medieval society, Ruskin's definition of the aesthetic and moral substance of Gothic finalized a change in attitude towards the period that had commenced a century earlier.

While horror, alienation, and the disintegration of stable identities constitute a predominant subtext of nineteenth and twentieth century art, the coincidental stylistic manifestation in an exuberant, abundant, or fragmented aesthetic had its periodic appearances and disappearances. In stylistic terms, the Gothic is closely related and sometimes convergent with the grotesque: an excess of complex and intricate decoration with bizarre distortions and exaggerations of human, animal, and vegetable forms. The Gothic and the grotesque applied to the visual arts, as to literature, remain fluid types that transcend formal categorization and resist definite conceptualization through a multiplicity of metaphorical meanings. In the 1890s, for example, a spirit of decadence and decay—with a disorienting fragmentation of political, philosophical and artistic concepts—in what Arnold Schoenberg called "a death-dance of principles," pervaded the cultural climate of Vienna, Paris, Berlin, London, and other European capitals and manifested itself in the decorative excesses of Art Nouveau.[65] In the twentieth century, the "Aesthetics of the Ugly"—the dissociation of art from classical ideals and from Hegel's idealistic philosophy of reason—has become standard fare, evident in Expressionism, Dada and Surrealism, and climaxing in the traumatic experiences of horror during World War II. Gothic elements are abundant in the Surrealist's celebration of irrationality, insanity and hysteria, which were valued as creative valves for subconscious desires, nightmares, or phobias as, for example, dramatized in Luis Buñuel and Salvador Dali's *Un Chien Andalou* (1928). Surrealism and the Gothic share a decisively anti-Modernist stance, rejecting Modernism's emphasis on order, rationality, and purity.

Luis Buñuel and Salvador Dali
Un Chien Andalou, France 1928

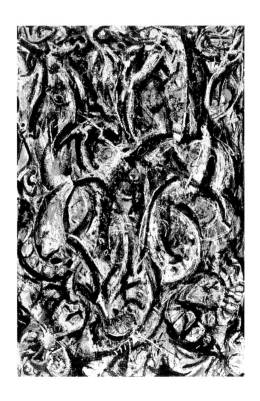

Jackson Pollock
Gothic, 1944
Oil on canvas
The Museum of Modern Art, New York
Bequest of Lee Krasner

In 1947, Clement Greenberg characterized Jackson Pollock's post-cubist paintings of the mid-1940s as "Gothic, morbid and extreme," inscribed with "paranoia and resentment," establishing a proximity in spirit to Poe and even detecting a sadistic and scatological sensibility.[66] Greenberg here employed Gothic as a negatively charged synonym for Surrealism, a movement he vehemently opposed: "Surrealism has revived all the Gothic revivals and acquires more and more of a period flavour, going for Faustian lore, old-fashioned and flamboyant interiors, alchemistic mythology, and whatever else are held to be the excesses in taste of the past," he wrote in 1944, the same year Pollock painted *Gothic*.[67] For Greenberg, retroactive nostalgia, formal fragmentation, and biomorphic remnants dangerously obstructed the forward thrust of Modernism. In the postwar decades, the Gothic continued to erupt sporadically into visibility: in the disjunctive, decaying, and soiled sculptures of West Coast "Beat" Bruce Conner or in Paul Thek's fetishizing displays of repulsiveness, assemblages of bloody chunks of meat in glass and steel cubes. Significantly, however, these manifestations remained confined to the margins of cultural discourse, violating the demands for monolithic statements and stylistic integrity.

The Gothic in contemporary art grows on the fertile ground of an excessive imagination, springing from a surplus of fantasy and desire and giving rise to images of horror, lust, repulsion, and disgust. Gothic art today speaks of the sub-

jects that transgess society's vague definitions of normality, discreetly peeling away the pretenses of outmoded conventions and transversing the amorphous border between good and evil, sanity and madness, disinterested pleasure and visual offensiveness. The Gothic reacts aggressively against the current "anti-intensity emotionology," as Peter N. Stearns has termed the protective withdrawal from authentic expression and display of profound affections. It challenges the anxious adherence to smooth operation and undisturbed functionality, and to "the requirement of a corporate, service-oriented economy and management structure; small-family size, with emphasis on leisure and sexual compatibility between spouses; consumerism; and anxiety about hidden forces within the body that might be disturbed by emotional excess."[68]

The internal characteristics that unite the contemporary Gothic have been defined as a preoccupation with "paranoia" ("the 'implicated' reader is placed in a situation of ambiguity with regard to fears in the text"), "the notion of the barbaric" (bringing us up "against the boundaries of the civilised" and "fear of racial degeneracy"), and "the nature of taboo" (addressing "areas of socio-psychological life which offend, which are surpressed").[69] The production of "horror and terror" in contemporary art manifests itself in a plurality of stylistic modes and presentational strategies. Gothic comes in the shape of formless and horrendous images of mutilated and rotting bodies with limbs covered in boils and wounds as, for example, in Cindy Sherman's disconcertingly repulsive-attractive photographs. It may also enter consciousness quietly—almost hesitantly—with the realization of terror being subtlely evoked. Robert Gober's reductive reconfigurations of simple everyday objects or body parts are transformed into nightmares, disturbing the illusion of domestic comfort. The old Gothic themes of the uncanny, the fantastic and pathological and the tension between the artificial and organic are infused with new potency as contemporary artists address concerns about the body, disease, voyeurism and power.

Gothic artists subvert the notion of agreeable, inoffensive beauty administered as an anaesthetic sedative in "therapeutic" cultural and educational institutions.[70] However, the ability to be shocked and moved by real or fictitious images of horror has been showing positive signs of attrition. Bombarded for years with the most graphic and explicit imagery, the public's tolerance threshold has been raised higher and higher. The spiral of ever more stunning special effects, direct brutality, and sexual innuendo might finally have reached its limits. The Disneyfication of culture provides us instead with a steady stream of bland second- and third-hand experiences, sanitized and hygienic entertainment that can be easily and absent-mindedly consumed. Even authentic images of atrocities and human suffering on television, as in reports about Bosnia, no

longer seem to have the calculated effect and are met with lack of passion.[71] The search for ever more provocative or shocking images must inevitably lead into the dead end of pure sensationalism and sensory induration, the images exhausting themselves in the "obscenity of the visible, of the all-too-visible.... It is the obscenity of what has no longer any secrets, of what dissolves completely in information and communication."[72] Even the art world's potential for arousing controversy has diminished considerably since the culture wars of the late 80s and early 90s. Many artists today again play out their "death wish": they want to be attacked and ridiculed in newspapers, magazines and on television (the latter unlikely in America), indulge in notoriety and achieve celebrity status. In Britain, class still functions as creative catalyst and the recent renaissance of contemporary art in London and other British cities can be partly ascribed to the healthy antagonism of an often fiercely hostile press, a continually suspicious public, and artists that thrive on rejection, scandals, and their

Francisco José de Goya y Lucientes
Grande hazaña! Con muertos! (Heroic feat! Against the dead!), ca. 1808-1814
From *The Disasters of War*, plate 39
Etching and lavis, working proof
Courtesy Museum of Fine Arts, Boston
1951 Purchase Fund

continuing ability to shock. Some reluctantly accept, others deliberately adopt, the persona of the artist as *enfant terrible*, cultivating a "schizophrenic" Dr. Jekyll and Mr. Hyde personality, preying for attention and fame. However, while some strategic maneuvering and strong attitudes may occasionally influence the (necessary) self-promotion in the art world, most artists are weary of the 80s example of instant burnout following celebrity status. Many artists today display a sincere belief in the power of art as they act out the old avant-garde drama of provocation and shock, resistance and unwanted cultural glorification as the inevitable final act: "Their [British artists'] work has been called nihilistic, but they embrace as much as they deny. They operate from a romantic, nearly nostalgic faith in the avant-garde assertion that art should entertain and disturb and question its own rituals while probing life's."[73]

Dinos and Jake Chapman's art, for example, presents itself in the demeanor of puerile schoolboys indulging in provocative and gratuitous displays of genitalia, violence, and blood, to be enjoyed in their very own entertainment park, "Chapmanworld" (the title—in Gothic type—of their 1996 exhibition at the London ICA). The carefully crafted and painstakingly painted models rely on the transformation of historical sources or are graphic materializations of psychoanalytical concepts, such as Bataille's "penial eye": "a final but deadly erection, which blasts through the top of the human skull and 'sees,' the overwhelming sun."[74] In *The Disasters of War* (1993) the artists translate Goya's etchings from his *Disasters of War* series (ca. 1808-14) into 83 miniature models with the "intention of detracting from the expressionist qualities of a Goya drawing and trying to find the most neurotic medium possible," while selecting one particular image to be blown up to a life-size, realist sculpture (*Great Deeds Against the Dead*, 1994).[75] *Cyber-iconic Man* of 1996 transforms a blurred black-and-white documentary photograph from George Bataille's classic *Tears of Eros* into a high-tech torture scene complete with realistic wounds and splattering fake blood, representing the epitome of "divine ecstasy and its opposite, extreme horror."[76] Combining the sacrilegious transmutation of classics from art history, authentic documentary sources, and their own genetic laboratory games, the artists succeed in their objective to reduce "the viewer to a state of absolute moral panic."[77]

The domestic sphere continues as the primary site of the inversion of assumed normality into a battlefield of the monstrous. Robert Gober's suggestive *Untitled (Closet)* of 1989 revives childhood memories of secrets explored in locked cupboards or closets. Here the space is open and empty, apparently stripped of any traces of past inhabitants. However, the small claustrophobic room becomes permeated with the visitors' own memories and responses. The closet, as Gober's

other transformations of furniture, doors, or sinks, are "objects you complete with your body, and they're objects that, in one way or another, transform you. Like the sink, from dirty to clean; the beds, from conscious to unconscious, rational thoughts to dreaming; the doors transform you in the sense…of moving from one space through another."[78] In Jeanne Silverthorne's work, banal electrical boxes and wires in black rubber grow and spread like carnivorous plants through the gallery space. The ICA, Boston installation starts almost invisibly in white rubber from an "Exit" sign on the second floor before descending three floors to the basement, the visceral mutations parasitically taking over the whole building. As much as the wires evoke associations of dead matter coming alive—in the tradition of Art Nouveau, Gaudí or *Alien*—they are also metaphors for the fragile body, "neurons and ganglia and intestines… taking what's usually behind the walls, the plumbing and the wiring, and disgorging these innards into space."[79]

Los Angeles artist Julie Becker similarly explores architecture, memory, and the idea of the home, however, to produce radically different effects. Her miniature reconstruction of real and fictional spaces in *Postersize Copy Machine* (1996) exudes the same fascination as dollhouses, crossed here with "a crime-scene model, complete with dingy shag carpeting, bad wallpaper and scattered notes written on tiny paper."[80] Further clues are to be found in photographs of her almost abstract *Interior Corners*, both of the model and of real corners that served as model, leading to frantic speculations that have to remain inherently inconclusive. "This installation…," she states about a related piece, "obsessively creates maze-like situations and multiple entryways for the viewer to enter and exit, through which he/she can access and assimilate information, create connections, pick up cues or clues, and construct or find narrative events."[81] In Abigail Lane's carefully staged crime scene, *The Incident Room* (1993) voyeuristic conventions of the male gaze (as epitomized in Marcel Duchamp's peepshow of *Étant Donné*, 1946-66) are undermined. The female wax mannequin surfaces from a pile of earth in a fake floor, surrounded by photographic lamps and accompanied by a fabricated newspaper report. Lane is more interested in the construction of complex narratives and intricate detective stories with indirect clues and evidence than in a sensationalist spectacle of murder, rape, or torture (for that her *mise en scène* is too ordered, the corpse's skin too clean, willingly betraying its artificiality). Instead, the "base materialism" of the female body withdraws itself from the objectification through the voyeuristic gaze, denying the spectator power over reality.[82]

Keith Edmier's installation *Nowhere (Insideout)* of 1995 makes visible the metaphorical function of architectural walls as the skin of a building, the win-

dow-like structure in semi-transparent, glowing purple resin ambiguously refer-
encing vaginal openings or wounds. Bloated, expanding and constantly at the
verge of bursting, *Nowhere* materializes an invisible energy or the last convul-
sions of a dying organism. Fascinated by film and special effects from early ado-
lescence, Edmier employs in his sculptures techniques he learned on sets of, for
example, David Cronenberg's *The Fly*. *Blister* (1995), a fleshy, flayed cornstalk
with a single, mutated corncob cast in dental-acrylic, "yields a symbolic harvest
rich in associations of monstruous fertility."[83] Underlying many of his objects is
a sublimation of formative or traumatic childhood memories, which are both
cherished as well as exorcised in these loaded objects.

Horror film's grip on the imagination has been one of the most powerful influ-
ences—on a formal, stylistic, and thematic level—on contemporary art over the
last decades: from the "High Gothic" of *The Cabinet of Dr. Caligari*, to the psy-
chological themes and distinct artificiality of American *film noir*, to Hitchcock's
masterful, teasing production of suspense, to the seemingly liberating battle of
special effects and graphic depiction of violence and sexuality since the late
60s. Douglas Gordon's *Twenty-Four Hour Psycho* (1995) simultaneously
fetishizes and deconstructs Hitchcock's classic horror film, both expanding sus-
pense to an excruciating length and delivering a disenchanting shot-by-shot,
frame-by-frame analysis. In his installation *30 Seconds Text* (1996), he again
plays with time and the careful sequencing and orchestration of perception.
Using a short description of a scientific experiment, the time required to read
the text (thirty seconds), and a mechanism alternating light and darkness in
intervals of the same length, Gordon produces a feeling of terror equal to the
most powerful movie.[84] Tony Oursler's recent video installations (for example *4*,
1997) are investigations into the history and present state of vision, voyeurism,
and scopophilia. The close-ups of eyeballs projected on large, variously-sized
spheres floating in space scrutinize the process of perception of "performers"
watching horror films on television. The work alludes to the classic filmic
exploration of voyeurism, Michael Powell's *Peeping Tom* (1959), about a sadistic
cinematographer who films his female victims as he kills them while they, at
the same time, are forced to watch their own agony in a mirror (one shot in the
film shows a large face distorted in a parabolic mirror). Oursler investigates the
complexity of vision as through a magnifying glass, with the cinematic appara-
tus (an essential element in theories of voyeurism) doubled in the video camera
used in filming and the video projector as part of the installation.[85]

The inspiration of horror and science fiction film, for example by the intesti-
nal-anthropomorphic-technological monstrosity of *Alien*, presents a subliminal
force for many artists. Gregory Crewdson both references David Cronenberg's

explorations of disease, mutation and social disintegration, as much as he understands himself "working in the American landscape tradition."[86] In his elaborately constructed photographic *tableaux*, the peacefulness of suburban and rural America becomes the scene for mysterious rituals or is corrupted by the traces of death, crime, physical decay and environmental disasters. In his dioramas the sublimity of nature is subverted by the artificiality of close-ups on rotting legs, dead foxes, giant moths, or robins watching an egg circle, throwing off-balance the equilibrium of the miniature and gigantic, macro- and microcosm.

In an era of genetic manipulation, disintegrating subjectivity, and the technological extension of human consciousness, the classic Gothic *topoi* of intervention into the process of creation, as established in *Frankenstein*, and the related motif of the double (or *Doppelgänger*, explored in E.T.A. Hoffmann's "The Sandman") are more pertinent than ever. "From the constantly shifting, decentralized growth patterns of postmodern urban centers, to cure resistant viruses and fractalized virtual realities, mutation suffuses every level of contemporary existence."[87] In his paintings, Alexis Rockman seduces the beholder through his old-master technique, alluringly luscious surfaces, and the richness of detail in animals, plants, and insects populating a prehistoric universe. Attraction turns into repulsion at the sight of a gigantic fly buzzing through the foreground of *The Beach: Demerara River Delta* (1994-96). Rockman obliterates the Gothic's opposition to realist aesthetics through his exaggerated hyperrealism that transforms the natural world into an arena of absurd mutations and genetic accidents, where evolution has gone wrong and the promises of extinction through human hubris lingers.

Keith Edmier's monstrous fabrications of human beings or plants, Robert Gober's realistic legs protruding from walls, Abigail Lane's wax corpse, or Cindy Sherman's assemblages of body parts all attest to a crisis of coherent selfhood. The uncertainty of "whether a lifeless object might not in fact be animate," was already cited by Freud as a primary source in the production of the effect of the uncanny.[88] The exact differentiation between human being and machine, robot, or cyborg has become impossible, giving rise to a "doubling, dividing and interchanging of self."[89] In her multiple views of the *Preserved Head of a Bearded Woman, Musée Orfila* (1991), Zoe Leonard insinuates the feeling of unease produced by the indefinite state between life and death, awake and asleep, which is nowhere more evident than in a wax museum. The ambiguous gender of the head subverts the fetishizing gaze of the observer, blocking the transference of desire as exemplified in the Pygmalion myth in which a beautiful female statue

comes alive.[90] It is in the "in-between, the ambiguous, the composite," as Julia Kristeva has defined, that the abject manifests itself, here enforced by the literally dismembered, "monstrous" female body put on display in a museum.[91]

Abjection in art produces rejection, disgust, repulsion and severs "the identificatory bonds between the viewer and the image."[92] It is evident, for example, in Mike Kelley's soiled and worn out dolls, sad objects of unfulfilled affection, or in his scatological drawings that exemplify contemporary art's "fixation not simply on sexual organs but, as well, on all bodily orifices and their secretions."[93] It has also been associated with the "monstrous-feminine" as externalized in Cindy Sherman's photographs of dismembered and incongruous composite bodies, rotting food, excrements and vomit. In her most recent photographs of grotesque demons and masked faces, Sherman has returned to her earlier investigation into contemporary (female) identity as an enactment of codified roles. Both the pictures of externalized bodily substances and identities disguised behind frozen masks are concerned with the mechanics and pressures of constructing and destroying feminine identity: "The images of decaying food and vomit raise the spectre of the anorexic girl, who tragically acts out the fashion fetish of the female as an eviscerated, cosmetic and artificial construction designed to ward off the 'otherness' hidden in the 'interior'."[94]

One of the enduring characteristics of the Gothic can be found in its emphasis on fragmentation, inconsistent narratives, and an excess of morphological, disjoined and decentralized forms and shapes—an "uncanny pathos which attaches to the animation of the inorganic," as Wilhelm Worringer defined the essence of the expressive Gothic.[95] The aesthetics of the grotesque and formless is present in much of contemporary art. James Elaine's oversized medieval chandelier welded in decorative iron with real carcasses and glass containers filled with poisonous green liquid or his illuminated, ornate shop sign without logo, critique the obsession with consumption as a desperate and ultimately futile attempt at defining identity through commodities. The ensemble, figuring under the title of *Objects from the Dying Salon*, is completed by the elegant presentation of found alarm clocks in a polished mahogany case; a juxtaposition that strips away the high gloss surface of fashion, advertising and merchandise display to remind the beholder—as in a traditional *memento mori*—of the transitoriness of existence. In his intricate spider webs constructed out of silver metal chain, Jim Hodges appropriates an overused prop of horror and inverts the tired trope to form a precious and fragile ensemble. The power of Hodges' installations derives from their invisibility, the deliberate denial of an iconic presentation on walls and quiet removal into dark and dusty corners or, with the larger

pieces, deliberately traversing a space and potentially catching the visitor in a moment of distraction.

Following Leonardo da Vinci's famous remark on the evocative nature of indistinct marks on walls, Sheila Pepe forms found fragments and discarded objects into accidental configurations, formless small-scale sculptures whose shadows are projected on the walls they are attached to. The amorphous figurines made out of pieces of wire, cloth, rubber bands, plaster, or wood—"low" materials found on the floor or street—find their *Doppelgänger* in shadows and distorted reflections of the self slowly metamorphosing into independent *alter egos*. Pepe's exquisite corpses and their obscure doubles revive the fantastic potential of art and reveal the delusive nature of perception before science and reason destroyed the thrill of phantasmagoric visions and superstitious nightmares. Since the late 1980s, Gary Simmons has applied his erased chalk drawings on slate painted walls, "obliterating" diagrammatic (and dichotomatic) images. His monumental *Ghost Ship* (1995) dissolves into the atmospheric background, evoking mythical stories of sunken pirates' ships and images from pre-war adventure movies. *Light House* (1996) places a tumbling building into a swallowing fog of sublime nothingness. The practice of erasure, as in literary theory, both negates and preserves traditional concepts or historical images while radically modifying their formal consistency and original meaning.

Pieter Schoolwerth's obsessive and overwrought drawings present an encyclopedic chronicle of contemporary American popular culture, organized around the strict implementation of an intricate, self-imposed system which reorganizes and convolutes the fifty states of America into a fantastic new geography (*Thee 83 Altered States ov Americka*, 1995-96). Reviving the aesthetics of the record cover and poster art of pop, hard rock, and heavy metal of the 60s and 70s (itself based on the appropriation of Art Nouveau, Neo-Gothic and medieval ornamentation), the signs, symbols, trademarks, and heroes of contemporary pop culture happily coexist with icons picked from art history books: the singer and performer Diamanda Galas next to Bernini's ecstatic Saint Theresa, the cast of the television sit-coms *Friends* or *Melrose Place* with the Alhambra. Visual profusion is balanced by the organization into twelve chapters with an explanatory opening panel and a concluding image of "Judgment Day" with a rocky apocalyptic landscape suggesting doom and damnation for the hedonistic, self-indulgent and amoral society depicted. In Schoolwerth's drawings, cultural critique and the identification with a Gothic sensibility and subculture overlap. For the *Gothic* exhibition, Mike Kelley and Cameron Jamie have chronicled, in documentary-style photographs, the phenomenon of the contemporary Goth club scene in Los Angeles with its adherence to dress codes and manners that

have characterized the subculture from its beginning. In a collaboration with artist Aura Rosenberg, Mike Kelley painted the face of the photographer's daughter in the style of a Goth, combining a childish delight in masquerade with the themes of disguise, alluding to double nature and role play in the Goth movement.

Wolfang Amadeus Hansbauer executes his monumental battle paintings in documentary black and white as well as nostalgic sepia tones. At the end of the twentieth century, the purifying, cathartic power of war no longer can be evoked as a solution to moral decline and decadence. History has long deteriorated into a farce, populated by comic style figures next to the intellectual heroes of a long gone past and starlets from pornographic movies. Hansbauer, "Callboy of the Gods" as he calls himself, is no despairing cynic, but observes the current state of the world and history with distanced amusement. Monica Carocci's large-scale black and white photographs with their blurry and scratched images feign authenticity and lay a similar (ironic) claim to historical truth. The indistinct shapes and figures appear like documents of mediumistic appearances as they are known from the heyday of spiritualism at the end of the last century. Based on miniature cut-out paper dolls or fashion photographs, the images are documents of an irreverent nostalgia as well as comments on the continuing fascination with the supernatural and occult while creating a new, magical if unstable world.

Oscillating between attraction and repulsion, recent art continues to explore the negative pleasures of the sublime which, as Edmund Burke defined it in the eighteenth century, is "productive of the strongest emotion which the mind is capable of feeling. I say strongest emotion, because I am satisfied the ideas of pain are much more powerful than those which enter on pleasure."[96] The Gothic in contemporary art captures, through a heightened sensibility, the shifts and mutations in the moral and intellectual fabric of society as permutated through media, culture, and politics. No longer concerned with the production of grand or majestic terror, the Gothic sublime today reflects a hesitant and apprehensive state of mind obscured by a deep fear of the unfamiliar future: "It is the threat of the apocalypse that is the spectacle of the sublime; it is the threat of self-extinction and 'self-dissolution' that forces the subject to retreat back into the comfortable frame of the beautiful." In a final ecstatic *danse macabre*, we are slowly waltzing toward the end of the millennium, verging upon the edge of an eternal abyss, closer and closer until swallowed by an all consuming vortex. It is the year 2000—and we are still here.

Jim Hodges

I Know This, 1994
Steel and silver chain
Courtesy of the Artist and CRG Gallery,
New York

Transgression and Decay

PATRICK MCGRATH

It is reassuring to learn that Horace Walpole, the inventor of the Gothic novel, was despised by the Victorians. They thought him a disgrace to his sex on account of his milky-white effeminacy. But he was even more deeply flawed than that. Macaulay wrote in *The History of England*: "None but an unhealthy and disorganized mind could have produced such literary luxuries as the works of Walpole.... His mind was a bundle of inconsistent whims and affectations. His features were covered by mask within mask. When the outer guise of obvious affectation was removed, you were still as far as ever from seeing the real man." Walpole's proto-Gothic novel, *The Castle of Otranto*, was published in 1764. Today the genre it pioneered still thrives, in part because of the very trait that Macaulay condemned in its author. Like Macaulay, we too have trouble seeing "the real man," though unlike Macaulay—and here we partake of the perennial skepticism of the Gothic—we have trouble even *believing* in "the real man."

From the moment it was spawned in Walpole's "unhealthy and disorganized mind," the Gothic has disturbed and subverted all that is certain, singular,

rational, balanced, established. Its *raison d'être* is transgression. It identifies limits so as then to assault them. The first full Gothic flowering came at the end of the eighteenth century, with the novels of Mrs. Radcliffe, and more particularly, with M. G. Lewis' *The Monk*, a gloriously horrible tale of a very bad priest. By the mid-nineteenth century the Gothic canon included Mary Shelley's *Frankenstein*, Emily Brontë's *Wuthering Heights*, and the work of Edgar Allan Poe. Then at the end of the century, within a decade of each other, were published Stevenson's *The Strange Case of Dr. Jekyll and Mr. Hyde*; Wilde's *The Picture of Dorian Gray*; and the greatest of all Gothic novels, Bram Stoker's *Dracula*, in which not one but three of the sort of Englishman that Macaulay would have approved of—plus a robust American and a Dutchman with an encyclopedic intellect—are pitted against an outlaw of unprecedented power and grandeur.

Bram Stoker
Dracula: notes and outline
Page 1, ca. 1890-96
Rosenbach Museum & Library,
Philadelphia

Count Dracula is immensely instructive for the student of the Gothic. He domi-
nates the genre by virtue of the sheer scale of his transgression. No mere thirst
for blood drives this vampire; his challenge is to the very idea of mortality. For
Dracula is committed to nothing less than the breakdown of the distinction
between life and death, and the creation of a race of undead beings whose rela-
tionship to time, to nourishment, and to sunlight mirrors his own. Like Satan,
his real father, Dracula's argument is with God, and with the biological arrange-
ments God made for humanity.

It is not only God's authority that Dracula flaunts. This master vampire has a
tendency to prey upon susceptible young women and arouse in them a ravening
sexual hunger. For an upstanding Victorian like Bram Stoker, who understood
clearly not only the place of women in patriarchy but the appropriate attitudes
they should display while occupying that place—docility, sweetness, piety,
etc.—this provocation of female physical appetite was as evil an act as could be
imagined. The Gothic tends always to assume this posture in relation to the
dominant values of a culture. It negates. It denies. It buries in shadow that
which had been brightly lit, and brings into the light that which had been
repressed.

Nothing has come after *Dracula* that can match its enormous sweep and vitality,
for the simple reason that the wealth of psychological insight that the Gothic
raised from the darkness of the unconscious—and most comprehensively
expressed in *Dracula*—was usurped by Freud. Before Freud, the Gothic had
exclusive access to the workings of the disturbed psyche, and a monopoly on
the depiction of strange and violent behavior. Freud expanded and systematized
this body of knowledge, gave it the name of *psychoanalysis* and thus lent it a
dignity and prestige it could never have achieved under the rubric of sensa-
tional horror fiction. Although in some current disarray, psychoanalysis has in
this century largely fulfilled the traditional function of Gothic literature. Freud's
case studies stand alongside the best of Poe.

We can observe the Gothic in its prefiguring of central psychoanalytic concerns
if we return to Macaulay and his uneasy failure to find in Walpole "the real
man": here, in its founder's implicit refusal to treat his own identity as consis-
tent, coherent, and unified, the Gothic displays its tendency to subvert any and
all established structures of thought. The idea of the "real man"—or the "true
self," or the "essential identity"—has no validity in the Gothic. The Gothic rec-
ognizes the fluidity, the multiplicity, the contingency of identity. It shies away
from absolutes and essences, it understands that any figure—including the
self—will change its appearance according to the perspective of the observer

and the context against which it is observed. Both Dr. Jekyll and Dorian Gray, for example, become entirely different entities according to the time of day. After dark, each is the antithesis of his daytime self. And Dracula: so profound is his rejection of a singular and coherent identity, not only can he change into, among other things, a lizard or a bat, but he refers to himself as "we." Jonathan Harker, the young man who travels to Castle Dracula early in the book, takes this as an expression of aristocratic hubris. We know better. Dracula can no more be a unified Cartesian "I" than he can respect any of the other givens of the culture in which he has launched his grand project. Many of the dominant themes and motifs of the Gothic—masks, monsters, grotesques, doubles, ghosts, madness, intoxication, dreams—speak to this *instability of identity,* and in the broadest sense make a question of our central assumption within identity, and ask: *what is the human?*

It is here that the Gothic raises its most disturbing challenge to the order of things. The Gothic has always been fascinated at the prospect of *undoing the human.* Traditionally this involved sundering the Christian amalgam of body and soul. The disembodied soul—the ghost, the phantom, the ectoplasmic apparition—returns in the Gothic literally to haunt a world grown complacent. More disturbing, however, is the body that lacks a soul—the ghoul, the zombie, the vampire—and thus lacks all capacity for identification and empathy. Count Dracula is of course our prime instance of the type. He can pass for human but lacks any characteristic that would properly qualify him as human. He cannot walk in sunlight, or tolerate the crucifix, or die; he sleeps a deathlike sleep that may last hundreds of years, but within that death he cannot rot. And of course he cannot feel like a human. He has no capacity for mercy, tenderness, sorrow, or love.

Dorian Gray is another of this type. After he trades his soul for eternal youth he loses all capacity for human feeling. Those who become involved with this beautiful young man are invariably destroyed, ruined, or driven to suicide. Significantly, the first symptom of moral decay that becomes apparent in the painting, after it has taken over the aging process of its subject, is a mark of cruelty in the face. In losing his soul, and preserving his youth, Dorian has become cruel. Thus is his humanity destroyed.

A different possibility is articulated in *The Strange Case of Dr. Jekyll and Mr. Hyde.* Here it is not so much that the doctor is severed from his soul as that a lower part of his nature comes at certain times to dominate his higher, better self. We can see here a shift away from a Christian paradigm to an idea with a distinctly Darwinian/Freudian flavor. The suggestion implicit in Dr. Jekyll's

story is that man is less a fusion of body and soul than he is a hybrid of the human and the animal, with the animal in him kept in constant thrall to the higher self, with which it uneasily cohabits. Robert Louis Stevenson, who learned his psychology in the fiercely dualistic Calvinist Church of Scotland, created Dr. Jekyll in order to imagine what it might look like if the animal—or the id—overwhelmed the higher self. The result is a creature, Mr. Hyde, who strongly resembles a contemporary sociopath. His violence is random, vicious, and without meaning. Stevenson presciently identifies the single most dramatic instance of a modern social pathology in this short book. He shows that when the controls start to weaken, what is unleashed is hideous both in its ferocity and its blindness. What we carry within us is the beast, and a mad, ravening beast at that. We are rabid.

Stevenson was not the only Gothicist to point the way forward to the sicknesses of late-twentieth century society. In *Heart of Darkness,* Joseph Conrad identified colonialism as an engine of evil and inhumanity, and showed that in its pursuit of the resources of the undeveloped world—in this case, central Africa—the colonial project created monsters out of men. Kurtz is the monster here, the ultimate regressive, like Dr. Jekyll a brilliant man overwhelmed by the primitive and instinctual in his own nature.

It becomes more and more apparent as one digs deeper into the obsessions of the genre that this theme of regression and breakdown—of collapse into less complex forms of organization—is almost invariably present in the Gothic in some manner. And this is its second great theme, after transgression—the theme of *decay*. We find it in all the familiar tropes and motifs. The Gothic revels in ruin, whether it be architectural, moral, biological, ontological, or psychic, and every manifestation is emblematic of death. The Gothic consistently attempts to speak about the unspeakable—that is, death—through a frenzied elaboration of all that it can seize upon that points toward death, that suggests, signifies, or symbolizes death. There is, then, a sort of death wish implicit in the Gothic, what Freud identified as a tendency in all living organisms to slide back toward an undifferentiated state of nonbeing, to lose identity, to merge organically; in a word, to die. In its crumbling mansions and its crumbling minds, in its fractured, partial beings and its monstrous grotesques, in its blasted ideals, its bestial killers, its rank jungles, its fevered dreams, in all its manifestations of decay, the Gothic seeks only to speak of death.

What then does it mean, that the Gothic is apparently enjoying one of its cyclical resurgences of popularity? It means that a perception is prevalent that social

structures are breaking down, that the violent impulse is overwhelming the civilized constraint, that the primitive and instinctual forces of the unconscious mind cannot be quelled by the normal inhibitory mechanisms. In other words, the death drive is rampant, as it was in Europe in the 1930s when Freud first detected in his contemporaries' enthusiasm for total war an instinct as powerful as the libido, though directly antithetical to the pleasure-seeking appetites and the creativity of the libido. The Gothic is the form of art that permits us to confront these fears and apprehensions. In the Gothic we can safely look at the destructive energies we detect in the world around us, as well as in our own psyches, and defuse the menace we discover there. The Gothic allows us to manage the nightmares of a world in which control seems increasingly tenuous.

But the Gothic is a twin-themed genre, driven by transgression as well as decay, and in its transgressive tendency resides its political potential. As Joseph Conrad so mordantly illustrated in *Heart of Darkness,* a tale of breakdown could carry within it a precise indictment of the system of economic and racial exploitation that stimulated the breakdown in the first place. Similarly, *The Picture of Dorian Gray* teaches the moral that no aesthetic system can be seriously entertained that does not exclude cruelty. The Gothic speaks both to the death wish, and to the impulse to identify specific conditions and power relations that foster what we experience as evil. It is a supple and resilient genre that shows no sign of exhaustion. Rather, it is capable of infinite renewal, as its diverse themes and rich stock of symbols are gathered up and reinvested with meaning by successive generations of artists.

Sheila Pepe

Untitled (fuzz and books) from the
Doppelgänger series, 1994
Installation with object, shadow,
wall drawing
Courtesy Judy Ann Goldman Fine Art,
Boston

Edifying Narratives

The Gothic Novel, 1764-1997

A N N E W I L L I A M S

In 1764 a book called *The Castle of Otranto: A Gothic Story* was published anonymously in London. In the first chapter, a giant helmet comes crashing down into the courtyard of the Castle, killing Conrad, only son of Prince Manfred. With suspicious alacrity, Manfred responds to the loss of his heir by proposing to divorce his aging wife Hippolyta and to to marry Isabella, his son's betrothed. He conducts his implicitly incestuous but quite literal pursuit of this princess through the dark vaults and dim corridors of the Castle, spaces uncannily furnished with weeping statues and sighing ancestral portraits.

But Manfred is doomed to failure at every turn. He accidentally kills his other child, Matilda, and he learns that his own claim to the throne he inherited is illegitimate. A young "peasant," Theodore, effects the fall of the House of Manfred, both literally and figuratively: "The walls of the castle behind Manfred were thrown down with a mighty force, and the form of Alphonso [patriarch of the family line and owner of the giant helmet] appeared in the centre of the ruins: 'Behold in Theodore the true heir of Alphonso!' said the

vision." Manfred and Hippolyta retire to separate convents; Theodore (who had been in love with Matilda) marries Isabella, intending to pass the remainder of his life "in the society of one, with whom he could forever indulge the melancholy that had taken possession of his soul."

This slender volume was an immediate best-seller. With the second edition, the author disclosed his identity; he was Horace Walpole, son of the great Prime Minister, and a noted antiquarian, raconteur, collector, and dilettante, who had spent the previous decade in remodeling his country house, Strawberry Hill, in "Gothick" style. Walpole declared that his story had its origins in his dream of an enormous gauntlet resting on the balustrade of the staircase, a vision so compelling that he sat down and began to write, completing his narrative in a mere six weeks.

No historian of the Gothic novel fails to repeat this story of Walpole's dream house and house dream. It is, however, somewhat misleading as a myth of origins. There was very little novel (in the sense of "new") in either the plot or decor of *The Castle of Otranto.* The word "Gothic" in the subtitle signified in Walpole's time "medieval" as well as "rude and barbarous." A taste for all these qualities had been developing throughout the eighteenth century. Antiquarianism—interest in the past both for its own sake and as a source of national identity—was flourishing. Alexander Pope's *Eloisa to Abelard* (1717), one of the best-loved poems of the century, uses Gothic architecture to portray a woman "lost in the cloister's solitary gloom." (Indeed, Walpole wrote that part of Strawberry Hill was modeled on the Paraclete, Eloisa's abbey, as imagined by Pope).[1] The "graveyard school" of the 1740s had taught readers of poetry to appreciate "the gloomy horrors of the tomb."[2] And Shakespeare, though "barbarous" in the eyes of neoclassical French critics such as Boileau, was increasingly praised as a fount of Englishness, as a great writer who ignored the Aristotelian "unities" and was the better for it. Meanwhile, among the wealthy, landscape gardens ornamented with "picturesque" ruins had superseded the French fashion for geometric patterns as in the gardens of Versailles, where to English eyes, the *parterres* signified French despotism. And Edmund Burke's *Philosophical Enquiry into the Origins of the Sublime and the Beautiful* (1759), had claimed aesthetic respectability for the grand, the indeterminate, the boundless, the infinite, the dark.

Furthermore, *The Castle of Otranto* was not, technically speaking, a "novel" at all. Literary scholars generally reserve that term for designating prose fiction in a realistic mode, narratives that accurately mirror social and historical conditions. *Otranto* (and all so-called Gothic novels) are more properly called

J. M. W. Turner
*The Transept of Tintern Abbey,
Monmouthshire,* 1794
Watercolor
Ashmolean Museum, Oxford

"romances," lurid fictions driven by the wish-fulfillment dreams, or the night-mares, of author and audience. To give Walpole his due, however, one must acknowledge that his "Gothic Story" hit upon a set of images and conventions that was to preoccupy the literary imagination of Great Britain quite obsessively until around 1820, and then to disappear, reemerging periodically in a series of "Gothic Revivals." Walpole placed a dynastic family plot within a Gothic ("rude," "barbarous," "medieval") setting. This combination seemed particularly effective in evoking those emotions, terror and melancholy, that the reading public by 1764 found pleasurable. And he published it in the newly popular medium of the novel, cheaply marketed and widely distributed.

The Gothic tradition has not been highly regarded by literary scholars, despite the fact that it has attracted many canonical writers, such as Coleridge, Keats,

Cover of *Mistress of Mellyn*
by Victoria Holt
Fawcett Publications, Inc., 1962
Courtesy of Ballantine Books, a Division
of Random House, Inc., New York

Victoria Holt's *Mistress of Mellyn* was a
mainstream best-seller in 1960, serialized
in *The Ladies Home Journal,* and also
selected by the Literary Guild and
Reader's Digest Condensed Books.
Between July 1960 and February 1961 it
went through five hardcover printings. The
first paperback edition by Fawcett World
Liberary (New York) appeared in
September 1961 with the cover design
that was soon to be both cliché and icon
of the mass-market Gothic: a woman flee-
ing the castle with one lighted window, an
event that virtually never takes place in
these narratives. It may evoke Cinderella's
flight from the castle on the stroke of
midnight, as the folktale, like the popular
Gothic, concerns the crises of female
identity.

*The famous best-seller
suspense novel*

CREST
BOOK
d468

50¢

Mistress
of Mellyn
Victoria Holt

Cover of *I am Gabriella!*
by Anne Maybury
ACE Books, 1962
Courtesy The Berkley Publishing Group,
New York

Anne Maybury's *I Am Gabriella!* is char-
acteristic of Holt's many imitators. The
cover illustration places the narrative in a
contemporary setting: the heroine wears
horn-rim glasses (appropriate in the story
about one cousin's recognition of the
other) and her skirt length is fashionably
daring for 1962. The blurb on the back
cover entices potential readers with the
following description: "In an isolated
chateau with a strange old woman and an
evil-faced brute, Karen found the missing
girl—who kept insisting, 'I am not
Maxine; I am Gabriella!' *Who was the
girl with Maxine's face?*"

Cover of *The Lady of Glenwith Grange*
by Wilkie Collins
Paperback Library, Inc., New York, 1966

The public appetite for mass-market
Gothics in the 1960s led editors to search
the archives for anything that might be
published with the appropriate cover. All
of Daphne du Maurier's novels were
reprinted, for instance; and many long-
forgotten novels such as Wilkie Collins'
The Lady of Glenwith Grange were now
available in paperback, as were real rari-
ties such as *Glenarvon*, Lady Caroline
Lamb's Gothic *roman à clef* about her
affair with Lord Byron.

the Brontës, Melville, and Faulkner. (Those who admire these authors have tended to deny, dismiss, or rationalize this family relationship.) Reasons for their low opinion no doubt include the Gothic tradition's intermittent but often extreme popularity, the sensational and subversive nature of its materials, and its long and close association with women writers as well as readers. Jane Austen's affectionate satire of the Gothic in *Northanger Abbey* (1818) acknowledges the dangers of such company; Isabella Thorpe, who initiates the heroine Catherine Morland into the delights of the Gothic with her list of "truly horrid" books, is an exceptionally silly and superficial girl. In addition, "the novel" itself had to struggle for respectability during the nineteenth century; it did so by growing increasingly preoccupied with the social and ethical issues best dealt with in a more realistic narrative mode. In their themes and topics, novelists seemed to express a growing conviction that if "the novel" was to be taken seriously, it had better claim the high seriousness that only realism affords. (Despite whatever powers *The Monk* may have, it is no *Middlemarch*.)

And yet Walpole appears to have assumed that his "Gothic Story" might instruct as well as delight. He agreed with the old idea that the author bears a responsibility to edify the audience. Walpole's tone in both his prefaces is ironic; but when he (posing as translator) piously suggests "the author" of *Otranto* might have hit upon a "more useful moral" than that "the sins of the fathers are visited on their children to the third and fourth generations," he both articulates his book's theme and accepts the premise that stories should be instructive. (In objecting to this particular "moral" as well, he raises some interesting questions about his own Oedipal anxieties as son of the most powerful man in England.) A generation later, Ann Radcliffe's *The Mysteries of Udolpho* (1794), the most popular and influential of all early Gothics, still conforms to this didactic convention. It concludes with this rousing peroration: "O! useful may it be to have shewn, that, though the vicious can sometimes pour affliction upon the good, their power is transient and their punishment certain; and that innocence, though oppressed by injustice, shall, supported by patience, finally triumph over misfortune!"[3]

While these claims may sound a bit disingenuous to our ears, they should not be entirely dismissed, even though the explicit morals the authors intended to convey are not the most interesting lessons the Gothic teaches. Certainly Gothic conventions have had remarkable staying power, which implies that their reappearances, their continual rebirth in various guises, reveals something constant—and anxiety-provoking—in Anglo-American culture of the past two centuries. By 1820 the public taste for Gothic fiction had sharply declined, assuming a less prominent place in Victorian literary subculture.

ANNE WILLIAMS

Robert Gober

Untitled, 1994-95
Wood, wax, brick, plaster, plastic, leather,
iron, charcoal, cotton socks, electric fire
Courtesy of the Artist, New York

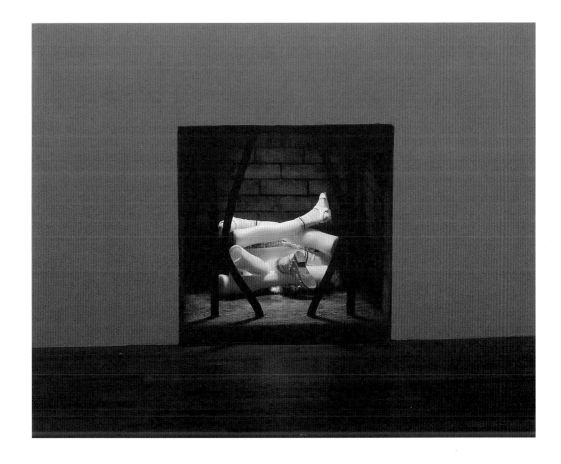

Douglas Gordon

Monster, 1995
Color photograph
Courtesy of the Artist, Glasgow

30 Seconds Text, 1996
Timer, lightbulb and vinyl lettering
Courtesy Bloom Gallery, Amsterdam

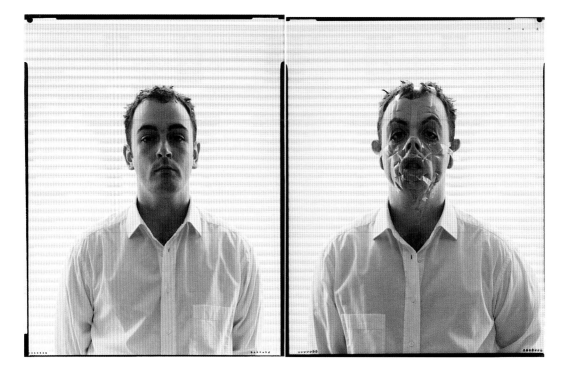

30 seconds text.

In 1905 an experiment was performed in France where a doctor tried to communicate with a condemned man's severed head immediately after the guillotine execution.

"Immediately after the decapitation, the condemned man's eyelids and lips contracted for 5 or 6 seconds...I waited a few seconds and the contractions ceased, the face relaxed, the eyelids closed half-way over the eyeballs so that only the whites of the eyes were visible, exactly like dying or newly deceased people.

At that moment I shouted "Languille" in a loud voice, and I saw that his eyes opened slowly and without twitching, the movements were distinct and clear, the look was not dull and empty, the eyes which were fully alive were indisputably looking at me. After a few seconds, the eyelids closed again, slowly and steadily.

I addressed him again. Once more, the eyelids were raised slowly, without contractions, and two undoubtedly alive eyes looked at me attentively with an expression even more piercing than the first time. Then the eyes shut once again. I made a third attempt. No reaction. The whole episode lasted between twenty-five and thirty seconds."

...on average, it should take between twenty-five and thirty seconds to read the above text.

Notes on the experiment between Dr. Baurieux and the criminal Languille (Montpellier, 1905) taken from the Archives d'Anthropologie Criminelle.

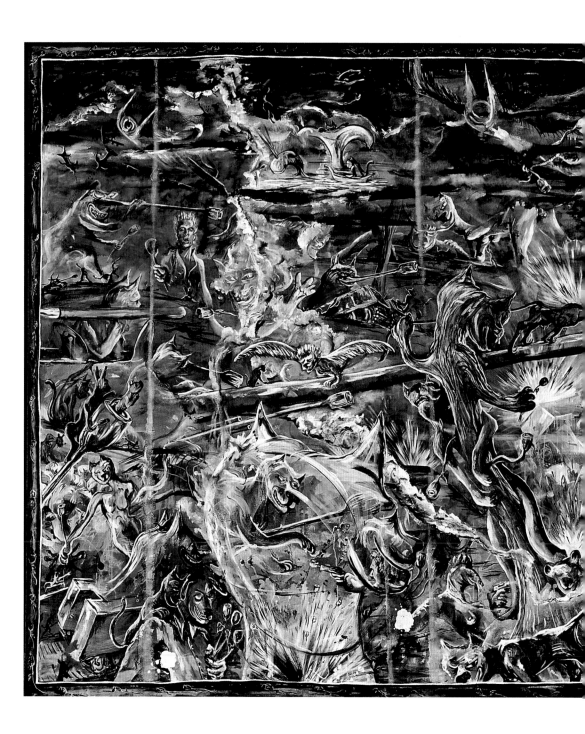

Wolfgang Amadeus Hansbauer

Friendly Fire, 1996
Acrylic on canvas
Courtesy Jablonka Galerie, Cologne

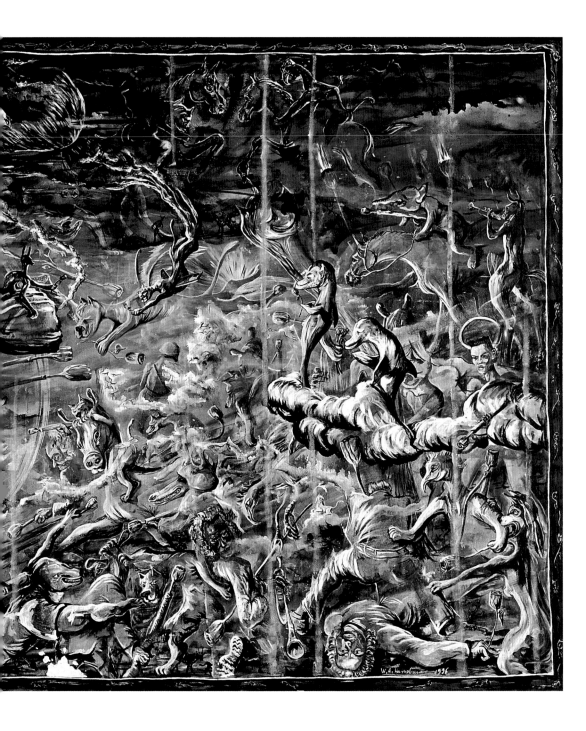

Jim Hodges

Far, 1996
Silver-plated chain
Collection of Howard Rachofsky, Dallas
Courtesy CRG, New York

In Blue (detail), 1996
Silk with thread
Collection of Tina Petra and Ken Wong,
Los Angeles
Courtesy CRG, New York

Aura Rosenberg

Mike Kelley/Carmen Rosenberg
Miller, 1996
From the series *Who am I, What am I,*
Where am I ?
C-print
Courtesy Wooster Gardens, New York

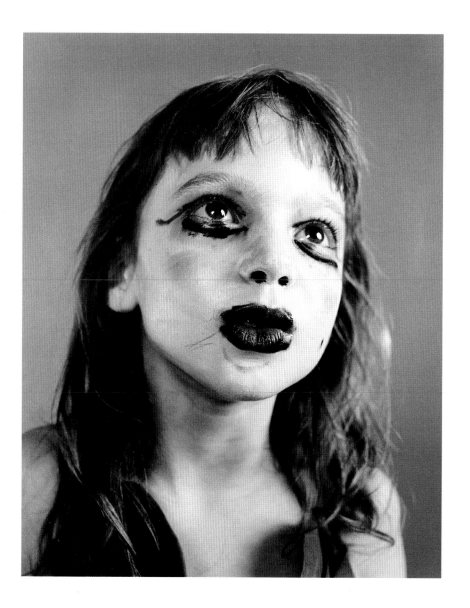

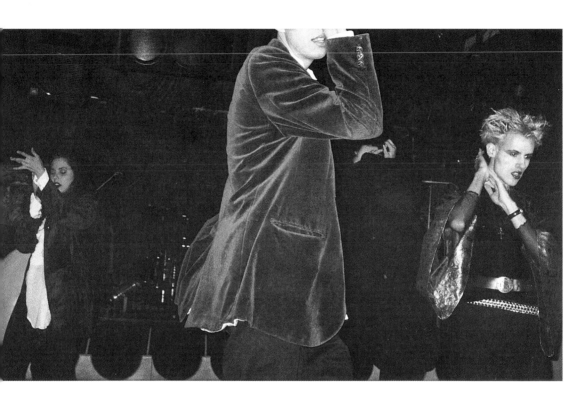

Mike Kelley and Cameron Jamie

Monday's Goth, 1997
Black and white photograph
Courtesy Patrick Painter Editions,
Vancouver

Mike Kelley and Cameron Jamie

Wednesday's Goth, 1997
Black and white photograph
Courtesy Patrick Painter Editions,
Vancouver

Abigail Lane

The Incident Room (detail), 1993
Earth, wax body
The Artist, Courtesy Victoria Miro Gallery,
London

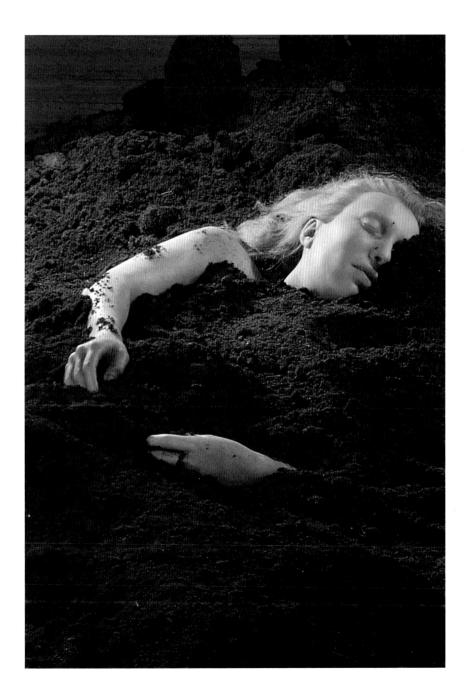

UK LINES

Private funeral for James Hunt

THE FUNERAL of racing hero James Hunt is to be a 'totally private affair' at the request of his family.

But a public memorial service is planned to allow fans to pay their last respects to the 45-year-old former world champion who died of a heart attack three days ago.

A family spokeswoman said: "The family want the funeral to be totally private, just for family and close friends. The memorial will be in about four to six weeks."

Fighting crime

TV policeman Nick Berry is joining the real fight against crime. Former EastEnders star Nick, who plays rural bobby PC Nick Rowan in the successful ITV series Heartbeat, stars in a crime prevention video made by Suffolk police.

Tax campaign

MORE than 1,000 motorists face prosecution for tax disc evasion after a crackdown by Essex police. The campaign, run jointly with the DVLA, also resulted in 5,000 vehicles being relicenced - bringing in revenue of £365,000.

Classic find

A COUPLE got more than they bargained for when they bought a new £47,000 house - they found a £15,000 classic car in the overgrown garden. Nick and Theresa Brown discovered the rare Austin Atlantic A90, one of only 500 ever made, in the garden at their new home in Hayling Island, Hampshire.

Six appeal

TEST star Chris Lewis is set to knock cricket bosses for six - by posing naked for a women's soft porn magazine. The England all-rounder, currently playing in the second Test against the Australians, was paid a five figure sum for revealing all in the next issue of For Women.

Firemen smoke

COUNCIL workers who break a smoking ban could be sacked - unless they are firemen. East Sussex County Council is set to introduce the rule for its 23,500 staff by 1995. But firemen returning from stressful incidents will be permitted a smoke, said a spokesman.

Police tracing mystery caller

Calls flood in after plea for information

POLICE trying to trace an apparently distraught woman who left a plea for help on an office answering machine were today following up several lines of inquiry.

More than 60 people from all over the country phoned Warwickshire police after officers appealed for help in tracing the woman, who claimed she was being held against her will.

Staff at contract cleaning company Northgate Services in Warwick found the heart-rending plea on the answer phone when they arrived for work.

The sobbing young woman pleaded: 'Please, someone help me. I need help. I'm in

the old broken down shed in Harbury...somewhere in Harbury, I think. Please help me...these people have got me here. Please he...'

The line then goes dead, when the phone could have been snatched from her hands.

Police revealed details of the call yesterday after secretly trying to trace the girl in Harbury, a village seven miles from Warwick, since the call was discovered on Monday morning. Spokesman Matt Tapp

said: "Speech therapists and voice trainers have listened to the tape and say it is a girl in her teenage years or early 20s who has and is still suffering some form of trauma.

"It is vital we discover one way or another who this woman is and determine what type of help she needs."

Officers are asking people to ring 0926 496901, listen to the tape themselves and tell them if they recognise the voice.

Mr Tapp said: 'We had 60 calls overnight from people up and down Britain suggesting lines of inquiry.

"Some names have been suggested to us which will be actively pursued today.'

He added: "Some other callers have suggested buildings she may have been referring to and these will be checked.'

Mr Tapp said aerial searches of Harbury and a five mile radius had been made before the mystery call was made public.

He said tapes of the woman's plea were being listened to constantly, with well over 1,000 calls logged in the first few hours after the police appeal.

National and international news - every day in your Echo

UN needs more help - Hurd

UNITED NATIONS peacekeeping efforts are being hampered by governments failing to supply enough troops, Foreign Secretary Douglas Hurd said last night.

He also accused countries of not paying their share of costs on time.

'Britain pays her bills on time,' he said. 'So do most of our EC partners, the Nordics and the countries with a long tradition of peacekeeping such as Australia and Canada.

'But some others, who share the heavy burden of international responsibility do not.'

For operations in Somalia, the former Yugoslavia and Cambodia, he claimed the United States owed £156 million, the Russian Federation £110 million and Germany £38 million.

Speaking at a banquet for the diplomatic corp at the foreign office, he called for more countries to lend a hand.

MONSTER HIT: Movie director Steven Spielberg is ploughing full steam ahead with a Jurassic Park sequel after the mammoth record box office takings on the film's first weekend on release. Dubbed Park II, plans were always in the pipeline but have been stepped up to ride on the dinosaur blockbuster's success.

PO raider foiled by pensioner

AN 86-year-old man helped pin down an armed robber who attempted to raid a subpost office.

The pensioner and the manager grappled with the raider after he produced an imitation gun and demanded cash at the counter in Carlisle, Cumbria, yesterday.

After a fierce fight in which the pensioner was slightly injured, the raider was disarmed and the police were called.

A man was arrested and is helping police with their inquiries.

Parents visit

THE PARENTS of convicted drug smuggler Patricia Cahill are to visit their daughter in a Thai jail for the first time in two years.

Pat and Frances Cahill will fly to Bangkok on Sunday after a sponsor stepped in to pay for the flight.

Kidnap victim's jokes of horror

KIDNAPPED est... agent Stepha... Slater joked with h... captor in a grim ga... to try to save her l... Nottingham Cro... Court heard.

Stephanie, 26, f... Birmingham, said laughed at Mic... Sams' sense of humou... try to build a rappo... make it harder for his kill her.

The court heard t... fear reduced Steph... to the brink of sui... when Sams abdu... her, bound, blindfo... and gagged her locked her in a co... shaped box.

But she told the j... "He said on two o... sions that he woul... sorry to see me go, m... ing the facetious c... ment 'can't you another week.'

"I said I would ha... decline his offer. Pa... the exercise was suading him to trust... Toolmaker Sams, 5... Sutton-on-Trent, Newark, Notts., admitted kidnap... Stephanie, holding... prisoner and deman... a £175,000 ranson... her release.

He has pleaded guilty to the kidna... murder of 18-yea... Leeds prostitute...

Nessie's better b...

BOOKMAKRS... offering smaller o... Elvis Presley an... Loch Ness M... being sighted this... than a British... winning Wimbledo...

Bookmakers W... Hill say they are of... odds of 1,000-1... Briton winning t... but have had no ta...

"Those are the... odds as we offer a... second coming of... Christ, or a female... twice the odds... Nessie being disc... and four times th... about Elvisra... ing," said spok... Graham Sharpe.

people

IN THE NEWS WORLDWIDE TODAY

TALK show host Oprah Winfrey has dismissed rumours she is about to secretly marry long-time boyfriend Steedman Graham.

SINGER Tom Jones says Elvis Presley thought he was black before they met in 1965.

Watch Clinton

US President Bill Clinton and Vice President Al Gore have been immortalised on wrist watches. Clinton's, his face peering out from behind his wife Hilary, is called The Man Behind The Woman. Gore's image disappears off the watch face every 30 seconds.

POP star Terence... D'Arby, who stripped o... music magazine Q, say... did it to free himself... being raised in a relig... and oppressive society...

Abigail Lane

The Incident Room (detail), 1993
Newspaper
The Artist, Courtesy Victoria Miro
Gallery, London

The bride, the body, the mystery and its maker

ARTIST'S DEADLY PLOT REVEALED

An artist who planned to deceive unsuspecting National Trust-goers this summer with a sculpture too real for comfort has at last been named.

ABIGAIL LANE, 26, was revealed as the perpetrator of a deadly hoax.

Offered fiction in the guise of fact, unwary visitors to the beautiful Killerton Gardens, near Exeter, would have been lead on a wild goose chase, attempting to find a woman who does not and never did actually exist.

Vanished

Appeals for information on the disappearance of a young bride, who had been seen by no-one since last year, were to have been posted throughout the grounds. These posters, offered only scant circumstantial detail, but nevertheless sought the co-operation and help of the public to solve the proclaimed mystery.

But there never was a real mystery, or a true bride. The posters were fakes.

Visitors on the scent of this perplexing trail would have been participants in a truly gruesome game, and in due course would have found the 'treasure' to this would-be hunt. It would seem that the search had become a murderous and chilling enquiry.

Protruding limbs would reveal a woman's body buried amongst the summer flowers.

Only a close inspection would have found the corpse thankfully not real, but modelled in wax.

BODY OF EVIDENCE: Underhand Deceit

MISSING
Can You Help?

However the artist has confessed that she wanted the body to have looked as real as possible and was seeking the advice needed to achieve this grim perfection when her plans were uncovered.

Exposed

It would appear that the bride at the centre of this deception was in fact a lifeless mannequin who featured in last year's costume display at Killerton House. Returned to storage at the end of last season, she made way for this years group of ladies in 1920's sportswear.

A return of the mannequin this year in such grizzly circumstances could have caused widespread dismay.

"Its presence in the garden," commented a spokesperson, "might have resulted in unnecessary shock or offense to innocent members of the public." Now the plot itself has had to be buried.

"A life-like model of a living mannequin would have been acceptable," the spokesperson continued, "but a dead one was not."

"I thought the public always appreciated the skill and achievement of realistic rendition, of being true to life", was the artist's comment.

But this was an art the public could not have enjoyed.

The sculpture has subsequently surfaced in the more appropriate setting of an Art gallery.

Miss Lane, meanwhile, is still confused as to what is real and what is not

AL.

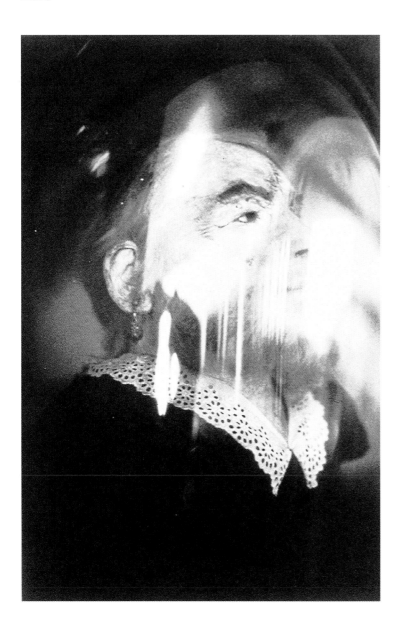

Zoe Leonard

Preserved Head of a Bearded Woman,
Musée Orfila, 1991
Gelatin silver prints (from a five-
part work)
Courtesy Paula Cooper Gallery,
New York

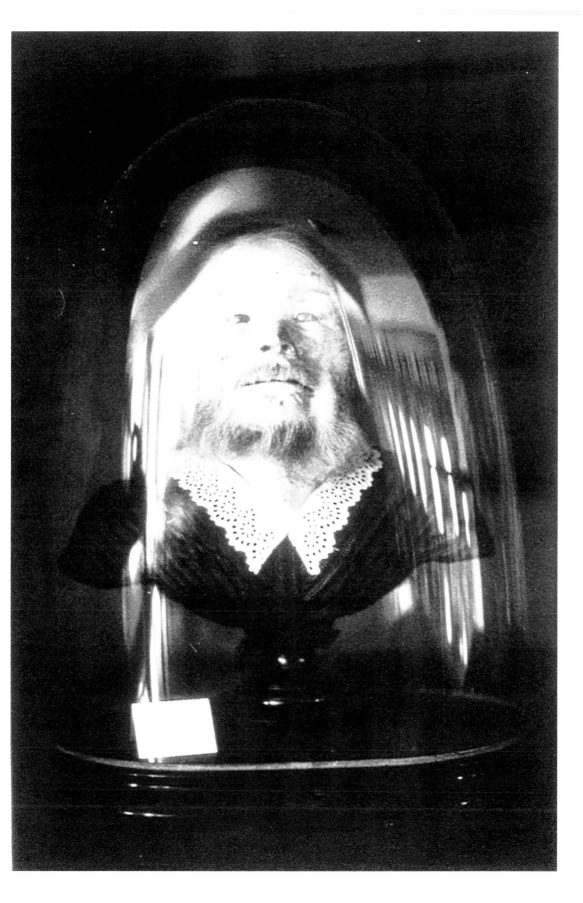

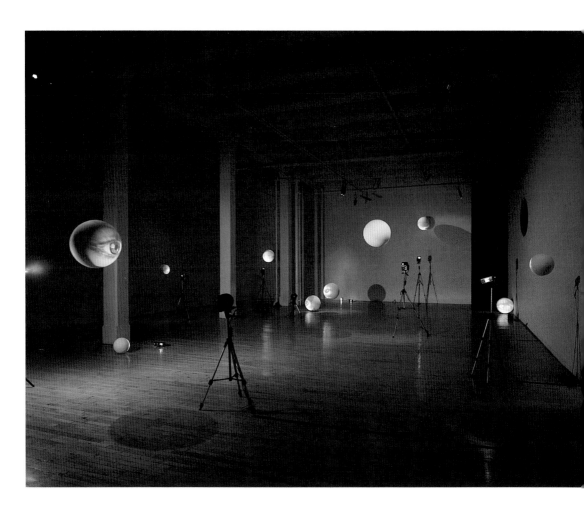

Tony Oursler

Installation view at Metro Pictures, 1996
Courtesy Metro Pictures, New York

The Gothic reemerged spectacularly, however, with *Dracula* (1897). In contrast to the "historical" settings of the earlier Gothic novels, Bram Stoker makes his contemporary: London of the 1890s, populated by Darwinian-minded scientists and the "new woman," that alarming creature who has learned to type and presumes to expect equality and partnership in marriage. Thus, not only does Stoker's vampire imply the fearful, ancient, foreign "other," he also encodes late-Victorian anxieties about "nature red in tooth and claw" and a resurgent female principle in the culture.

Since *Dracula* was contemporary with the invention of cinema, and this new medium (like the appearance of "the novel" in the eighteenth century) proved effective in the diffusion of Gothic imagery, Stoker's blood-sucking aristocrat, as well as the monster in Mary Shelley's earlier *Frankenstein* (1819) were quickly exploited as material for the Grade B horror flick. And in the 1960s Gothic reappeared as best-selling mass-market paperback fiction. Hundreds of novels emulating Victoria Holt's *Mistress of Mellyn* (1960) were sold with an iconic cover illustration: a woman wearing a look of terror and a diaphanous gown flees from a darkened mansion with one lighted window. A complementary strain of supernatural Gothic also reemerged at about the same time, with Ira Levin's *Rosemary's Baby* (1965) and Stephen King's first novel, *Carrie* (1974). This latest Gothic revival subsided in the early 1970s, when the mode of historical romance known as the "bodice-ripper" inundated the paperback market.

It is easy to enumerate Gothic narrative formulas; it is more difficult to determine, however, the roots of their appeal. I would suggest that those elements that continually reappear may be read as complex cultural metaphors. The haunted castle, for instance: as Walpole's title, *The Castle of Otranto* declares, this genre was at first identified with a particular kind of edifice. In later variations any kind of enclosed space, so long as it is associated with mysteries or secrets, may serve. Gothics usually feature several other elements: characters who are types rather than realistic and sharply individualized people; complex plots full of exciting and violent action; situations derived from the conflict between individual desire and social constraints, such as the necessity of marrying "appropriately;" supernatural or seemingly supernatural events; suspense motivated by family secrets, such as inheritance or kinship. This fantastic *mélange* is often framed by some mediating fiction regarding the provenance of the text, like Walpole's declaration that he had merely translated this story he had found in the library of "an ancient Catholic family in the north of England." Equally familiar is the pretense that the narrative is the heroine's autobiography.

A haunted castle, so crucial to early Gothic, connotes many inherited traditions, such as the structures of political power and families, which are not only inherited but potentially imprisoning: in short, the Gothic novel evokes the weight of the past. Held in the name of the king by the head of a noble family, this structure might even be read as a physical manifestation of "The Law of the Father," the French psychoanalyst Jacques Lacan's term for the interlocking and mutually supporting systems of a society's cultural power, diffused throughout its institutions, social arrangements, and even its language, so as to reproduce itself through the generations.[4] Since the medieval church was, like the government and family, organized as a patriarchal hierarchy in which members bear the name of "father" and "mother," "brother" and "sister," "son" and "daughter," the overlapping realms of family, church, and government function metonymically: that is, a problem of dynastic inheritance may be involved with church politics; a daughter's desire to marry inappropriately may lead to incarceration in a convenient convent, where the "Mother" Abbess enforces the desires of the actual father. Moreover, an inherited castle literally embodies the choices, tastes, and means of the forefathers; these may at the same time facilitate and constrict the lives of their children, and conceal vital secrets from them. Maria Torok and Nicholas Abraham suggest in their concept of "the phantom" that psychological experiences as well as physical traits may be inherited through cultural structures. Traumatic events may resonate through the generations, so that a son may experience the symptoms of his father's neurosis.[5]

It is perfectly logical, therefore, that the castle should be, or seems to be, haunted. Not only is the patriarchal "family romance" an inherently Gothic tale; we can also see that the early Gothic novelists' insistence on the "historicity" of their stories allows them to deploy their culture's fantasies of a past imagined as dark indeed: violent, cruel, despotic, superstitious. The broad structures and themes of the Gothic novel, therefore, demonstrate the effects of the Enlightenment on the popular imagination: Gothic fictions are the fantasies, quasi-memories, of a culture newly conscious of itself as different from its past: not rude, not barbarous, not despotic, not superstitious. It is equally logical that the fascination with Gothic darkness that had grown for at least a century prior to Walpole's book finally exploded in the Gothic novel of the 1790s, the decade immediately following the French Revolution. This event marked the final collapse of several ancient hierarchies: the monarchy, an inflexible class system, and the hegemony of the Roman Catholic Church. And yet the trauma of the Revolution remained, for English observers, a vicariously experienced horror in the dreadful realm of "the other."

ANNE WILLIAMS

One might speculate, therefore, that the Gothic simply offers a nostalgic fantasy of a more orderly past. But this hypothesis, while partially true, is inadequate to explain the genre's recurrent popularity. Why it should be so becomes clearer if we turn to the most important of Gothic conventions: these tales aim to please readers by scaring them.

According to eighteenth-century aesthetic theory, there are two kinds of fear: horror and terror. They are, though complementary, very different responses. Horror is physical revulsion at some gruesome object; terror is imaginative, aroused by contemplation of the dark, the dangerous, the unknown. To come across a worm-eaten corpse (a common early Gothic experience) arouses horror; to awaken in a crypt and fear that it might contain a worm-eaten corpse (another common experience) creates terror. By the 1790s, readers began to notice that Gothic novelists tended to specialize in one or the other of these effects. Ann Radcliffe consciously sought to create terror, which she justified on the grounds established by Burke.[6] In his scandalous novel *The Monk* (1796), however, which was not published in an unexpurgated edition between 1797 and 1950, M. G. Lewis exemplifies the techniques of "horror." The differences between "horror" and "terror" reveal an unexpected theme at the core of the Gothic tradition.

Radcliffe's terror plot is a familiar story, at least to women readers, the Ur-plot of Charlotte Brontë's *Jane Eyre* (1847), of Daphne du Maurier's *Rebecca* (1938), and of the countless variations that appeared in the mass-market Gothic revival of the 1960s. In *The Mysteries of Udolpho,* the orphaned Emily St. Aubert is sent to live with her vulgar, social-climbing aunt who decries her niece's proposed engagement to Valencourt, a most charming young man, but a younger son. This aunt marries a mysterious Italian, Count Montoni, who carries her and Emily off to Udolpho, his brooding, half-ruined castle in the Apennines. There Emily experiences all kinds of terrors, and suffers, too, at the hands of Montoni, who intends to trick her out of her inheritance and to marry her to his friend, the lecherous Count Murano. Eventually, she and her maid Annette escape Udolpho and make their way back toward France, where they happen to be shipwrecked on a beach owned by Emily's long-lost cousin, the Vicomte de Villeroi. It turns out that Emily's aunt was the Vicomtesse, murdered by Laurentini di Udolpho. She is cousin of Montoni and avatar of Charlotte Brontë's Bertha Mason, the madwoman in the attic: a wild, bad girl who poisons her lover's wife and goes mad upon immuring herself in a convent. At last Valencourt and Emily are reunited, reconciled, and married. They return to Emily's childhood home, presumably to live happily ever after.

In contrast, the horrors of *The Monk,* precociously published by the nineteen-year-old M. G. Lewis portray a world far less benign. The main plot concerns Ambrosio, an infant abandoned on the steps of a monastery and reared by the monks to be perfectly virtuous. Famous throughout Seville for his sermons on chastity, he secretly yields to the wiles of Matilda, a beautiful young woman who resembles the Monk's painting of the Madonna, and who has disguised herself as a novice in order to seduce him. She succeeds without much difficulty. Once fallen, Ambrosio becomes ever more lustful, appropriating Matilda's now revealed magical powers in order to abduct and rape a fair maiden, Antonia, killing her mother Elvira in the process. Having satisfied his desires, the Monk kills Antonia as well.

Meanwhile, we also read of Agnes, who is forced to take the veil against her will. She attempts to elope with her beloved Lorenzo, disguising herself as "The Bleeding Nun," a specter that appears in her aunt's German castle every five years at midnight on May 5. Lorenzo mistakes the ghost for Agnes, and finds himself inadvertently wed to the Nun, who turns out to be his ancestress (another mad, bad girl) who had broken her holy vows and then murdered her lover. Meanwhile, Agnes is incarcerated in the Convent of St. Clare. When the cruel Abbess discovers that the young woman is pregnant, she imprisons her in the vaults, where she gives birth to a son who dies because she didn't now how to nurse an infant. She goes mad. Rescuing Agnes, Lorenzo discovers Antonia's body. Ambrosio, imprisoned for murder, strikes a desperate bargain with Lucifer, who gleefully discloses that Matilda was a demon disguised as a woman, sent to effect the proud Monk's fall from virtue. And more: Antonia was his sister, Elvira his mother. He has committed not only fornication but incest, not only murder but matricide. The demon carries him away from prison and drops him in a desert gorge where he dies an excruciating death.

Although these two novels have exotic settings and complex plots hinging on the discovery of family secrets, their differences are equally significant. Radcliffe's novel is broadly comic in its narrative structure: hero and heroine survive their terrors and learn from them. (Emily's experiences illustrate the connection between "apprehension" as "fear" and "apprehension" as "understanding"). The heroine is finally united with her beloved and married; the ghosts are all explained. Radcliffe thus creates a world that is ultimately explicable, in which an orphaned, isolated young woman may not only survive, but triumph. *The Monk,* however, is, like *Otranto*, tragic; it traces a hero's fall from greatness to destruction or death. The ghosts are real, and nothing is to be trusted. Not one's senses, not nature (whose rules may be suspended arbitrarily), and certainly not women; not even, and perhaps *especially* not mothers.

ANNE WILLIAMS

Terror expresses the power of mind; horror demonstrates the power of nature. "Horror" and "terror" imply contrasting cultural attitudes about the nature of "the female" in the literal and symbolic sense, including the "feminine" nature and materiality. (It is not a coincidence that our words "matter" and "mother" both come from the Latin *mater*.) Since ancient Greece, (male) philosophers and theologians have conceived of "the female" as "otherness"—dark and disorderly and dangerous. In this view even woman's quasi-miraculous powers of maternity align her with irrational power and loathsome materiality, since birth is always followed by death. The plot, the decor, and the structure of *The Monk* enact such assumptions about women and maternity. As the fate of its female characters implies, *The Monk* is profoundly misogynistic. The seductive demon Matilda, who presents herself in the guise of the Holy Mother, awakens Ambrosio's carnality and so destroys him. Another woman he kills in pursuit of that lust turns out to be his mother. A frenzied crowd literally beats the cruel Mother Abbess of St. Clare to a bloody pulp; Agnes the mad mother refuses to part with the worm-eaten corpse of her infant, which the narrator describes as a sight disgusting to any eye "but a mother's." The Bleeding Nun, most potent of Lewis' horrific fantasies, uncannily violates almost all patriarchal taboos about female sexuality. By renouncing sexuality and maternity (her distinctive female-ness), a nun becomes "virtuous" (a word derived from the Latin, *vir*, man). This nun, who is ironically named "Beatrice," not only betrays Christ the Bridegroom with an earthly lover, she murders the latter as well. The blood on her habit is horrifying because it signifies the subversion of the patriarchal desire to control female sexuality. Disturbingly, this female apparition breaks all the rules: she seems alive, but is dead; she appears to be a nun, and yet is stained by blood (an ambiguous sign of violence *or* fertility).

"Horror," therefore, springs out of a fundamentally conservative world view that adheres to the ancient Western model of reality, though to foreground the horri-ble in fiction or any art, paradoxically brings it to consciousness. "Terror," on the other hand, is thoroughly revolutionary in its implications. Since terror is an experience of the individual imagination, Radcliffe narrates her stories so that we share the perspective of the heroine. Later Gothics in the terror mode almost always use a first-person narrator. But this technique has important ramifica-tions: it replaces the "I" tacitly assumed to be male, the "I" of centuries of philosophers, theologians, and poets, with a female subject. The literary artist is no longer necessarily "a man speaking to men" (in Wordsworth's phrase); she may well be "a woman speaking to women."

The recognition that such a shift is not only possible but important has recently been facilitated by the most important change to affect our reading of the Gothic

since it became an object of academic interest in the 1890s: the development of feminist criticism. In conjunction with the revival of political feminism in the 1960s, women teaching literature in universities began to realize that their training had taught them to "read like a man," that is, to assume the male perspective, which is necessarily different, since the masculine "I" has always been privileged in Western culture.[7] Although taught to assume that this perspective was "universal," they began to realize that it is far from disinterested. Some of the more notorious cultural clichés about women, classifying them unproblematically as virgins or whores, witches and bitches, may be recognized as the categories of a male perspective. At first, feeling newly empowered as readers, they focused their investigations on such images of women in literature, and this made the Gothic suddenly interesting for other than antiquarian reasons.

The emerging feminist critics' initial take on the Gothic was fairly predictable: they tended to regard it with some suspicion, since in these novels women inevitably seem to experience a fate worse than death. They are either pursued, stabbed, or raped, the helpless victims of horror Gothic, or pursued and threatened with stabbing and rape, and then married off at the end of the story in terror Gothic. This latter fate is almost as bad, since these narratives seem to imply that marriage to a wealthy man is a worthy aim—indeed the only proper aim—for a young woman. Numerous feminist critics, therefore, argued that the Gothic inculcated patriarchal standards in its readers while at the same time offering a kind of vicarious contemplation of patriarchal horrors. One may argue that in exploring the mysterious house and learning its secrets, the heroine is initiated into the implications of a male-dominated system and how to succeed in it: protect your virtue and marry as well as possible. The Walpole or Lewis kind of plot "horror" (reemerging in such bestsellers as *Rosemary's Baby* and *Carrie*) had an even more distressing subtext: the uncontrollable dangers associated with the female, dangers that must be resisted whenever possible, but that can never be conquered.

And yet a feminist critic might also wish to inquire why women's writing seemed to be so preoccupied with dangers to women and bizarre distortions of reality. Furthermore, the Radcliffe formula seemed to have some kind of therapeutic or empowering effect, and it can be no coincidence that two most dramatic eruptions of Gothic in the popular press (the 1790s and the 1960s) coincided with two important outbreaks of political feminism. In *Literary Women* (1976), a pioneering work of feminist criticism, Ellen Moers coined the term "Female Gothic." In her examination of Mary Shelley, Emily Brontë, and

Christina Rossetti she proposed that these writers used Gothic conventions to express their sense of women's experience in their culture. Two years later, Sandra Gilbert and Susan Gubar's magisterial book *The Madwoman in the Attic,* adopted Charlotte Brontë's imprisoned madwoman as a figure for woman writers in nineteenth-century British and American culture. (Note, too, that they invited one to remember that mad can mean either "crazy" or "angry.")

During the 1980s, French feminist theorists such as Luce Irigaray, Hélène Cixous, and Julia Kristeva, all trained in a rigorously philosophical and psychoanalytic tradition, encouraged feminist criticism to address theoretical issues relating to questions of women's writing and the act of writing as women. Analysis of the Gothic from this perspective suggests that the development bears a paradoxical relationship to this cultural "female principle." Certainly the tradition as a whole contains many elements perpetuating the stereotypes—even archetypes—of the female that have dominated Western culture for many centuries. And yet, if Lacan is correct in calling language one of the cultural forces that perpetuate the tradition and the social status quo, then the kind of literary appropriation that occurred when women began to write their own stories could easily become a socially revolutionary development. In *Otranto* and almost all of its literary antecedents, the female characters exist as objects and victims in relation to a male protagonist, while in the tales of Radcliffe and her successors, the reader shares a female perspective; we see hero and villain alike as relative to *her.*

Literature creates a virtual space that escapes the "real world," where limits are imposed by culture, consciousness, and the laws of physics; and yet imagination, invited into this place to play, may, paradoxically, return to the world with the power to revise at least two of these three limits. Following a particular character through a set of circumstances that arouse particular responses, Gothic fiction offers its readers an imaginative space that both insists on "reality," on historicity, on materiality, and at the same time liberates the reader from the constrictions of that history. Similarly paradoxical are the effects of pleasurable fear, which we find in the vicarious experience of horror and terror. The reader, particularly the female reader, may contemplate both the horrors of the ways in which the culture at large regards the female, but also some alternate possibilities in imagining the world as it appears to a female I/eye. By expressing a fascinated ambivalence toward the past, the Gothic novel both condemns that time of darkness and superstition, and revels in it. Clearly, the experience of fear in art may exorcise fear, since artistic fear is chosen, sought, and controllable.

Aside from the empowering possibilities inherent in a newly developing female literary tradition, the Gothic may have one other important legacy: the conception of the self that is most familiar nowadays in psychoanalysis. Here is another paradox. The Gothic has proved extraordinarily amenable to psychoanalytic interpretation, but perhaps this is true not because Freud had discerned a dynamics of selfhood as simply true and universal, one which the Gothic was somehow intuiting. Instead, it may be that by means of the images and affects aroused by Gothic conventions, our culture was imagining, one century prior to Freud, some of the concepts that he would articulate: that the self is a structure, like a house; that it is haunted by history—both one's own and that of one's family; that this psychic "house" has secret chambers that need to be opened if the house is to be livable. For what is the process of psychoanalysis but the construction of a story—long, complicated, rambling, digressive—about the past which concludes when the story has been told, when all the doors of all the secret rooms have been opened?

At the end of the twentieth century, Gothic novels continue to be written and read. Anne Rice, Stephen King, Barbara Michaels, and a host of others supply the shelves with endless paperbacks. Gothic horror films continue to thrill: consider, for instance, the long series of *Halloween* movies, or the *Nightmare on Elm Street* sequence. And yet, I would speculate that the Gothic tradition may at last be drawing to a close. In the beginning its conventions seemed compelling to the greatest, as well as to quite ordinary literary minds. All the high Romantic poets exploited the possibilities of Gothic at some point in their careers; Faulkner may have been the most important writer to do so. Nowadays it seems that the popular vocabulary most likely to appeal to the serious literary artist is that of science fiction: not Montoni, one's wicked uncle by marriage, but an alien from another galaxy is more likely to be the abductor. And while the *Alien* films and many episodes of *The X-Files* use Gothic conventions (and certainly each has a heroine who is easily beleaguered), it seems that we are in the process of reimagining our place in the universe: the most frightful others reside in the vast deserts of strange planets, not in the dark vaults of our history on earth.

ANNE WILLIAMS

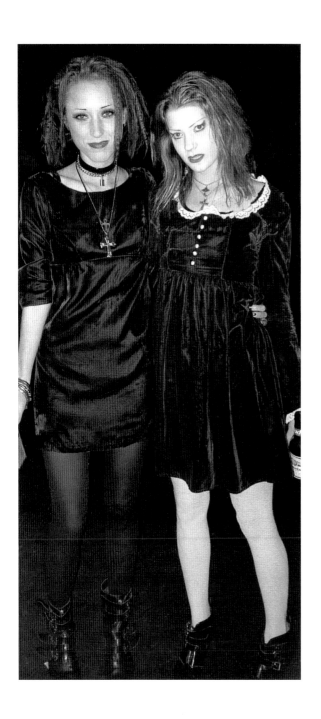

Mike Kelley and Cameron Jamie

Thursday's Goth, 1997
Black and white photograph
Courtesy Patrick Painter Editions,
Vancouver

Bela Lugosi's Dead
and I Don't Feel So Good Either

Goth and the Glorification of Suffering in Rock Music

JAMES HANNAHAM

If rock and roll is just the blues with an emphasis on adolescent sex, then Goth rock is rock and roll with death and madness. Gothic imagery and influence has skulked at the margins of rock music for decades, and indeed the blues has plenty of subject matter in common with what came to be known, in the late 1970s and early 80s, simply as "Goth." Its less-than-subtle influences streamed from the Gothic novels of the nineteenth century as well as contemporary horror films, especially 1950s B-movies.

Even though blues songs might have dealt with death, madness, and loss, the blues were meant to be part testimony and part catharsis. Black blues singers wailed in order to explain and share their hardship, and by extension build a sympathetic society. In a similar way, one of the predecessors of the blues, the Negro spiritual, attempted to accomplish this feat in a more literal way. The spiritual was often used as a code to signal slave escapes, and its lyrics usually drew parallels between making a break for the promised land in heaven and stealing away to the promised land up north.

Once rock and roll became the engine of American youth culture it remains today rather than simply "jungle music," however, the social meaning of the blues was altered. To say that it had a positive or negative effect on the quality of the music is irrelevant. But when people who were fans of the blues rather than originators began to play it, this fact allowed for the subject matter of the blues to become an end in itself. The pain it described could not only be felt by the singer, but fetishized and focused inward as well. Pain could be treated not just as something to express, but something to strive for. As Shel Silverstein once sang, "What do you do if you're young and white and Jewish.... And you've never spent the night in a cold and empty boxcar... and the only levee you know is the Levy who lives down the block?" The answer is, as Bob Dylan proved, you sing the blues anyway.

It's easy to forget that most white Americans first heard the blues and rock and roll created in their backyards only once it had been filtered through the ears of the British Invasion. It arrived, not sanitized, exactly, but translated, idealized, and somewhat abstracted. Not that England's bluesmen couldn't feel authenti-

Screamin' Jay Hawkins, 1990

cally disenfranchised or sad, but their sadness was the result of an entirely different environment than, say, your average Mississippi bluesman. But by the time it reached England, the form of the blues had been established. It then became possible for the most salient component of the blues—misery—to switch from impassioned declaration to a kind of rapture, a goal, the ultimate state of being for a blues singer. Chances are when a black American sang the blues, she just had them. When an Englishman did it, he also wanted them.

The simple glorification of suffering, of course, was not enough to give rise to the excesses of Gothic rock. For that, a certain degree of showmanship and capitalism was necessary. Gothic rock perhaps began with Screamin' Jay Hawkins' 1957 hit, "I Put a Spell On You," which radio stations banned for his "cannibalistic" howling, supposedly the result of Hawkins' intoxication during the recording session. Legendary DJ Alan Freed encouraged the natural showman Hawkins to milk the controversy for all it was worth, advising him to make his stage entrances from out of coffins (an act for which he later was paid five thousand dollars every time he performed it), dressed in high vampire style, with a black cape and a walking staff adorned with a skull. He eventually sold two million copies of the record and later quipped, "I wish they'd ban all of my records."

As the late 50s and 60s progressed, rock and roll became the theater of the world. As pop stars got more ambitious and successful, following the Beatles' example and turning their bands into entertainment industries in their own right that made films and stage shows and produced the work of other artists, their positions of wealth and power became ironic: they'd come to play rock music with the ideals of young rebels, determined to dismantle the system, only to be swallowed by it. Their creative output and personae were used by advertisers to sell products rather than change society. The hypocrisy in packaging grandiosity and teenage rebellion for mass consumption created another Gothic monster: Alice Cooper.

Cooper, a minister's son who named himself and his band after a girl at his Sunday school, was discovered by rock's mad genius, Frank Zappa. Unlike Zappa, however, Alice Cooper the band was not known for musicianship, but for its bizarre theatricality. Audiences at Alice Cooper shows were regularly treated to mock chicken slaughtering, simulated autoerotic erections and fake blood. In a particularly notable dramatization of his epic song "Dead Babies," Cooper, made up in the runny black mascara that became his trademark, brought out hundreds of plastic dolls and dismembered them, to the delight of his audience.

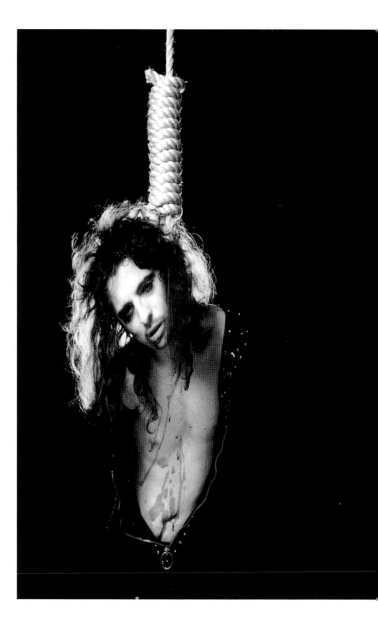

Alice Cooper (from his album *Killer,* C. 1971) brings Gothic to rock n' roll and creates a new genre: shock rock. Courtesy The Alice Cooper Archives, Los Angeles

Cooper's antics may have shocked people, but his Grand Guignol rock-theater seemed rooted deeply enough in the realm of fantasy to let his audience retain a sense of order. Cooper himself, born Vincent Furnier, was usually quick to make a distinction between his onstage and offstage images. "My posture changes when I become Alice, even my voice," he told *Kerrangg!* in 1987.[1] "It's like a possession—well, I wouldn't call it possession but it is like being overcome with this character." Offstage, Cooper is an avid golfer. His character, Alice Cooper, the iconoclastic, gender-bending social misfit, not only exorcised Furnier's personal demons, but channeled that suffering into a larger-than-life

cartoon of pain. Furnier created in himself a grotesque rock star that symbolized music industry excess, self-absorption, cult of personality—in short, he took counterculture to its illogical extreme. Cooper's influence remains one of rock's biggest triumphs of style-over-substance.

That same style-over-substance turned into the albatross around the neck of the particular branch of subculture that emerged from punk in 1978 and later become known as "Goth." In fact, it's difficult to distinguish between "Goth" and "post-punk," for the simple reason that Goth is more of a fashion statement than a coherent musical style. In the period from 1978 to about 1984, hundreds of bands dyed their hair black, wore black lipstick and white pancake makeup, black lace and chains. Despite stylistic similarities, heavy metal music remained separate from this phenomenon; in fact, the two genres can be said to have divided along gender lines. Heavy metal was aggressive, sexist and therefore "masculine," while Goth had a softer, more accepting, "feminine" cast. You can hear it in "Goth-chick" Claudia Hazzard's description of how to appreciate a Goth classic: "You can totally emerge yourself in the music, the consuming power of this song. This conjures up images of horror films, dark skies, castles and forbidden vaults. The lyrics are of a vampire nature and intoxicate you."[2] Goth inspired a euphoric if cheesy utopianism rather than heavy metal's warlike feudalism.

At the same time, punk flicked its emotional switch from anger to depression, and became more atmospheric in the process. But not all atmospheric post-punk bands sported Goth fashion, and not every death-rocker played atmospheric post-punk. The careers of the most successful atmospheric post-punk bands— The Cure, Siouxsie and the Banshees, New Order, Cocteau Twins, Dead Can Dance—tended to be long and uneven, ranging stylistically from New Order's "death disco" to Dead Can Dance's Middle Eastern and medieval-influenced ragas. The Cure switched gears a number of times, from snappy power pop to ponderous dirges to happy ditties about being in love on a Friday.

Punk and Goth were indistinguishable at first. In 1976, at age 17, Siouxsie Sioux, the Ur-Goth, was part of a clique of Sex Pistols fans known as The Bromley Contingent, famed for their outrageous modes of dress. At the time, Sid Vicious of the Pistols was drumming for an early incarnation of Siouxsie and the Banshees that had played an either disastrous or cathartic date at London's 100 Club:

> A wall of noise illuminated the fact that no one could play. Siouxsie said the Lord's Prayer. The melange lasted 20 minutes. They walked off, bored. "She is nothing if not magnificent," Caroline Coon wrote at the time. "Her short hair,

which she sweeps in great waves over her head, is streaked with red like flames. She'll wear black plastic non-existent bras, one mesh and one rubber stocking and susbender belts all covered by a polka dotted transparent plastic mac." Another observer said that the set was "unbearable."[3]

Already, those enraptured by the visual rather than musical aspects of punk began to idolize Siouxsie. When The Bromley Contingent made their way into the studio audience when the Pistols played the *Today* show, the rules changed. "From that day on," Sex Pistol Steve Jones recalled, "It was different. Before then it was just music—the next day it was the media."[4]

Once they'd given punk a name, Siouxsie wanted no part of it. Avidly anti-establishment, The Banshees had taken two years to land a record deal despite their high profile, partially because their lead singer had made it a habit to insult record company executives in the audience. Fans were writing "Sign Siouxsie Now!" on the sides of record company buildings. By 1981 The Banshees had converged upon London's legendary Batcave, the Soho establishment run by members of the band Specimen. "It was a lightbulb for all the freaks and people like myself who were from the sticks and wanted a bit more from life. Freaks, weirdos, sexual deviants... that's very much the spirit of what the Batcave was," former Specimen keyboardist Jonny Melton remarked.[5]

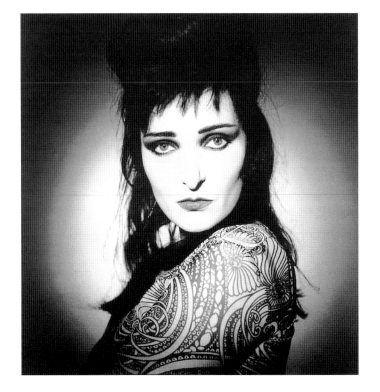

Siouxsie Sioux
Courtesy Geffen Records, Los Angeles

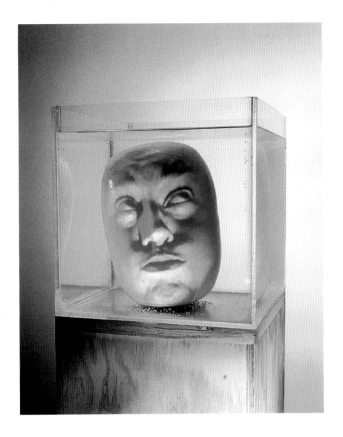

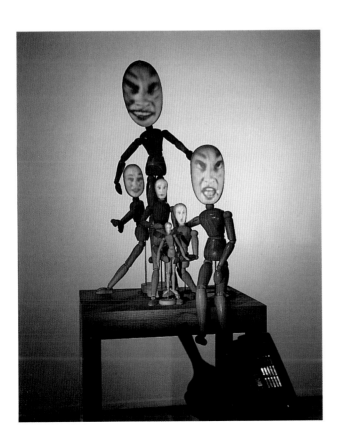

Tony Oursler

Submerged, 1995-96
Performance: Tracy Leipold
Video projection system, wood, plexiglass,
ceramic, water
Courtesy of the Artist and Metro
Pictures, New York

Flock, 1996
Performance: Tracy Leipold
Video projection system, wood, paint
Courtesy of the Artist and Metro
Pictures, New York

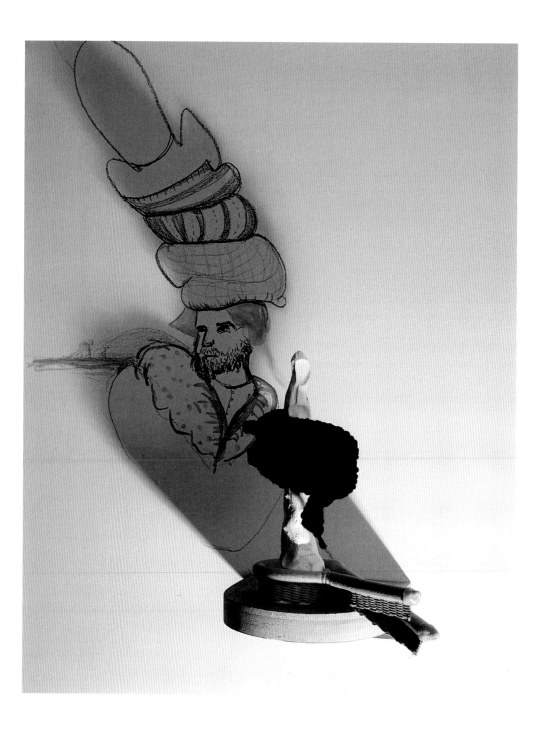

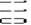

Sheila Pepe

Untitled, from the *Doppelgänger Series*, 1997
Object (black), shadow, wall drawing
Courtesy Judy Ann Goldman Fine Art, Boston

Seven Things with Fixed and Ambiguous Pictures, 1995
Installation with objects, light, shadow and wall drawings with sound activated motion
Courtesy Judy Ann Goldman Fine Art, Boston·

Untitled, from the *Doppelgänger Series*, 1997
Object (red), shadow, wall drawing
Courtesy Judy Ann Goldman Fine Art, Boston

Alexis Rockman

The Beach: Demerara River Delta,
1994-96
Oil, sand, polymer, lacquer, mixed objects
on wood
Collection of Gian Enzo Sperone,
New York

Airport, 1997
Envirotex, digitized photograph, vacuum-
formed styrofoam with aluminum finish,
oil paint, plasticine, Laughing Gull
specimen on wood
Courtesy Jay Gorney Modern Art,
New York

Rt. 10, 1997
Envirotex, digitized photograph, oil paint,
latex rubber, rat body parts, rattlesnake,
asphalt, unknown bird part on wood
Courtesy Jay Gorney Modern Art,
New York

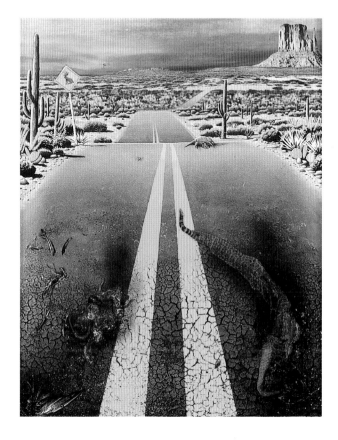

Pieter Schoolwerth

Thee 83 Altered States ov Americka:
Chapters 1 & 2, 1995-96
Colored pencil and paint pen on paper
Courtesy of the Artist and Greene
Naftali Gallery, New York

Thee 83 Altered States ov Americka:
Chapters 3 & 4, 1995-96
Colored pencil and paint pen on paper
Courtesy of the Artist and Greene
Naftali Gallery, New York

Pieter Schoolwerth

Thee 83 Altered States ov Americka:
Chapter 11, 1995-96
Colored pencil and paint pen on paper
Collection of Vicki and Kent Logan, San
Francisco

Cindy Sherman

Untitled (# 311), 1994
Cibachrome
Courtesy of the Artist and Metro Pictures,
New York

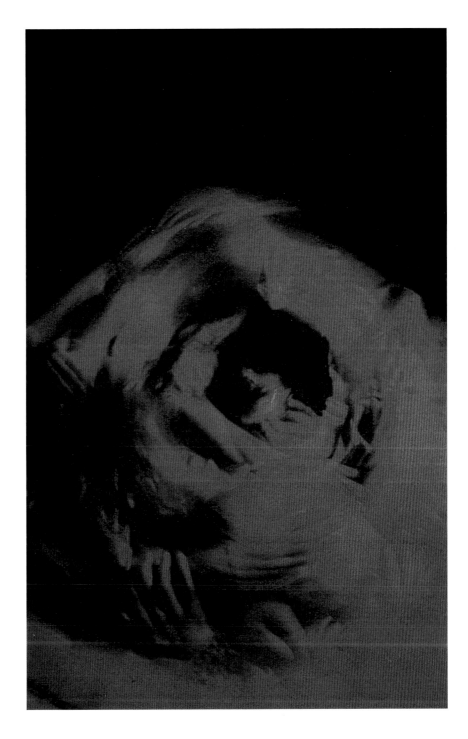

Cindy Sherman

Untitled (# 319), 1995
Cibachrome
Courtesy of the Artist and Metro
Pictures, New York

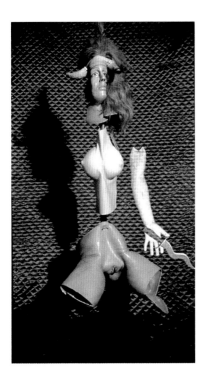

Cindy Sherman

Untitled (#322), 1996
Cibachrome
Courtesy of the Artist and Metro Pictures,
New York

Untitled (# 307), 1994
Cibachrome
Courtesy of the Artist and Metro Pictures,
New York

Untitled (# 308), 1994
Cibachrome
Courtesy of the Artist and Metro Pictures,
New York

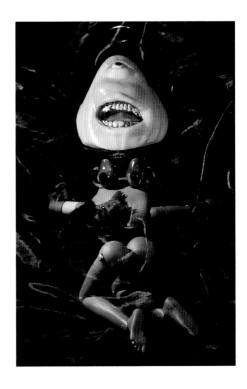

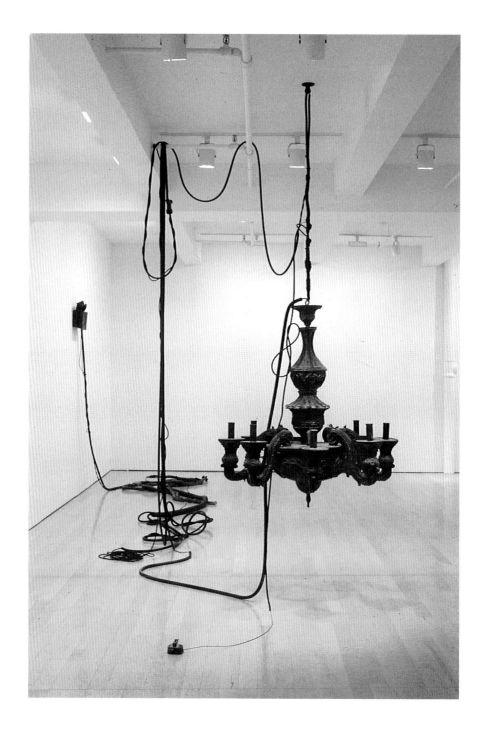

Jeanne Silverthorne

Untitled, 1995
Latex, resin and rubber
Courtesy of the Artist and McKee
Gallery, New York

Wires with Postcard, 1994
Rubber, latex, frame, ink on paper
Courtesy of the Artist and McKee
Gallery, New York

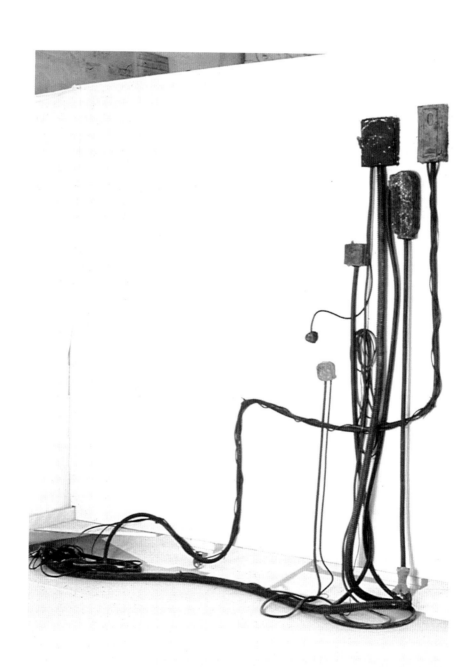

Gary Simmons

Lighthouse, Inaugural Wall Project, 1996
Paint and chalk on wall
Courtesy Museum of Contemporary Art,
Chicago

Ghost Ship, 1995
Charcoal on vellum
Courtesy of the Artist and Metro
Pictures, New York

Gary Simmons

Ghoster, 1996
Paint and chalk
Courtesy of the Artist and Metro Picures,
New York

Siouxsie and the Banshees' material took a turn from punk's habit of rooting out poser hypocrites—"Too many critics/Too few writing" she summed up in "Love in A Void" (*Kaleidoscope*, 1979)—to obsessions with madness and exotica. For the center of a scene whose fashion and contrary stance idealized and emulated old horror films and witches, the powerful vibrato howl that won Siouxsie "best female singer" polls in the British music press for years running became the siren song. Her heavy black makeup, tangled pile of black hair and smear of red lipstick, pioneered during gigs when Cure leader Robert Smith became the Banshees' guitarist for a while, became a trademark of 80s "new wave."

Rock and roll's Gothic undercurrents, however, have rarely merged their dramatic elements—think vampires—with their purely existential ones. Everyone feels a certain amount of alienation, mental stress, and fear of death. However, not everyone puts on white pancake makeup, black lipstick, teases their hair and then gets onstage and sings about it. The requisite adornment that goes hand in hand with a "Gothic" aesthetic, as rock and roll defines it, calls the sincerity of the wearer into question. They've dealt with their feelings of alienation from society by reinventing themselves as "monsters." The observer then wonders whether or not, in addition to the artifice meant to reinforce the message of the music, or as Morrissey puts it, wearing "black on the outside/'Cause black is how I feel on the inside" (in the song "Unlovable," *Louder than Bombs*, 1987), doesn't in fact cancel out the sincerity of the wearer by further obscuring his or her identity.

The pop culture legend that finds his way into the Rock and Roll Hall of Fame is an eloquent, unpretentious and genuinely tortured soul who can represent the pain of his listeners in the mass media—a secular Christ figure. It's an extraordinary person from humble beginnings—the poorer the better—who lives his pain and often dies young and/or tragically, à la John Lennon or Kurt Cobain. Except for his race, the archetypal rock icon remains essentially unchanged since the heyday of the blues. The more rock stars live up to their images, the more "real" they appear. Rap stars are held so closely to their outlaw standard that Snoop Doggy Dogg's murder trial only raised his credibility, and Tupac Shakur was killed in a drive-by shooting.

Goths, by turning death, madness and violence into archetypes, de-personalize their connection to horrific events. They position themselves as reporters or tour guides to the macabre, rarely its victims. Even when Siouxsie puts her own memory of an encounter with a child molester into song, she casts herself not as nine-year-old Susan Ballion, but as the sex offender, "Candyman" himself, who

intones, "Oh trust in me my pretty one/Come walk with me my helpless one" (*Tinderbox*, 1986).

When Peter Murphy of the seminal Goth band Bauhaus informs us in a scary voice that (as we already suspected), "Bela Lugosi's Dead," or Siouxsie, decked out in Theda Bara exotica, serenades the victims of Mount Vesuvius, they emphasize the distance between their own pain and that which they describe. Their icy remove doesn't leave us with the impression that it matters to them if Lugosi has passed away, or if the volcano petrified hundreds of Pompeii's citizens under molten lava, merely with the feeling that death is forbidden, mysterious and therefore glamorous.

Of course, any long-lived movement for whom fetishizing death is a primary directive must be, by necessity, taking this stance in the service of art. Those that truly had the courage of their convictions would simply kill themselves, or so the logic seems to go. If this is the case, Joy Division was the only atmospheric post-punk band that managed to combine the ideals of blues-style confessional of which legends are made with the bleak vision of Goth. As author and critic Jon Savage explains in his foreword to a biography of Joy Division's lead singer Ian Curtis:

> [Joy Division's] first album *Unknown Pleasures*, released in June 1979, defined not only a city [the depressed, postindustrial Manchester, England] but a moment of social change: according to writer Chris Bohn, they "recorded the corrosive effect on the individual of a time squeezed between the collapse into impotence of traditional Labour humanism and the impending cynical victory of Conservatism."6

Thus, death rock became a moot point on May 18, 1980, when Ian Curtis' wife Deborah discovered that Ian had hanged himself in their kitchen, their phonograph's stylus still stuck in the dry groove of a copy of Iggy Pop's *The Idiot* in the next room. He was twenty-three. At the time, Joy Division was well on the

way to becoming famous for a gloomy, impressionistic sound and lyrics that
didn't just describe feelings of doom and hopelessness but embodied them.
Curtis' suicide, coming on the heels of an attempt a month before, and at least
one other when he was fifteen years old, put the stamp of authenticity on Joy
Division's dour oeuvre.

At the time of Curtis' suicide, the band's discography consisted of a few EPs
and only one full-length LP, the stark and lonely *Unknown Pleasures.* They'd
completed their second, *Closer*, in March of that year, but had not yet released
it. Amid much British music press fanfare, the band had made plans to embark
on their first tour of the United States.

Joy Division defined what Goth could have become. When they began in 1977,
under the name Warsaw (later changed when they got word of a London band
called Warsaw Pakt), their angular guitar hackery and fuzzbass echoed the Sex
Pistols and The Buzzcocks. But by the time they recorded 1979's *Unknown
Pleasures,* the angsty minimalism of songs like "Digital" had given way a bit, to
a slow, dreamy brooding heretofore unheard-of in punk rock. They began the
switch from the energy and anger of 1976's punk revolution to the self-pity that
would characterize the new wave of the 80s. Plenty of bands had used echoey
reverb before, but with the assistance of producer Martin Hannett, Joy Division
pioneered its use as a metaphor for emptiness. Many Joy Division songs sound
as if they were recorded in the deserted school buildings, abandoned factories,
or under the lonely bridges of Manchester. These bleak soundscapes reinforced
Curtis' lyrics, which nakedly display his obsession with isolation. Curtis wasn't
simply describing the alienation of the individual from others and society, but
the way in which numbness and surrender divide the self. On "New Dawn
Fades," he sang, "Oh, I've walked on water/Run through fire/Can't seem to feel

Joy Division - live

it anymore/It was me, waiting for me/Hoping for something more/Me, seeing me this time, hoping for something else" (*Unknown Pleasures*).

Despite his youth, Curtis' voice sounded old. He was off-key a great deal of the time, but his intonation had a haunting power and a creaky authority to it. It unevenly lurched from vulnerability to anger, from deadpan to melodrama. It was the perfect instrument to deliver his vision: shaky and unsure of itself, at times nearly conversational in tone, it said nothing if not that Ian Curtis was an ordinary man in extraordinary pain.

Though Curtis' pen touched on subjects like Nazi death camps (Joy Division was named for the term the Nazis used to describe women prisoners kept to be used as prostitutes) and, on "Atrocity Exhibition," an insane asylum turned roadside attraction, his view of death leaned toward existentialism. "Existence,

Joy Division - live

well what does it matter?/I exist on the best terms I can/The past is now part of my future/The present is well out of hand," he sang on *Closer*'s "Heart and Soul."

In image, too, Joy Division lacked the theatrical pretensions of other bands that grew up alongside them and in their wake. Instead, they used funereal black-and-white photographs of religious statues on their record sleeves. They presented themselves on stage without referring to the glam-rock image-makers like T. Rex or David Bowie who influenced their peers, preferring to appear simply as regular if dull and remarkably disaffected working-class Mancunians. They were regular blokes who happened to be suicidal, a stance that contrasted heavily with the usual methods of incorporating Gothic influence into rock music. Despite their punk roots, they didn't accessorize with makeup, safety pins or outrageous hair. Nothing was posed. Curtis had developed a reputation as an energetic live act, due in no small part to his epilepsy. His bandmates were not even fully aware of the degree to which he owed his stage presence to his seizures. As guitarist Bernard Sumner reminisced, "[Ian] had a fit and we went on, he was really ill and we did a gig. That was really stupid."[7] Curtis' wife also observed:

> The fact that most of Ian's heroes were dead, close to death or obsessed with death was not unusual and is a common teenage fad. Ian seemed to take growing up more seriously than the others, as if kicking against it would prolong his youth. He bought a red jacket to match the one James Dean wore in *Rebel Without a Cause*. He wanted to be that rebel, but, like his hero, he didn't have a cause either. Mostly his rebellion took the form of verbal objection to anyone else's way of life.[8]

The restraint with which Curtis and Joy Division approached their misery, like their neighbors The Smiths after them, was one reason for the pervasiveness of their influence. Perhaps not all of the Goths who flocked to Joy Division's posthumous releases, who dressed as creatures of the night to prove their love of death, really wanted to die. They wanted a community of the living dead: a society that aligned itself with death because life was substandard. They wanted an Ian Curtis to die for them, so they wouldn't have to discover for themselves that death had no sting.

Keith Edmier

Piano Leg IV (Brandy), 1992-93
Rigid urethane and polyurethane enamel
Courtesy Friedrich Petzel Gallery,
New York

"Like Cancer in the System"[1]

Industrial Gothic, Nine Inch Nails, and Videotape

CSABA TOTH

In a speech in Los Angeles on May 31, 1995, then-Republican Party leader Robert Dole reignited the culture war in national politics by claiming that "one of the greatest threats to American family values is the way our popular culture ridicules them." Singling out media giant Time Warner, he confessed that "I cannot bring myself to repeat the lyrics of some of the 'music' Time Warner promotes. But our children do."[2]

Dole's speech harked back to events two weeks earlier. At that time, William Bennett, director of the neoconservative lobbying group Empower America, and C. Dolores Tucker, head of the National Political Congress of Black Women, had addressed Time Warner shareholders on the issue of cultural values. Afterward, the two had a private meeting with the company's chief executives. According to a *Newsweek* report, the meeting turned boisterous:

> Tucker demanded that Fuchs [Michael Fuchs, then head of the Warner Music Group] read lyrics from "Big Man With a Gun," a rap song by Time Warner's Nine Inch Nails.... Fuchs declined, saying he did not want to engage in "theater." Bennett... was characteristically pugnacious. At one point he asked executives: "Are you folks morally disabled?"[3]

Trent Reznor, 1996
Courtesy Visages, Los Angeles

What are these Nine Inch Nails that so drew Tucker and Bennett's wrath? Under the name Nine Inch Nails (NIN), we find Trent Reznor who exploded onto the music scene in 1989 with his industrial LP *Pretty Hate Machine* and has since become one of the most celebrated artists in the industrial Gothic scene. Reznor's performance before close to half a million delirious fans in Woodstock in 1994, and then his co-headliner status on David Bowie's *Outside* tour in 1995, signaled climactic moments not only in his career but in the history of industrial Gothic performance as well.

Mapping Industrial Gothic

In a pivotal commentary about Gothic, literary historian Judith Halberstam claims that Gothic "marks a peculiarly modern preoccupation with boundaries and their collapse" and as such enables "multiple interpretations and a plurality of locations of cultural resistance."[4] It appears that defining Gothic as a contemporary cultural phenomenon is a much easier task for fans than cultural critics. As textual readers, Goth fans bring a range of interests—vampirism, sex worship, necrophilia, and paganism—to bear on their interpretations of Gothic performances, and, in their subcultures, create visible signs of their allegiance. I construct Gothic as a long sub-moment in the history of *industrial* music, and, within my project, it is the visual register of specific music videos that marks Goth as a distinct cultural production. Industrial music's social criticism found its visual representation in industrial Gothic videos released by such artists as NIN, Psychic TV, and Test Department. They remark on the postindustrial disappearance of the laboring body against the backdrop of vacant factory yards, deserted farms, bleak downtowns, a polluted environment, and ever-present television screens. In this Gothic land of the end of the long cycle (of the post-

war boom), boundaries between the "normal" and the pathologized "other" collapse, and the "normal" is often more dreadful than its "unnatural" opposite. To understand contemporary Gothic we must understand it as a narrative strategy endemic in contemporary industrial art culture.

Emanating from the ruins of the urban-industrial space of the West, the work of industrial groups has borne testimony to the shifts in the history of late capital. The generation of industrialists—typically growing up and forming their groups in manufacturing ghost-towns—witnessed the transformation of an industrial/modern world into one of postindustrial/postmodern and attested to the shifts from production to reproduction.

I argue that the industrial scene located itself as a cultural form that, at least in part, articulated community reactions to specific social and political developments in the face of deindustrialization and the arrival of the postmodern moment in the West. In my research, I distinguish between two waves in the brief history of industrial music. The first wave in the 1980s—SPK (Sydney, Australia; then London), Einstürzende Neubauten (Germany), Throbbing Gristle (later, Psychic TV) and Test Department (England)—rejected repetitive modes of technology, considered itself sub-electronic, and, coextensively, deployed environmental/found sound as well as the body as its chief source of noise. To the contrary, the second wave of industrialists emerging in the United States in the late 1980s—most notably, the Wax Trax circle in Chicago, from which Ministry exercised the greatest influence—embraced electronic noise and the use of electronic media in general.[5]

While Gothic elements had been present in early industrial materials, it more naturally fed into and spun off the second industrial wave. Goth's "essentially rhythm-based discordancy... [and] increasing reliance on mechanical as opposed to organic, sound effects..."[6] simultaneously formed a substream within industrial and, through the cultural work of its fans, emerged as a semi-autonomous

Psychic TV
Unclean
Videostill
Courtesy Visionary, St. Annes on the Sea,
Great Britain

"Like Cancer in the System"

Al Jourgensen of Ministry

genre. In non-musical terms, I will suggest that Goth retained elements of industrial performance's fixation on both organic and technological decay, layered those with hallucinatory visions of body horror, sexual torment, and sacrifice in its renunciation of a normativizing culture, and gave them a spectacular visual staging.

Industrial Gothic provides an instructive example of how these artists produce cultural forms appropriate to postmodern realities and how their work represents a complicated cultural (and political) strategy to fracture the illusion of consensus within the abstract space of late capitalism. Theorists such as Fredric Jameson, Henri Lefebvre, George Lipsitz, Stuart Hall, Michel Serres, and Jacques Attali offer vital insights into the cultural logic of late capitalism.[7] In analyzing the work of industrial musicians and performers, I find significant parallelisms between their art practice and the theory of cultural Marxists. I strongly believe that an examination of these parallelisms validates and reinforces the work of both art practitioners and theorists, *and* at the same time, makes transparent the ideologically constructed nature of the practice/theory division.

The politics underlying the industrial Goth scene were complex. A crumbling welfare state in Western Europe, the rise of Reaganism in the United States, and

the mass embrace of the Right both at the polls and on the level of everyday life engendered the apocalyptic scenarios of industrial performers. Art practitioners of industrial Gothic perceived the deindustrialized space that late capital produced as the site of utmost abjection, "the end result of social entropy."[8]

To many first wave industrial performers, it was the body that signified the absence of rationalized economic desire in the postindustrial era. Bodies mangled, bruised, and in decay, confront us in powerful ways in industrialist Gothic material. The industrialists' furious initial drive to mention or display signs of the organic, of the laboring body juxtaposed with the haunted ruins of industry, can be viewed as a rejection of economic inscription. The industrial first wave seemed to believe in what performance theorist Peggy Phelan had described as unrepeatable, body-centered performance's ability to disrupt the reproductive machinery of representation and thus negate capital's "system of exchange and... the circulatory economy fundamental to it."[9] Such an art practice, according to Phelan, entails the "real" through the presence of living bodies: "Without a copy live performance plunges into visibility—in a manically charged present—disappears into memory, into the realm of invisibility and the unconscious where it eludes regulation and control."[10]

Pouring industrial noise into policed and silenced spaces contests late capital's *topoi,* and can become a resistant cultural intervention. Industrialists reimagined conventional tools (acetylene torches, electric saws, cement mixers), deployed found objects (blocks of concrete, scrap metal), and used experimental media (ultra sound, subliminals) for producing noise. Industrial music bore out Attali's dictum for emancipatory practice when it ceased to be a product separable from its author.[11] And when Einstürzende Neubauten's Mufti (F. M. Einheit) pounded on Blixa Bargeld's microphone-laced body, boundaries between the body and electronic apparatuses collapsed and new grounds opened up for cultural negotiations.

Or did they?

I believe that what the corrective second wave industrial performers, primarily in the United States, offered was precisely on this point. They suspected that the most such a work could achieve was, in the words of the Critical Art Ensemble, "a cheer for deviance," but, ultimately, could not fracture the sign of deviance. "Simply putting on a counterspectacle within the theater of the abject is not enough."[12] Hence, second wave industrial performers have gone beyond the organic body and have declared Information War. They use electronicity— meaning high electronics, noise dispatches on radio, visual attacks by video and on public-access cable television, and a combination of the two on the Internet

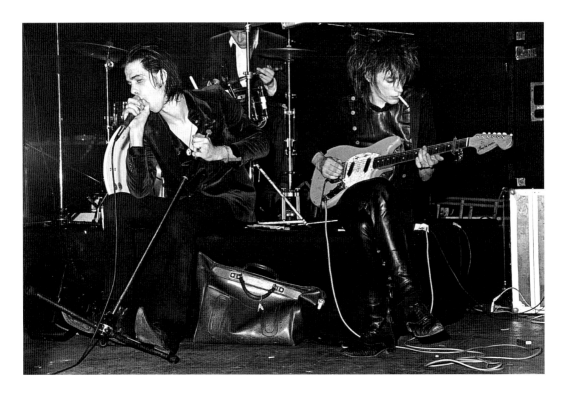

Nick Cave & Blixa Bargeld
30.9.86 Berlin

and the World Wide Web—in an attempt to deprogram the silent subjects of postindustrial space. As Genesis P-Orridge from Psychic TV claims, "to intervene 'magickally' on reality the most up-to-date available technology should be used."[13]

Second wave industrial performers' shift away from the body, or decorporealization of performance in favor of technology, is coeval with the perhaps most astonishing, genuinely Gothic, feature of late capitalism—the decorporealization of labor. This also necessitated a move of attention from bodily suffering to forms of invisible psychic pain—the kind of affective suffering that, for instance, NIN has set out to render visible and chronicle in familial, class, gender, sexual, and, implicitly, racial relations in contemporary America.

Nine Inch Nails' Gothic Video Assault

According to a biographical sketch in *OPTION* magazine, Trent Reznor grew up in Mercer and in Meadville near Pittsburgh, Pennsylvania, and launched his musical career in Cleveland, Ohio.[14] Reznor's earliest songs found their way to *Pretty Hate Machine* (1989), which became one of the paradigmatic albums of the era, and gave NIN a top spot in Lollapalooza in 1991. After a

lengthy break, Reznor released *Broken* (from which "Wish" won a Grammy, ironically enough, for best *heavy metal* [!] song), and then another major hit album *The Downward Spiral,* which led to the invitation to Woodstock '94 and Bowie's *Outside* tour in 1995. A bootlegged collection of seminal NIN videos ("Happiness in Slavery," "Closer," "Burn," etc.) was recently released under the title *Just Another Nail.*

Indeed, video, often available only in circuitous routes from obscure distribution points, is a crucial actor in the industrial Gothic scene. Gothic video is nomadic in at least two ways: materially, it circulates through the informal channels of an "underground" political economy;[15] discursively, it throws cultural elements together in a non-causal fashion and, as Critical Art Ensemble claims, allows "the meanings [it] generate[s] to wander unbounded through the grid of cultural possibility."[16] Thus, for instance, the irised, sepia-toned images of eroticism and death in NIN's "Closer" (a crucified monkey, a young, shaved, nude woman with a blindfold, a male strapped to a torture machine, a mechanized pig snout, a carcass hanging on a hook) produce the aura of the silent era only to be disrupted by the sudden appearance of a television set. In its dual capacity, industrial Gothic video then indeed becomes "the practice of everyday life" (Michel de Certeau) for the fan whose role as spectator expands into that of distributor and decoder. Of the videos NIN produced, perhaps none unleashes more the psychohorror of the postindustrial wasteland and creates the American Gothic than "Burn." In what follows, I examine "Burn" as a symptomatic instance of industrial Gothic video.

In the elliptic time frame of music video narratives, NIN's "Burn" forms a commentary on the social state of things, positing images of the ruins of modernity's dream of progress. As the montage progresses, it establishes complicated visual links between world-historical events and specifically American developments. We see a fascist march (in Italy), portrait of Hitler (twice), concentration camp victims, tanks rolling over trenches. Closer to home, a suburban mansion ("Absolutely No Trespassing" says the sign in front of the eerily lifeless, almost Gothic, edifice), 1950s street scenes and family photographs, a beer sale sign, the American flag, and a church. The rusty, rotting shells of an abandoned or foreclosed farm, the red bricks of a housing project (in bitter irony, the orange button with the smiling face "Don't worry, be happy" that circulated after African-American singer Bobby McFerrin's hit song, hovers over the brownstones), cooling towers of an atomic power station, and backed-up cars on a freeway bear testimony to the end of the long cycle. These "historical" images are juxtaposed in an increasingly frantic pace with scenes of family life and

especially family violence in America—a young boy violated by his father and a young girl sexually abused by hers. Toward the end, vampires loom over the contemporary wasteland.

The main character's life story in the video overlaps and occasionally merges with that of the serial killers in Oliver Stone's *Natural Born Killers* (1994). (Reznor compiled and composed the soundtrack for the movie.) Although NIN's video uses segments from the movie, for most of the time it successfully avoids the kind of moralistic response that permeates Stone's film (for example, rather simplistic, causal linkages between child abuse and adult violence; incest and murder; television and the economy of serial killing).

The NIN video situates vampirism within late capitalism or, if you like, within the postmodern setting, and Gothicization seems to have a radicalizing effect. The horror "Burn" invokes in the overlapping images of monsters at the video's end disrupts dominant culture's representations of family, sexuality, gender, class, and nation. The emergent vampire/monster is a mobile signifier, open to multiple interpretations. Reznor's vampire can be anything:[17] fugitive, fire

Nine Inch Nails, Woodstock 1994

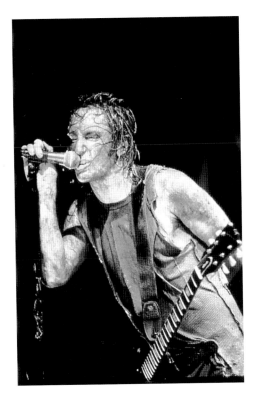

cultist, revolutionary, the sexual or racialized Other, or even capital itself[18] (as in Marx's famous metaphor[19]). The video, turning the position of the monster upside down in the filmic narrative, presents us with a version of the postmodern Gothic: images of the pyrolitic monster-child at the end exude an artificiality that, in turn, denaturalizes the humanness of the "not-monsters." Halberstam calls our attention to this marker of Gothic: in this instance, it is no longer the monstrous that we fear, but those who make monsters, hunt monsters, practice the monstrous, or generate neofascist discourses of the "impure" Other (anti-Semitism, hatred of people of color, of queerness, of immigrants).[20]

It is important to remember that, historically, neither the vampire Dracula nor the young Frankenstein has a voice; they are read and interpreted by all the other characters. And while their silence is pervasive and almost suffocating, Reznor, through his lyrics, often distorted beyond the point of intelligibility, gives voice to the monsters haunting the bankrupt, phobic cosmos of American suburbia.

Can the monster also be constructed as the one-sex model (male vampires reproduce, hence are feminized, combine men/women, etc.) in opposition to the naturalized sexual binarism of capital's patriarchal order? If so, is it a bachelor machine—a male self-representation couched in autoerotic fantasy, whose desire, as art theorist Nell Tenhaaf claims, is "frustrated and also regenerated by a nihilistic preponderance focused on celibacy, autoeroticism, and death."[21] Or is Reznor's monstrous technology a step toward Gilles Deleuze's desiring machine with its polyvocality and flows?

The NIN video periodically shifts from culture to nature. The scenes with monkeys, horses, zebras, insects, ladybugs, praying mantis, and flowers, especially the rose (symbolizing the violation of the young girl), seemingly serve as "stand-ins" for the nature/culture opposition. These sequences invoke the naturalist idiom of a violent primitivism—and a discourse that literary historian Mark Seltzer finds premised on the "miscegenation of nature and culture, bodies and machines."[22] However, the father with the gun in the corn field, or the fathers committing child abuse and anti-female violence, as Seltzer cautions, represent "something more than a regression from culture back to nature."[23] In the video, this violent primitivism—tied to male regeneration—finds its place in the simulation (reproduction) of the "natural" represented by the male's hunting in the "wild"—in the simulated nature of postmodern suburbia, his targets being his child and wife in the suburban home. Addictive violence and other forms of addiction by men (see the alcoholic fathers in "Burn"), are intimately linked to the uncertain status of production—"work"—in postindustrial America, and,

coextensively, to the uncertain status of the subject. The uncertainty of production leads to the gendering of production and, as Seltzer claims, generates "the violent transfer of the terms of self-identity [by the male] into terms of sexual difference" (misogyny, homophobia, etc.).[24]

Overarchingly, the NIN video addresses the organic/technological interface of the postmodern condition. Cultural critic Celeste Olalquiaga contends that technology disrupts the conventions that guided us between fantasy and reality and creates a third cognitive space: simulation.[25] In the simulated space of late capital, perception is formulated through media (in "Burn": Hollywood monster films, wartime newsreels, nature films, Las Vegas' neons, etc.; for counterpoint, see its use of home movies) that, Olalquiaga insists, "discard all types of categorical distinctions—temporal, geographical, and even physical."[26] Televisual signs constitute postmodern collective memory, overriding, but—and on this I digress from Olalquiaga—not irretrievably obliterating, history. NIN inspirator Genesis P-Orridge's declaration of a "political, magickal and sexual war" through video (reinforced by new possibilities in resistant technology) in order

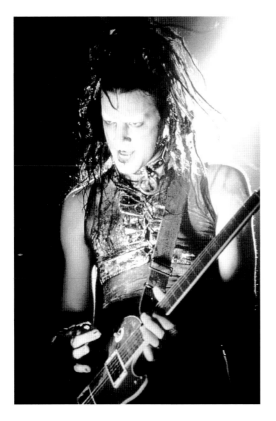

Nine Inch Nails, Woodstock 1994

to retrieve history, can enact a viable mode of discursive challenge to structures of domination. Gothic video can either call attention to the sign construction of simulation or establish a radical skepticism so that simulations cannot function.[27] P-Orridge may then be right, when he concludes, "...[video] is the nearer you'll ever get to an electronic molotov—go out and throw one. Cause the cathode ray tubes to resonate and implode. You are your own screen."[28]

Work by industrial and Gothic artists has been reflective of the complexities of cultural processes in the postmodern setting and of the relevance of flexible resistant cultural practices by collectivities that are either marginalized from or struggling within the dominant culture.

Gregory Crewdson

Untitled, 1995
C-print
Courtesy of the Artist and Luhring
Augustine, New York

Curtains

DENNIS COOPER

A rickety shack built from loose pieces of other folks' fallen down homes nearly hidden away in some humongous oak trees that this thick fog enclosed almost all day sometimes though you could smell what they cooked all the way into town on most mornings and very occasionally the family would walk up the dirt road and buy some supplies while that strange deaf-mute son of theirs sat on the steps of the general store writing things in his notebook and looking around at the rest of us living our lives with this look in his eyes thinking who knows what evil shit.

Pete's eyelids shut, bunched, quivered a second, then... opening.... Such a scary expression appeared. His eyes were amber, a bit dilated, and sparkly. Too excitable to know, yeah? So Jess examined how he was reflecting in them. And, weird, he looked scary as well. "I got this idea," he said.

"Oh, yeah?" To this day Jess can't believe he was sitting around in the presence of someone so... mentally right there. Hopefully Pete felt the same way re. him.

Pete cleared his throat. "I'm thinking we could ask Satan for something." All this bullshit was said in a thick Southern accent that made him impossible to know very well if at all. Hence, the charisma.

"Like what?" Jess's bewilderment did something odd to his voice. Luckily, Pete was always so into his own crazy thoughts. It made others feel useless. Hence, the charisma.

"I'm thinking for sex." Pete snickered just so. There couldn't have been a more perilous, incomprehensible moment. In the background, his boombox was playing the newest cassette by The Omen, a crappy industrial rock band that he and Jess loved in their ignorance.

"You got someone particular in mind?" Jess whispered this in a half-joking, fake, noncommittal, weak voice that exactly reflected his actual feeling.

"Well... " Pete studied Jess, his eyes growing more colorful if sort of uglier. Less distant, but much, much more fascist. In other words, incomprehensible. Maybe Pete's huge IQ was the problem. Anyway, the look in those eyes made Jess shivery. "Here, I'll show you."

3:07: I don't like those boys.
3:09: They're evil.
3:10: Excuse me. I'm gonna read their lips.
3:12: They got something bad in their minds.
3:13: I think it's sex.
3:13: I think they said me.
3:15: Me for sure.
3:16: Scared.
3:18: Go away.
3:20: Think of something else.
3:21: When the wind hits a treetop, it's born.
3:22: It keeps changing.
3:24: They're still there.
3:25: Help.
3:26: Gonna stare 'em down.
3:27: Staring.
3:29: Bored.

—Him.
—Who?
—That hillbilly boy. Sitting on the steps by the store. Writing in that notebook.
—Right.

—Let's just say theoretically... we ask Satan to give him to us for our sexual
 purposes.
—You got a guess at his age?
—Same as us. Maybe younger.
—Seems about right.
—So what are you proposing we do to him?
—I don't know, sit on our faces, blow us, sit on our dicks. Why, you thinking
 stranger?
—Yeah.
—Like what?
—First things first. Do we kill him afterwards?
—Why?
—So he won't tell his parents. And for kicks. And to see what it's like.
—Maybe. Yeah, I guess.
—I'm thinking definitely. I'm thinking it takes a few days.
—What's the plan?
—Oh, no plan. I'm just talking.
—Look at him.
—Yeah.
—He looks depraved.
—Totally.

Jess unfocused his eyes on the swaying around of a tree outside the shack's
dusty window. Its limbs were entrancingly lighted. But he couldn't connect
how he felt with its beauty. So he turned his head slightly and studied a framed
photograph of his only friend Pete, in particular two amber eyes. They were a
little too friendly, but, at the same time, not nearly friendly enough. Finally he
just closed his eyes and very slowly unlit everything in his mind 'til there was
only the heat of the day—which was slow and very weighty with moisture, and
laced like a shoe with the whirring of flies—and the bed, which was cold and
uneven and had no effect. Thus he was left to himself. And to his brain. And to
the sizzly sun. And to the sounds of the tree. And he pictured that hillbilly
boy's face, made a fist, raised it very high in the air, then brought it down in the
direction of hell, up and down about a hundred more times, until he'd com-
pletely erased shit.

A creek meandering through a little valley with steep sides that has this
spookiness when I walk alongside it. Turns out to be on account of the pirates
who supposedly hid in these parts long ago. So I pitch a tent, start this fire,
and, sure enough, around dusk these ghosts rise from the river like folks always
said. First I pull out my gun, taking shots at the ghosts, like I'd shoot at some

birds, but the noise of the shots or something else makes them lose it. They swarm me. It's sort of like after a football game maybe. I never felt anything like it. This swirling and blindness and pure cold and other shit I can't conceive about. So I get the fuck out, running as fast as I can up that creek to where the sides of the valley are sloping enough that I can climb my way out, and I don't give a damn about leaving the tent. Then I sit by the road, trying to recall the exact way that ghostly swarm felt, like someone more romantic might remember a kiss. And eventually Momma picks me up in her truck, and I write what I saw in my notebook. Using big, weird words. But when I show her the words they end up scaring or maybe annoying her so much she stares straight ahead and cranks the radio so loud my stupid skin shakes.

9:02: Leaf shaking, tree to the right.
9:08: Bored.
9:10: Something on the road?
9:13: Nothing.
9:47: Was asleep for a while.
10:12: Deer on the hill.
10:13: Thinking of shooting that deer.
10:15: Nailed it.
10:17: It's shaking a little.
10:23: Still now.
10:31: Bored.
10:34: Okay, okay. More deer. I see 'em.
10:35: Two of 'em. Shit.
10:38: Deciding.
10:39: Aim.
10:40: Got one of 'em. Head, I think. Other deer took off.
10:43: Going down there to look.
11:12: Back. It's dead.
11:13: Want to drag it up here.
11:42: Too tired.
11:50: Nothing on the road.
11:52: Still nothing.
11:59: Bored.
12:11: Wind blowing the deer's fur around.
1:01: Was asleep for a while.
1:04: Thinking of dragging that other dead deer over here.
1:06: Yeah. I'm off.
1:48: Laid that deer down by the first deer.

1:50: Watching 'em.

1:53: Gonna push 'em closer together.

1:55: Better.

With a jab of his elbow, Pete broke the store's window. No alarm, nothing. He reached through the uneven star and came back with a shitload of jewelry.

They ran until they'd reached that weird place only they recognized.

Jess was so breathless he couldn't think shit. The necklaces, et cetera, were scattered around in the grass. They looked like a wet spiderweb or whatever.

Pete's eyes were amber. The sky was so muggy and black they could barely stand up straight. They'd been snorting crystal meth every hour for hours. They were indescribably hot for one another by this point. That hurt. Everything was hateful apart from how they felt for each other.

Jess shut his eyes, reopened them, and made himself look amazing. Meaning terrified and stoned. He couldn't figure out how he did it. He knew it was ninety percent in the look in his eyes, possibly another ten or so in the curve of his lips.

Pete removed article after article of clothing until there was total perfection. There shouldn't have been anyone in the world that important. It killed Jess.

—Satan, it's us. We're calling you. Shit, it's fucking cold out here.

—Wait, put on some music. Put on The Omen tape. It's in the....

—Found it.

—Maybe louder. Cool. Now kill the cat.

—It's fucking scratching me. Shit, shit.

—Keep stabbing it.

—Okay.

—Now put it in the circle of candles. On top of the jewelry.

—Okay. Satan we're calling you. Come into the circle of candles. We got a little gift for you.

—We love you, Satan. You're the coolest.

—Concentrate.

—I am.

—Fuck, that's him. Look at that. It's like a smudge. On the cat.

—Oh shit. I think he's screwing me. Ow.

—Relax, let him. It's his thing, man. Uh... welcome Master of Darkness. We want to ask you for something. We want you to give us that hillbilly boy. What's his name?

—Dagger Nokes. Ow, ow.

—We want Dagger Nokes to be our sex slave so we can do whatever we want to him until we get bored. Can you do that for us?

—Ow, ow.

—Give us a sign. Wait, is that it? You see that?

—Yeah.

—The wind couldn't do that, right?

—I... don't think so.

4:08: Lake. Nothing else.

4:10: One fish.

4:11: Wish someone was here.

4:12: Just shot at a bird.

4:12: Missed.

4:13: Bored.

4:16: Some boy.

4:16: Watching me.

4:16: Oh, him.

4:18: Gonna write him some shit.

4:19: Hi, how's it?

4:19: His lips said, Come back to my house with me.

4:19: What for?

4:20: His lips said, For whatever I fucking want.

4:21: He's taking a leak on the tree.

4:21: Back.

4:23: He likes me.

4:24: He does.

4:24: Has a swimming pool.

4:25: Thinking about it.

A feeling so weird that you feel like you don't quite exist anymore but there's nothing else either so who gives a flying fuck how you behave since nobody's around to compare yourself to and if you do something you've never done in your life it's just a piece of the brilliance inside you and everyone says that it's totally cool to believe in yourself and anyway to never do what you want is the true craziness 'cos you know how....

—So you remember that weird little thingy we did? Well, let's just say it
 worked.

—Bullshit.

—Yep. Yesterday afternoon.

—Where'd you see him?

—In the woods.

—Doing what?

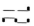

—Nothing. Sitting by the river writing shit in his notebook. I think he's just watching the fish swim around. So I take the chance, sit down beside him. And he lets me look deep in his eyes while I'm talking. He writes down that he's bored, and shows it to me, so I tell him my yard's got a pool, and my folks ain't around, and he walks home with me.

—Bullshit.

—Kid knows something's up. I can see it in his eyes.

—What did you do? God, I hate you.

—He strips to his underwear, and man, let me tell you, phew, then he swims around, pretending he's a seal or whatever, showing off, and I'm sitting by the side of the pool, checking out his ass, which is fucking perfection, and acting all amused like he's a great entertainer. Then we go inside the house, and he's wrapped in a towel, shivering, and we're doing lines of crystal, and I'm telling him he's sexy in little roundabout ways.

—So how old is he anyway? What was our guess?

—We thought our age, and he is.

—How'd you get him in bed?

—I was telling him about you and me, and how we fool around sometimes, and commit these little robberies together, and he writes down that he thinks that sounds cool, and how he sometimes wonders if he's gay and all that. I mean, he couldn't have opened the door any wider.

—I hate you.

—So I ask him, Hey Dagger, has anyone ever licked your ass? And he's laughing. And I tell him how sexy it feels, and how I'm a genius at licking asses, which I am, and he starts writing down fart jokes and all that, then, boom, he writes down that he'd love me to lick his ass, really, with exclamation marks and everything, like I'd be doing him this huge fucking favor.

—Fuck you.

—So we're in bed, and I'm bending his body around, trying different positions, and licking his ass, and he's jerking off. I take my time, soak him down, really loosen him up, get my tongue way fucking in him. I'm talking deep. I can taste the fucker's shit.

—Gross.

—No way. If you could see this boy's ass.... So his hole gets so loose, it's a freak show. I'm seeing all the way into his body. I've never seen anything like it. So I put a little mirror up against it, so he can check himself out, and he just loses his mind. And I'm seeing this golden opportunity, right, and I put a few fingers inside him, and oh my God, phew, and that's such a fucking turn on, 'cos you know how I get, that I lean down and kiss him, and he's kissing me back, sucking my tongue, trying to taste his own asshole, I guess. Then I fuck

him harder than I've fucked anyone in my whole life, and shoot a load and all that.

—Jesus Christ.

—Yeah.

—That boy. The one we asked Satan for.

—Yeah.

—So how come you didn't kill him?

—Didn't have to. Maybe next time. Thought you'd want to be involved.

Something not right in the way them two boys always have that deaf hillbilly boy along with them and how they all look at each other like they was some family except maybe not the deaf hillbilly boy seeing as how he's always chasing them all over town like nobody will pay him no mind and that's pretty darned strange since it weren't so long ago that boy never did nothing period and we thought he was evil but maybe it turns out he's not the strange one after all and we don't know enough about such things as what them boys do in the woods late at night and besides nobody round here wants trouble so who wants to say something to them not us.

Jess and Pete led Dagger out to that scar in the woods where Satan liked to take working vacations. Daylight drizzled through big, smelly leaf overhangs and scattered bunches of unfocused diamond-shaped sun particles over things.

"Now you get down," Pete said. He pushed Dagger's shoulders, and when the deaf-mute was kneeling in the appropriate spot, the other boys made a circle of candles around him and copped a few feels. As soon as they stood up, the wicks lit themselves.

"He's here," Jess said. He threw off his clothes, as did Pete. They had boners from feeling up Dagger, who was already naked and all that.

Pete chanted to Satan. Jess echoed the chants about a half-second later. When Dagger looked sort of smudgy, they, especially Pete, asked the Master of Darkness to make the weirdo in the circle of candles immortal or something so they could kill him for kicks and not worry about it.

The sun particles started sweeping around, like in discos, except the only sound was the wind hitting trees, some industrial crap, a few singsongy chants, and the wee, constant scratch of a pencil and paper.

1:07: They're killing me.

1:08: Oh shit.

1:09: No, they stopped.

1:10: One of 'em's screwing me.

1:11: They hate me.

1:11: I'm dead.

1:12: No, they woke me up.

1:14: They just took a piss on my face.

1:14: I'm so great. Both of them said so.

1:15: One of 'em's strangling me.

1:17: Scared.

1:20: Okay now.

1:23: They're strangling me again.

1:24: They love my ass.

1:24: No, they hate it.

1:27: I still want some crystal.

1:29: One's kicking my ass. One's kicking my face.

1:30: They're stabbing me.

1:30: I just took a shit.

1:31: I'm dead.

1:33: I am.

1:33: They're screwing me anyway.

1:35: They hate me.

1:37: They just came.

1:40: Bored.

Dear Momma,
I no your son. You no see again. I love you.
Dagger

—That was definitely the most awesome thing I've ever done in my life. Do you realize what's happened? We're gods, asshole.

—I'm completely creeped out.

—Wuss.

—Fuck you.

—So get lost then. Like I care. I'm going to make a million trillion fucking dollars with this shit.

—Yeah? Well, I'm the one Satan screws, and I say this is bullshit and evil and wrong, and it's all fucking over, okay?

—You think Satan gives a damn who he screws?

—Just stop it, okay? This is scarier than shit.

—No way.

—Then later.

—No way. You're going to fucking tell everybody.

—Put that down.

—Put yours down.
—You first.
—You.

Jess walked into the dead electric light of the general store and pulled out the gun. Then everything in front of him smudged. Fucking weird. Thanks to the crystal meth damage or something. Or that's how he explained the effect. Like aftershocks in the eyes. Nothing he could do about it. So he held up the gun, stuck it way out in front of him. It got totally lost in the smudge. But the clerk saw it, didn't he? Yeah, uh-huh. 'Cos loose change sort of sprayed across the countertop. Greasy coins, a few dollar bills that disintegrated like lint when he grabbed them. Wiped the loot into his knapsack, missed one stupid nickel. Noticed it lying there. Shit. Don't know why he even thought to retrieve it. But he was prying it up. Or attempting to. Greasy little thing. And it hit him. How the light had gone dead. Just like that, just as vague as that sounded. Not just gone out of the nickel. It was too fucking hard to describe. Shitty fantasies. Fucking crystal meth. Concentrate. Gone out of the venture, the sex, murder, Satanism, robberies, et cetera, okay? Like that. So he handed his gun to the clerk, and said, Fuck it.

Jess stared at the glare, focusing on the spot where he'd last seen the cop's stupid face before light ate it up, and kind of sunned his eyes, opening them wide, so their pupils could suck at the light, which had obviously done what it set out to do, seeing as how he'd confessed to killing Pete, since he no longer cared about prison and death row and that, seeing as how all that beautiful light had erased shit.

Jess kneels in the circle of light beneath a crumpled clip lamp. It spotlights his hand, pencil, white sheet of paper, leaking just enough into the cell to put this glow on the page. He's drawing the dead Pete. Too bad he's completely untalented, because he can't manage a likeness. Just scribbly lines trying to add up to something. Anyway, done. Or... wait, maybe he'll add another figure, himself, standing next to the corpse looking down at its badly drawn form with a complicated look on his face, not that Jess' hand can communicate that kind of subtlety. No, forget it. Done. He crumples the paper.

Seance
How does it feel in the ground, Pete?
Cold and good, I guess. Feels right.
And you just... lie there... and...?
For a while now, enjoyin' the nothin'.

DENNIS COOPER

And when the time moves along?
I'm just floatin' away to wherever.
You aren't afraid of the "nothin'"?
What, of the worms and shit? Naw.

People say death is the ultimate.
So I've heard. Not my decision.
People say life's more mysterious.
It'd have to be. I don't remember.

So, why not just... kill myself?
Boy, that's a hard one to answer.
'Cos I'm tired of life's bullshit.
Well, ain't no bullshit 'round here.

So you'd recommend dyin'?
Hard to say. Why you askin'?
'Cos death just seems so awesome.
Maybe, but all I ever feel is....

10:10: So it's cold.
10:11: Gotta get out of here.
10:14: Thinking.
10:14: Okay.
10:14: Make a sign.
10:15: Thinking.
10:16: My name's Dagger.
10:16: Okay.
10:18: I need a ride to somewhere.
10:19: Holding the sign up.
10:21: Car, okay.
10:21: Nothing.
10:26: Still nothing.
10:27: Shot a bird.
10:27: Gonna put it in my pocket.
10:30: Car.
10:36: Car.
10:40: Nice road.
10:41: Lying down.
10:41: Better.
10:44: Better.
10:46: Wait.

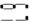

I love this road. It weaves off into the mountains out there, you can see it. And it just totally reeks. Don't know why. I've been lying beside it for days, part obscured by the brush, awaiting the right car to pass, and a nice passerby. Someone in elegant duds, whom I can fleece. God forgive me, I'm broke. The sun's creepy, a hard piece of scalding red shit way up there that has no consciousness of its own, so you can't tell it anything real like, Go away. Everything should have a mind. So you could communicate with it. So I could say, Grass, get taller and cover me better. Or.... School bus, stop here, right this second, and dump all your passengers out on the road so I can fuck, rob, or kill them. I wouldn't even mind if the bus said, No way, you're too fucking lowly a jerk to waste time on. Or if the sun said, Oh go ahead and burn up, you moron. Or if I could say to this road, Hey, can you glisten a little? 'Cos that would look so unbelievable. And it would glisten for me, to be nice. Then it might say, Okay, now you walk on my surface a while, I don't know why. And I would, even if it got me arrested. 'Cos the road is so peaceful or something. Anyway, everything understanding everything, know what I mean? People's guns saying, No, not him, asshole, kill him. And my pistol would swing itself around and do the shooting for me. And I'd just go, Well hey, I didn't make the decision. And my gun would go, Yeah, I made the fucking decision. And what could the cops do? Melt down the gun? Well, they could. And maybe that would be sad, 'cos if the gun had a mind, I'd be attached to it. Shit, you can't win. There's no way the world's ever gonna be totally perfect, unless nothing and no one had minds. If we all just kind of lay here, only moving around when the wind kicked us up, or if the rain got too hard, or if there was a flood. Natural things. I'd lie here in the grass for days, weeks, spacing out, then some storm would move me twenty feet that way, and my world would change, and I'd get to know new blades of grass and new dirt and new flies or whatever. I wouldn't die, I'd just change. Dry out, get wet, smell one way, smell another way. No boredom, no love, no fear, no being broke, no... nothing. Maybe that's what'll happen at world's end, after one of the millions of viruses sneaks in our bodies, and no one, no matter how big a genius, can cure us. We'll just... whatever, collapse where we are, and, I don't know, never see, feel, or do anything, and eventually we'll lose sight of each others' existence, and just become what I previously described. Lumps of nature. In my case, a small, smelly thing in some brush. A stupid thing drifting through history, no worse or better than trees or the bugs or our guns. Oh, I long for that day, I have to tell you. But until then I just love this road.

Douglas Gordon

Twenty-Four Hour Psycho, 1993
Video installation
Courtesy Lisson Gallery, London

Shivers

SHAWN ROSENHEIM

Horror, Edgar Allan Poe insisted 150 years ago, is not of Germany, but of the soul. Whatever the merits of this remark for literature, the origins of the horror film are emphatically Teutonic. Although a number of nations produced impressive films (see for example Carl Dreyer's *Vampyr*, 1922) throughout the silent period, the German studio UFA reigned supreme, producing such land-mark works as *Nosferatu, A Symphony of Terror* (Nosferatu, eine Symphonie des Grauens, 1922, F. W. Murnau); *Metropolis* (1926, Fritz Lang); *M* (1930, Fritz Lang); and more in which terror was a central emotion. Perhaps the most important of these films is *The Cabinet of Dr. Caligari* (1919), Robert Wiene's Expressionist catalogue of images and devices (the mad scientist, the endan-gered woman in white, the "undead" monster who kills at his master's bidding) exploited in hundreds of later films. Shot entirely in studio, on macabre, canted sets, with dislocated or forced perspectives, *Dr. Caligari* tells of a sinister doctor accused of using a somnambulist named Cesare to commit a series of murders. The story is recounted by Francis, a young man who represents himself as the hero who unmasks the Doctor, but as an epilogue indicates, Francis is insane, the Doctor is the head of the mental institution in which Francis is lodged, and the whole story has taken place within his head.

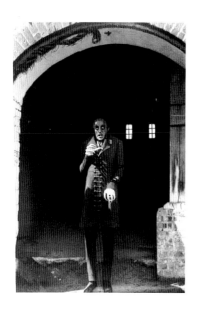

Max Schreck in F. W. Murnau's
Nosferatu, Germany 1921

Robert Wiene
The Cabinet of Dr. Caligari, Germany
1919

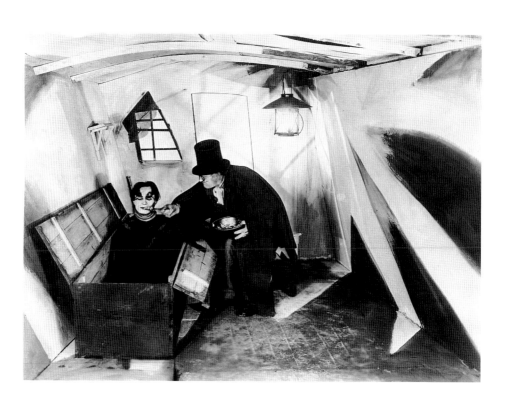

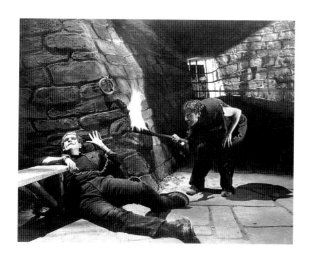

James Whale
Frankenstein, USA 1931

Although the film has attracted its share of detractors, put off by the thorough-going artifice (André Bazin and Sergei Eisenstein among them), *Caligari* has been seized on by an enormous variety of filmmakers, ranging from commercial directors like James Whale to experimentalists such as Jean Epstein and Kenneth Anger, all of whom found themselves attracted by its radical subjectiv-ity of perspective. In this respect, *The Cabinet of Dr. Caligari* is a good generic model, as much concerned with the violence done to epistemology as it is with that done to bodies. "I must know everything.... I must penetrate into his inner-most secrets," says the modern doctor, on learning of the eleventh-century origi-nal after whom he is named; "I must myself become Caligari."

It was not until 1930 that the horror film appeared importantly in America, led by *Dracula* (1931, Tod Browning), which, much to the surprise of Universal Studios, became a critical and commercial hit. A wave of monster films immedi-ately followed, including *The Mummy* (1932, Karl Freund), *The Invisible Man* (1933, James Whale), and *King Kong* (1933, Merian C. Cooper). The success of these films owed much to the UFA films of a decade earlier, not only in terms of their Expressionist visual design and lighting, but in terms of their makers as well, many of whom, like directors Fritz Lang and Paul Leni, had migrated from Germany to Hollywood, where they often worked under contract to Universal Studios. On the whole, these films have held up remarkably well. Their plea-sures range from the justly famous scenic work in *Frankenstein* (1931), to Claude Rains' melancholy performance in *The Invisible Man*, to the high camp of *The Bride of Frankenstein* (1935, James Whale), a film later more imitated than mocked in Mel Brooks' *Young Frankenstein* (1974).

Tod Browning
Freaks, USA 1932

Virtually the only film that still inspires terror, though, is Tod Browning's *Freaks* (1932). The plot is very simple: Cleopatra, the beautiful trapeze artist, is loved by Hans the midget. When Hans comes into an inheritance, she marries him, intending to poison him for the money. At their wedding banquet (an unforgettable scene in which the "freaks" initiate Cleo into their ranks, chanting, "We accept her, one of us, gooble gobble, gooble gobble," as the camera cuts from one "freak" to another in direct, audience-implicating close-ups) a drunken Cleopatra insults Hans and his clan, before humiliating her husband by carrying him away from the party on horseback. When Cleo is discovered drugging Hans, the "freaks" unite to seek vengeance against her and her lover Hercules (the circus strong man), killing him and mysteriously mutilating her,

reducing her to the armless, legless Chicken Woman on display in the circus sideshow.

The key to the film's effect was Browning's determination to hire real "freaks." Browning had himself worked in a circus as "The Living Hypnotic Corpse" (shades of Cesare!), and he cast the film with sideshow artists including Johnny Eck the Half-Boy, the Siamese sisters Daisy and Violet Hilton, Rordian the Human Stump, and the "pinheads" Zip and Pip. Initially, *Freaks* violates our lurid expectations (why else does one go to see a movie called *Freaks*?) by insisting on the *ordinariness* of sideshow culture in quasi-documentary scenes that demonstrate the performers' mastery of ordinary human skills and feelings: the legless woman drinks with her feet, the Bearded Lady has a baby with her husband, the Human Skeleton ("Oh, she's gonna have a *beard*!" one character chortles). The "freaks" constitute a coherent, tightly knit society, one far more amiable than that of the strong man and the beauty, until the film's climax, when the "freaks" pursue Cleo and Hercules through a torrential lightning storm, crawling under and around the circus vehicles stalled in the mud like "a distinctly other larval species," "a village of monsters" whose actions confuse the audience's allegiance.[1]

Though it flopped at the box office (most exhibitors refused to show it, and MGM, embarrassed, pulled the film from distribution for fifteen years), *Freaks'* devious manipulation of the canons of beauty and ugliness renders it a disturbing film even by contemporary standards. Though we can understand and even endorse Cleo's truncation, we are less able to forgive the film's cast for their very success in adapting to their disabilities, anamorphically mirroring ordinary human culture in a way that destroys any naturalized idea of the normal. The horrible and beautiful are the same under the skin, as it were; each concept dialectically producing its opposite, and charging that opposite with something of its opposite significance.

This association of beauty and fear continued in the quietly influential work of Val Lewton, an RKO producer in the 1940s who was given carte blanche to devise terror films to serve as the "B" film on double bills. Made very cheaply, with a minimum of scenic construction and a number of different directors, these films (especially Jacques Tourneur's *The Cat People*, 1942, and *I Walked with a Zombie*, 1943) still draw audiences through their elegant, economical use of light and sound to produce fear (perhaps the most effective attack in *The Cat People* occurs at night in an indoor swimming pool, where the intended victim, desperately treading water in the middle of the pool, panics at the sinister

noises and reflected shadows around her). Though films like *The Cat People* were commercially minor, Lewton's work was very much in the spirit of the burgeoning *film noir*. Linked closely in visual style to the UFA films of the 20s (again, the creators of *noir* were disproportionately German exiles, including the directors Rudolph Maté (*The Dark Past,* 1948), Robert Siodmak (*The Killers,* 1946), Edgar G. Ulmer (*Detour,* 1945), the cinematographers Karl Freund and John Alton, and the composer Franz Waxman), these films were distinguished by their pervasive cynicism and much greater anxiety over gender, often represented through the complementary figures of the spider woman and her impotent and deluded consort. No longer localized in the figure of the overreaching scientist or the monster, in these films evil is distributed through the world, infecting all social relations; or it is hidden within, burbling up from the unknown recesses of the self. Visually, these films relied on unbalanced framings, shadowed or divided images of the protagonists' faces, and low-angle camera shots to produce a sense of entrapment and sexual malaise.

While the 1950s marked a resurgence in the popularity of horror film (this was the decade in which the term "horror film" first came into common usage) most broke little new ground. One major exception was the ubiquitous invasion film (as in: *Invaders from Mars,* 1954, W. C. Menzies; *Invasion of the Body Snatchers,* 1956, Don Siegel; *Invasion of the Brain Eaters,* 1958) in which bodies, families, even the earth itself were penetrated by alien forces intent on subverting the hero's masculine authority over his family, his democratic politics, or the entire

Alfred Hitchcock
Psycho, USA 1960

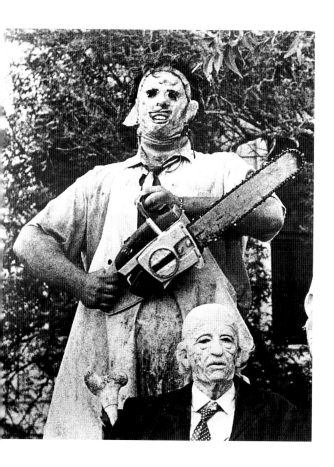

Tobe Hooper
The Texas Chainsaw Massacre, USA
1974

human species. The most interesting subversion, though, was the aesthetic one represented by Alfred Hitchcock's *Psycho* (1960), an exercise in audience manipulation in which Hitchcock sacrificed the visual elegance, large budgets, and star power of his preceding films to lay bare the rude dynamics of audience desire. The effects of *Psycho* have been widely felt, not least in proliferating tits-and-gore films in which sexually experienced (and therefore threatening) women first disrobe, and are then dismembered and murdered for their aggression. (See the publicity still used for Herschell Gordon Lewis' *Blood Feast,* 1963, in which a former Playboy model reclines dead in a bathtub, perfect except for her severed leg, thereby compressing the central narrative of *Psycho* into a single image). Such films were remarkably indifferent to technical merit: throughout the 1960s an increasing number of filmmakers prospered thorough ineptly violent films that betrayed almost no cinematic self-consciousness.

By the early 1970s this changed, as a number of talented young filmmakers made their mark in slasher films; these included Tobe Hooper (*The Texas*

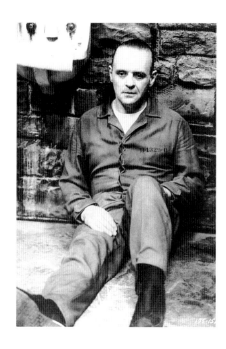

Anthony Hopkins in Jonathan Demme's
The Silence of the Lambs, USA 1990

Chainsaw Massacre, 1973); John Carpenter (*Halloween,* 1978); and Wes Craven (*Last House on the Left,* 1972), who, like Herschell Gordon, was a former English professor. The attractions of the slasher were both practical and aesthetic: not only did the cheapness of the genre make it easier to break into film-making, but in its assault on the audience, the slasher lent itself to self-conscious investigation of the nature of cinematic desire. As Carol Clover writes, Hitchcock "explicitly located thrill in the equation victim = audience. So we judge from his marginal jottings in the shooting instructions for the shower scene in *Psycho:* 'The slashing. An impression of a knife slashing, as if tearing at the very screen, ripping the film.' Not just the body of Marion is to be ruptured, but also the body on the other side of the film and screen: our witnessing body.... Hitchcock's 'torture the women' then means, simply, torture the audience."[2] Given the enormous profit margins on many of these films (*Halloween* cost less than $500,000 to make, and grossed over fifty million dollars), their directors were quickly put in charge of more expensive studio productions, many of them sequels. As audiences grew used to more explicit depictions of sex and violence, the slasher morphed with more socially reputable genres: science fiction (*Alien,* 1979, Ridley Scott); the thriller/black comedy (*Body Double,* 1984, Brian de Palma), even the highbrow slasher (*The Silence of the Lambs,* 1991, Jonathan Demme), for which Jody Foster won the

Academy Award for Best Actress, an event that would have been unthinkable thirty years earlier.

Although the production of slasher films has sharply tapered off in the last five years, their interpretation has now become an academic cottage industry, with critics arguing the sexual politics of films like *Silence of the Lambs* (is Buffalo Bill a homophobic stereotype? Is Hannibal Lecter actually a figure for the infant's sense of the omnipotent, all-devouring Mother?) in dozens of journal articles, conference papers, and books. For many feminist critics, the films provide evidence of male hysteria over independent female sexuality, and in particular, over the threat of castration provoked by the sight of the woman's body. As Linda Williams argues, women are punished in horror films not in only the violence performed upon them, but through their paralyzing recognition of their castrating similarity to the monster. As a consequence, although the horror film "permits the expression of women's sexual potency and desire, and associates this desire with the autonomous act of looking," it does so "only to punish her for this very act, only to demonstrate how monstrous female desire can be."[3]

Recently, critics like Clover have looked more closely at the cinematic address of the slasher. Without denying the "spectacular nastiness" of many of these films, she shows that slasher audiences have a much more mobile identification than critics have guessed, one capable of shifting from monster to victim to what Clover calls the Final Girl: the clever, curious, resourceful figure who will

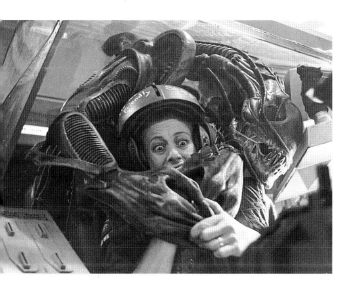

Sigourney Weaver in James Cameron's
Aliens, USA 1985

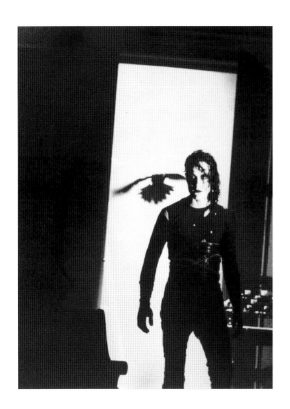

Brandon Lee in Alex Proyas'
The Crow, USA 1994

resist and eventually defeat the film's devouring monster. Such characters—androgynously named Stevie, Laurie, Joey, Max, or Ripley—are presexual, and stand in for the largely adolescent male audience undergoing the throes of sexual maturation. Far from identifying solely with the killers, such viewers are pitted in a struggle, "at once terrifying and attractive, with the parental Other. It is a rare [slasher film] that does not directly thematize parent-child relations."[4]

In the last fifteen years, American culture has been strongly marked by the return of the Gothic, manifested not only in literature and art, but in a fascinated, fetishized experimentation with the body's surfaces and depths. With the simultaneous tendency towards *noirish* stylization, evident in *The Crow* and the *Batman* films, horror films have in some ways returned to their Expressionist roots, even as these roots have spread into the culture at large. The designs of H. R. Giger (in *Alien, Species,* and elsewhere) have not only influenced the general look of 80s monsters (at once insect-like, intestinal, and technological), but have permeated popular culture, shaping the appearance of Gothic music, S&M iconography, and pornography. Even horror films uninfluenced by German Expressionism share an interest in decor, theatricality, and a

certain instability of tone, as horror threatens to tip over into comedy (*An American Werewolf in London,* 1981, John Landis), or erupts out of what seems to have been a different genre altogether (*From Dusk Till Dawn,* 1996, Richard Rodriguez).

Such generic blurring leads to a question: if horror is in some way an encounter with the things that terrify, how is it also a source of pleasure? How is exhilaration produced out of sensations of dread and constraint? Aristotle's notion of catharsis would be useful here, as would the psychoanalysis of sadism. But the answer I wish to emphasize, partial though it is, is that horror works to reactivate the viewer's somatic consciousness. The root of *horror* is a Latin word that means "to bristle," or "to shiver." Like thrillers, action films, and pornography, the horror film works to affirm our corporeal being by making the body respond symptomatically to what it sees. In truth, the horror film isn't a well-defined genre at all, but is rather a mode of filmmaking and a collection of scenarios

Dennis Hopper and Isabella Rossellini in David
Lynch's *Blue Velvet,* USA 1986

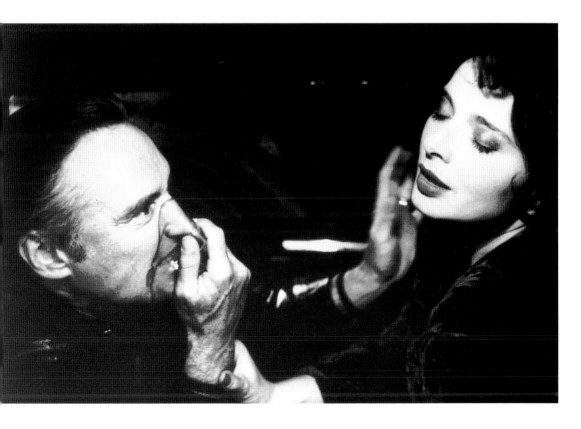

meant to stimulate reactions of bodily violation, paranoid alertness, and adrenaline rush.

This may be why the horror film has so little to do with the genuine terrors of this century. Certainly, we have no shortage of images documenting technologized battle and its effects, concentration camps, or catastrophic suffering. Yet with few exceptions (the *Faces of Death* video compilations, for example, or Dusan Makavejev's remarkable *WR: Mysteries of the Organism,* 1971), which combines footage from Nazi pro-euthanasia films, Stalin propaganda movies, and staged footage to investigate the ties between fascism, violence, and sexual repression), this is not the territory of the horror film, which prefers its sources of trauma to be intimate and familial. The best model here may be the creepy scenes between Isabella Rosellini and Dennis Hopper in *Blue Velvet* (1986, David Lynch), where Hopper's Frank Booth oscillates between misogynistic sadism (striking Dorothy, as he orders her: "Don't you fucking look at me") and a collapse into maternal fetishism, nuzzling the fabric of Dorothy's dress and crying out "Fuck me, Mommy.... Baby wants to fuck." Secretly watching from the closet, Kyle MacLachlan's Jeffrey represents the viewer, who, though apparently safe, will eventually be required by the movie to inhabit all three positions of father, mother, and child in this ruthless family romance.

Horror is thus an *erotic* fear, in both constructions of that phrase. This eros is closely related to its epistemic theatricality, its now-you-see-me, now-you-don't quality which requires viewers to find pleasure in shifting between identification and amusement, between sympathetic abjection and a connoisseurs' appreciation for the technical production of fear. This, too, is part of the legacy of Hitchcock, who sounded a note in *Psycho* ("Mother! Oh, God! Mother, mother! Blood! Blood!") that was at once jokey and terribly knowing of the audience's secret fears. Hence, while it is certainly possible to develop interesting political readings of the different forms of horror (subversion of gender roles and sexual identity in the 80s), its taproot is finally the inescapable condition of human embodiment. Like Cindy Sherman's photographs of grossly exaggerated genital sculptures, the horror film brings home to us the body's vulnerability and hunger. Dracula, Norman Bates, even Hannibal Lecter, win our sympathy less through the pleasures of sadistic projection than through their mirroring of the audience: we too are monsters, cannibals, *disjecta membra* bound for death.

One can see our divided relation to horror films clearly in the conclusion of *The Bride of Frankenstein*, when, rejected by his mate, and betrayed by his creator, the monster decides to repudiate his unmet human desires, and to turn toward the comfort of the grave. Reaching for the lever which controls the laboratory's

electricity, however, he pauses: "Go," he says to Henry Frankenstein and his fiancée, separating them from himself, Dr. Pretorious, and his would-be bride. "You live. We stay. We belong dead." The film then cuts from a close-up on his splayed hand over the lever to the bride, hissing like a cat in ecstatic anticipation; then back to the monster, a tear rolling down his cheek, just before the castle explodes in a gush of electrical sparks. We are both Henry Frankenstein, fleeing from the film back to life, and the monster's bride, galvanized by the prospect of imminent extinction. Though we would turn away from the terrible spectacle, we cannot: we are the terrible spectacle. At such moments, in which our hearts race and palms sweat, our bodies become the somatic theater in which the horror is brought to climax. We awaken from transcendental dreams, shivering, to our lives.

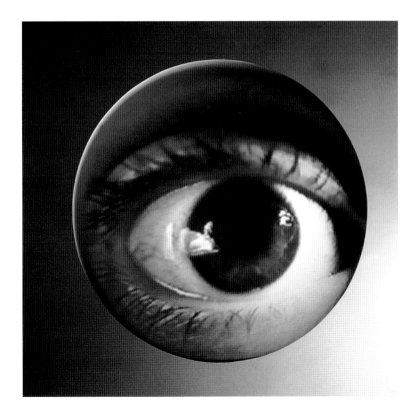

Tony Oursler

Who's, 1996
Performance: Linda Bennett
Video projection system, acrylic on fiber-
glass sphere
Courtesy of the Artist and Metro
Pictures, New York

An Inconsolable Darkness

*The Reappearance and Redefinition of Gothic in
Contemporary Cinema*

JOHN GIANVITO

In his book, *Century's End: A Cultural History of the Fin de Siècle from the
990s through the 1990s*, author Hillel Schwartz remarks that the ending of
every century posits itself as "the last gasp, the critical moment, the overture to
a new age," fraught with presentiments of doom or renewal which go essen-
tially unrealized. As a consequence, there has historically been an accumulative
buildup of unfulfilled prophecies, fears and hopes toward successive centuries'
ends. With the close of the millennium now at our doorstep, and having
observed that Western society has "been preparing for the end of our century
further in advance than people in any other century," Schwartz anticipates that
"those Manichaean tensions common to the *fin de siècle* experience will be
exaggerated in the 1990s."[1] The resurgence of the Gothic in literature, art, fash-
ion, music and film, may, to some observers, be one of the signs.

> The strength of the vampire is that people will not believe in him.
>
> —Dr. Van Helsing in *Dracula*

> Evil's single biggest advantage is that people simply can't believe it.
>
> —Winston Churchill

The allure of the Gothic genre, at least in its traditional manifestations, extends beyond fascination with the so-called dark side, the "other" side, of human nature and of reality's appearance. The contemporary popularization of Gothic found in the likes of romantic fiction, commercial horror film, or heavy metal music, represents, by and large, little more than Gothic posturing, draping itself in the surface trappings of the genre in a kind of "Gothic chic" but devoid of the elements that initially inspired and continue to comprise the heart of Gothic experience.

In the archetypal Gothic work, the pull is toward (this beautiful expression) the "inspiring of dread." It is a venturing into a world "created by the circle of... [the protagonist's] own fears and desires, in a state of enthrallment, both thrilling and destructive...."[2] Whether set in a haunted castle or a haunted imagination (and, more often than not, the dividing line is indistinct), the Gothic experience is about stepping into darkness, into that which is forbidden, repressed. This attraction, which has been well chronicled and analyzed, is not that superficial one we all recognize as the excitement of a good fun-house fright (while such elements may be part of the experience) but resides in a deeper desire to give a shape, a face, to one's greatest fears and thus gain some control over them. For nineteenth-century readers, as author William Patrick Day suggests, the key function of the Gothic fantasy was to give expression to readers' "fears and anxieties about their fragility and vulnerability," the source of which was felt to be "in the failure of religious, scientific and philosophical systems to create a sense of wholeness and unity in self and in the world, which would have allowed individuals to define their own existence." Thus the immersion in the Gothic according to Day, "turned the anxiety and fear in that cultural gap into pleasure, articulating and diffusing the anxiety and fear that called it into existence."[3] Now, precisely two hundred years since the Gothic novel attained the peak of its popularity, evidence of a renewed fascination with the depiction of vampires, the undead, the possessed, and the diseased, with incarnations of evil and madness, all points to a revival of a Gothic sensibility which, while frequently more complex in its makeup than its historical antecedents, often aspires to a similar goal of reclaiming some kind of control over that which frightens most. For contemporary German filmmaker Fred

Kelemen, whose 1994 film *Fate* (Verhängnis) stands as a haunting example of redefined Gothic sensibility, the root connections to antiquity run ever deeper:

> ...in the ancient caves of Lascaux, France, for example, the first reason for mankind to make pictures was to "bannen," to fix it, to bring out, to capture the demons, because when you name them, they'll lose their power. That was the first reason people started to paint.... I think that is a lot like film, because cinema is like a modern cave, people come together—that's why the darkness is so important—and you have the screen like a wall in the old caves. And the aim is to put a spell on the demons. To exorcise, if you want. But we have other demons today, because our civilization is different from old cultures.[4]

And yet while the intentions may be similar, what has been supplanted in contemporary manifestations of the Gothic is the requirement to be transported, either geographically, as across some mountainous divide in Transylvanian mists, or psychologically, via the descent into the imagination of a neurotic sensibility. Replacing these genre traditions at the close of the twentieth century is reality itself. In *Fate,* Eastern Europe is witnessed as a despairing nightscape in which each individual is now left to fend for him or herself, each capable of devouring or being devoured at a moment's notice. Spanning the time period of a single evening, *Fate*'s depiction of displaced individuals, weighted down by poverty, isolation, and agonizing pain, of lives torn asunder by murder and rape amidst a seemingly lawless "Wild East," offers hope only in so far as its characters survive the night, a "fate" they might just as well wish to relinquish.

In Derek Jarman's elegiac *The Last of England* (1987), the once "majestic" British empire is revealed to be a withered ruin of burnt out flats, garbage heaps, and blighted industrial wastelands. Openly implicating himself in the predicament of his country, Jarman interweaves into the mix of images, home movies of a privileged and carefree childhood, contrasting them with a funereal present full of rampant unemployment, terrorist assaults, and post-Falklands preening. In voiceover, Jarman speaks of his own generation, a generation of failed protests, of party goers and drug consumers, lost in a landscape in which "tomorrow has been canceled due to lack of interest." It is a portrayal of an England haunted by the specter of its bloodied past and equally bloody present (Jarman's father having been an RAF commander, the links continue to straddle both the public and personal spheres). Employing a distinctive display of rapid-fire montage (both aural and visual), Jarman achieves in *The Last of England* through non-traditional means a traditional Gothic sense of unease and disturbance out of the sights and sounds of Thatcher-era Britain.

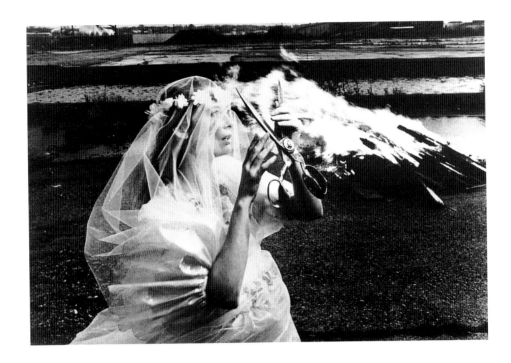

Derek Jarman
The Last of England, Great Britain 1987

Possibly even more unnerving by dint of its commonness, ubiquity, and virtual invisibility, is the menace that infects Todd Haynes' *Safe* (1995). The story of an affluent San Fernando Valley "homemaker" who progressively discovers herself "allergic to the 20th century," *Safe* is the contemporary horror film par excellence. Shot in a cool, distanced style, *Safe* is a work that successfully provokes a myriad of discomforts. Initially, it is the sheer revulsion produced by immersing us in the vapid lifestyle of Carol and Greg White, ensconced within a household where every room is picture-perfect and utterly divested of signs of being lived in. It is a white upper-class enclave with its own private security and Hispanic housekeepers to polish the silver, where neighbors all know one another, carpool their children, and the only fear is that of black street gangs invading from Los Angeles. The dream is of an utterly controlled haven, safe from any disruption or alien influence. That is, until Carol begins to get sick. Bit by bit, Carol starts to tire, then wheeze, cough, vomit and bleed as her immune system begins to break down under the weight of the sixty thousand chemicals that are now estimated to be part of the fabric of our everyday lives. Retreating to the further isolation of a New Mexico New Age health center, Carol falls further victim, this time to the insidious brainwashing of the center's guru-like director. Ultimately, in yearning for protection from both the real and imagined dangers of this world, Carol fails to secure for herself an identity of her own, one which is strong enough to find its own way. Sequences such as when Carol

collapses in convulsions as she accidentally enters a cleaner's while they're fumigating, or the final scene depicting Carol isolated in her tiny womb-like residence, her skin blotched and pallid, clinging to her oxygen tank, generate a disquiet in the viewer as anxiety-producing as the sight of any Halloween ghoul, and, I would argue, more so. What makes *Safe* finally so harrowing is the result both of Haynes' unsentimental, detailed, and convincing direction of the material (not to mention a standout performance by Julianne Moore) and the fact that *the evil* that lurks in the film is of the everyday variety from which no one in the audience is immune. The degree of chemical infiltration of our society is by now so vast and so systemic that it would be nearly impossible to detect, let alone isolate, all the potentially hazardous agents that envelop our lives.

With the replacing of imagined evils with contemporary societal ills it should be intriguing to see just where this trend may lead. One thing I've long found curious about the public's fascination/flirtation with experiences of fear and terror are the unspoken limits beyond which it is considered taboo to venture. While Hollywood gore-merchants continue striving for more extreme ways to shock their audiences (partly the result of their own self-produced desensitization), a true image of horror—the sight of a severely malnourished child, the detailed image of a mass grave being exhumed in Bosnia or Panama, an authentic depiction of torture—would be beyond the pale. People want to be made uncomfortable, but not that uncomfortable. Ironically, when an equally perverse fascination comes along that does desire images of genuine suffering and horror, this too is similarly forbidden, as with the popularity in the mid-1980s of the *Faces of Death* video series which was soon forcibly removed from distribution.

Todd Haynes
Safe, USA 1995

Yevgeni Yufit
Daddy, Father Frost Is Dead, Russia
1991
Courtesy of the Artist

Redefining Gothic in an idiosyncratic blend of absurdist satire, morbidity, and gallows humor is the self-proclaimed "Necrorealist" movement launched in the 1980s in and around Saint Petersburg, Russia. A collective movement comprised of painters, photographers, sculptors, and filmmakers, Necrorealism's founder and chief engineer is artist Yevgeni Yufit. In films such as *Daddy, Father Frost Is Dead* (1991) and *The Wooden Room* (1995), Yufit portrays the detritus of a decaying social order, a world in which nothing functions any longer as it once did, in which there are people still clinging fiercely to tasks whose meaning and value have long since been lost and for whom brutal self-survival or suicide seem the only available options. In fact, in Necrorealism, the division between the living and the dead is effectively indistinguishable; virtually everyone has the countenance of a George Romero zombie. Photographed in a sepulchral black-and-white gloom, in feel somewhere between *The Night of the Living Dead* and Dreyer's *Vampyr* (the one film, incidentally, Yufit requested to see on a recent visit to the Harvard Film Archive), both films are essentially wordless, possessed by the logic of dreams more than of narrative design, and leavened only by a kind of Beckettian drollery as when, in *The Wooden Room,* the lead character attempts to kill himself by tying a noose around his neck, fastening it to his dog's collar, and throwing stones, hoping to be yanked into the hereafter.

JOHN GIANVITO

Whether read as satire on the ailing conditions of life within post-cold war, post-Soviet, Russian society or as evocations of a more universal modern-day *malaise*, Yufit's films refuse easy reception. Fraught with inexplicable behavior, desolate, disorienting geography, and willfully leaden performances, his films leave one never sure just what the appropriate stance is to take in a world gone mad—thus, as it should be. The overall impression is as if listening to a joke poorly translated and seemingly in bad taste, told as if to prevent its teller from being consumed by grief. One of the only images even suggesting a vestigial hope is that of a tiny bell dug out of the ground, rung in private ritual, and carefully covered over again in earth.

The portrayal of a directionless society, adrift in a fever dream from which there is no waking nor any hindrance to the rampages of manifest evil is not uncommon in late-twentieth century cinema. It is in essence the image to be found in the work of other contemporary Russian filmmakers such as Viktor Aristov's *Satan* (1991) and the neglected *Patience Is a Virtue* (1989), or in the spectral visions of Aleksander Sokhurov's masterpiece *Whispering Pages* (1993). It is the worldview evinced in Lars von Trier's *The Element of Crime* (1984), set among the ruins of a post-nuclear Europe (von Trier having remarked that all his early films were made under the philosophy "Evil Exists"), as well as in the over-the-top histrionics of Polish director Andrzej Zulawski's *Possession* (1981), a movie in which the very filmmaking itself seems as possessed as anyone, and everyone, on screen. Closer to home, one can find beneath the darkly comic excesses of Gregg Araki's *The Doom Generation* (1995) the genuine expression of a very real desire to locate meaning in the tumult of the everyday, to find purpose in a world gone haywire, where every man, woman, and child must make their way, without compass or law.

Amidst this spectrum of baleful visions surveying the waning not only of a century but of the natural world, and the bruising of the human spirit within that world, there is one work that, in aspiring to sound a threnody for our times, realizes artistically the measure of its ambition.

Throughout the 1970s and early 1980s, German filmmaker Hans-Jürgen Syberberg attained international renown for a series of films, often epic in scale, seeking to examine the state of the contemporary German psyche and the state of Western civilization in general. Via a series of highly stylized, extremely literate and yet deeply musical films, including *Ludwig, Requiem For A Virgin King* (1972), *Karl May* (1974), *Our Hitler* (1977), and *Parsifal* (1982), Syberberg meditates on the erosion of high culture in the onslaught of both fascism and capitalism, the loss of positive relationship to myth, and the need to confront buried

Edith Clever in Hans-Jürgen Syberberg's
The Night, West Germany 1985

history if nations are ever to understand themselves, heal, and move forward. Describing the trajectory of this cinematic enterprise as a *"Trauerarbeit,"* a monumental "work of mourning," Syberberg's films throughout this period are characterized by their use of artifice and spectacle, the regular employment of rear-screen projections, and fantastical stages full of puppets, miniatures, and talismans.

In 1985, Syberberg brought forth a work that was at one and the same time a reduction and an expansion of his cinematic project. In *The Night* (Die Nacht), Syberberg strips himself of most of the stylistic hallmarks by which he was recognized and instead focuses his whole, undivided, and loving attention on a single woman alone in a dark void, addressing us and the darkness for six hours straight. In Syberberg's words, *The Night* is nothing less than "a swan song for Europe, in the tradition of the Night Meditations," a monologue accompanied by Bach's "Well-Tempered Clavier," incorporating texts from Plato, Goethe, Hölderlin, Novalis, Wagner, Beckett, Nietzsche, and others.[5] There are Syberberg's own pastoral reminiscences of a childhood in Pomerania before its scorching in World War II, and a report on the dying of Europe's forests from pollution. In a half-hour prologue (the only color sequence in the film and the only one with natural light), the woman delivers Suquamish Indian Chief Seattle's famous 1855 speech addressed to the U.S. government upon the surrendering of the land. It is, again in Syberberg's words, "The thor-

oughly ridiculous attempt in this plastic age, the whole, everything together again, everything in one."[6] Like venturing into the deepest wood to hear the oracle, one voyages through the expanses of this hymn to the night buoyed by an incomparable, wholly entrancing performance by actress Edith Clever (Kundry in *Parsifal*, and the creative locus of five subsequent monologue works performed with Syberberg since *The Night*). We are in a space without definition, without time, and the world, falling to rack and ruin (witnessed metonymically, during the film's prologue, in the dilapidated, graffiti-sprayed interiors of the former Danish Embassy in Berlin), remains off-screen. The tone is resolute and unambiguous—night has descended upon us and death is on the horizon. And yet, unlike the telling, say, of Poe's "A Descent into the Maelstrom," it is not a plunge into terror that is summoned forth but rather we enter into an unusual, nearly indelible, calm. As Clever address us, enshrouded within this Cimmerian netherworld, the tragic dimensions of this vision, the sense of impending doom, while always threatening to overwhelm the scene, are, for the moment, in suspension. As the light falls and rises in infinite, subtle display, and wisps of smoke drift in and out of the darkness, Clever maintains her spot upon a small,

Aleksander Sokhurov
Whispering Pages, Russia/Germany 1994
Courtesy North Foundation/Zero Film/
Eugene Taran

Isabelle Adjani in Andrzej Zulawski's
Possession, France/West Germany, 1981
Courtesy Harvard Film Archive, Cambridge

raked mound of sand, offering us a recitation before sleep.

What Syberberg has performed with *The Night* is a kind of Gothic inversion. The film assumes an audience duly aware of the horrors and villainies of the twentieth century and thus, by and large, keeps the weight of this awareness in abeyance, subjugating it to the shadows. As long as there is art, and memory of art, and the passion to resurrect it, evoked simply through the power and wonder of one human being performing (crucially placed in the feminine), then this night cannot only be endured but perhaps redeemed. It is rare to find works willing to risk such gestures.

With the drawing to a close of the 1990s now at hand, the signposts marking the degeneration of the value of what has been classified as Western civilization are abundant and easy to read: the dominant and virtually unfettered concentration of power and capital in multinational corporations, the literally daily extinction of animal and insect species, shifts in climate, the devaluation of learning, the numbing/dumbing of society through insipid pop culture, increased nationalism, increased xenophobia, and so on. Earlier in this century, indications of

this collapse were already amply apparent to another German writer, philosopher Oswald Spengler. In his book *The Decline of the West* (1923), Spengler outlines the movement of history as an organic cycle of birth, growth, decay, and death of subsequent civilizations. As such, Spengler proclaimed the West to be nearing its final phase of existence. Despite the initial strong embrace of the work, over the years *The Decline of the West* has met its own decline, largely disappearing from view, having been vilified over the years by many critics for, among other reasons, its perceived pessimism, fatalism, and defeatism. In a recent reappraisal of Spengler's work, however, critic Adda Bozeman argues that "contrary to numerous respected theorists and historians in the Occident, who accentuate the themes of evolution in their work and who are programmatically 'upbeat' in conjecturing the future in terms of progress, Spengler was convinced that the full measure of life can be discovered only when decline and decay are perceived and assessed as clearly as beginning and becoming. It is this dual focus that seems to have irritated many of his detractors, causing them to charge Spengler with the social sin of pessimism."[7] Much the same might be said for those detractors of contemporary Gothic who minimize the crepuscular visions of such artists as little more than unproductive and depressive doomsaying.

"If the world has not approached its end," writes Aleksander Solzhenitsyn, "it has reached a major watershed in history, equal in history to the turn from the Middle Ages to the Renaissance. It will demand from us a spiritual blaze.... This ascension is similar to climbing onto the next anthropological stage. No one on earth has any other way left but—upward."[8] A stirring sentiment indeed. But, for those artists still burning from sight of the here and now, artists who have not ceased struggling to prevent being swallowed up in impenetrable darkness nor convinced themselves that there could be no merit in crying out in the night, there is no solace to be found. For such individuals as these, I extend the sole comfort of a phrase recollected from Spengler: "In the presence of fire, man never feels alone. The flames keep him company."[9]

Jeanne Silverthorne

Untitled (detail), 1994
Rubber and resin
Courtesy McKee Gallery, New York

Reflections on the Grotesque

JOYCE CAROL OATES

What is the "grotesque"—and what is "horror"—in art? And why do these seemingly repellent states of mind possess, for some, an abiding attraction?

I take as the most profound mystery of our human experience the fact that, though we each exist subjectively, and know the world only through the prism of self, this "subjectivity" is inaccessible, thus unreal, and mysterious, to *others*. And the obverse—all *others* are, in the deepest sense, *strangers.*

The arts of the grotesque are so various as to resist definition. Here we have the plenitude of the imagination itself. From the Anglo-Saxon saga of Grendel's mon-ster-mother, in *Beowulf,* to impish-ugly gargoyles carved on cathedral walls; from terrifyingly matter-of-fact scenes of carnage in the *Iliad*, to the hallucinatory vividness of the "remarkable piece of apparatus" of Franz Kafka's "In the Penal Colony;" from the comic-nightmare images of Hieronymus Bosch to the strategic artfulness of twentieth-century film—Werner Herzog's 1979 remake of the 1922 classic of the German silent screen, F. W. Murnau's *Nosferatu the Vampyr,* to give but one example. The "grotesque" is a sensibility that accommodates the

genius of Goya and the kitsch-Surrealism of Dali; the crude visceral power of H. P. Lovecraft and the baroque elegance of Isak Dinesen; the fatalistic simplicity of Grimm's fairy tales and the complexity of vision of which, for instance, William Faulkner's "A Rose for Emily" is a supreme example—the grotesque image as historical commentary.

The protracted onstage torture of Shakespeare's Gloucester in *King Lear* is the very height of the theatrical grotesque, but so is, in less graphic terms, the fate of Samuel Beckett's hapless heroes and heroines—the female mouth of *Mouth,* for instance. From Nikolay Gogol's "The Nose" to Paul Bowles' "A Distant Episode," from images of demonic flesh of Max Klinger, Edvard Munch, Gustav Klimt and Egon Schiele to Francis Bacon, Eric Fischl, Robert Gober; from Jeremias Gotthelf ("The Black Spider," 1842) to postmodern fantasists Angela Carter, Thomas Ligotti, Clive Barker, Lisa Tuttle and mainstream best-sellers Stephen King, Peter Straub, Anne Rice—we recognize the bold strokes of the grotesque, however widely styles vary. (Is a ghost story inevitably of the genre of the grotesque?—no. Victorian ghost stories, on the whole, are too "nice"—too ladylike, whatever the sex of the writer. Much of Henry James' ghostly fiction, like that of his contemporaries Edith Wharton and Gertrude Atherton, though elegantly written, is too genteel to qualify.) The grotesque is the hideous animal-men of H. G. Wells' *The Island of Dr. Moreau*, or the taboo-images of the most inspired filmmaker of the grotesque of our time, David Cronenberg (*The Fly, The Brood, Dead Ringers, Naked Lunch*)—that is, the grotesque always possesses a blunt *physicality* that no amount of epistemological exegesis can exorcise. One might define it, in fact, as the very antithesis of "nice."

It was in 1840 that Edgar Allan Poe, our greatest, and most beleaguered, artist of the grotesque published *Tales of the Grotesque and Arabesque,* containing works that would become classics—"The Fall of the House of Usher," "The Tell-Tale Heart," "The Pit and the Pendulum," "The Mask of the Red Death," "The Cask of Amontillado." At this time there existed a rich, diverse literature to which the architectural term "Gothic" had been applied. Poe was well aware of this literature: Horace Walpole's *The Castle of Otranto: A Gothic Tale* (1764), Richard Cumberland's *The Poisoner of Montremos* (1791), Ann Radcliffe's masterpiece *The Mysteries of Udolpho* (1794) and *The Italian* (1797), M. G. Lewis' *The Monk* (1796), Mary Shelley's *Frankenstein* (1818), C. R. Maturin's *Melmoth the Wanderer* (1820); the uncanny fables of E.T.A. Hoffmann, of which "The Sand-Man" (1817) is most Poe-like; and the tales of Poe's fellow Americans Washington Irving (whose affable prose style masks the grotesqueries of "Rip Van Winkle," "The Legend of Sleepy Hollow") and Nathaniel Hawthorne. And there was Charles Brockden Brown's *Wieland* (1798), our premier American-

Gothic novel. In turn, Poe's influence upon the literature of the grotesque—and the mystery-detective genre—has been so universal as to be incalculable. Who has *not* been influenced by Poe?—however obliquely, indirectly; however the influence, absorbed in adolescence or even in childhood, would seem to be far behind us.

This predilection for art that promises we will be frightened by it, shaken by it, at times repulsed by it, seems to be as deeply imprinted in the human psyche as the counter-impulse toward daylight, rationality, scientific skepticism, truth and the "real." (Leaving aside for the moment whether rationality is in fact in contact with the "real.") Are Aubrey Beardsley's sly-sinister hermaphrodite figures less "real" than the commissioned portraits of James McNeill Whistler? A sensibility that would find intolerable the lurid excesses of Sheridan Le Fanu's *Carmilla* (1871) or Bram Stoker's *Dracula* (1897) might respond with much feeling to vampire tales cast in a more "literary" mode, like Henry James' *The Turn of the Screw,* and such Symbolist-"realist" works by Thomas Mann as *Death in Venice,* "Mario the Magician," "Tristan" ("...while the child, Anton Kloterjahn, a magnificent specimen of a baby, seized on his place in life with prodigious energy and ruthlessness, a low, unobservable fever seemed to waste the young mother daily."). Of all monstrous creatures it has been the vampire that by tradition both attracts and repels, for vampires have nearly always been portrayed as aesthetically (that is, erotically) appealing. (Peter Quint is the hinge, redhaired, wearing no hat, "very erect," upon which James' *The Turn of the Screw* turns—unless he is the screw itself.) And this is the forbidden truth, the unspeakable taboo—that evil is not always repellent but frequently attractive; that is has the power to make of us not simply victims, as nature and accident do, but active accomplices.

Children are particularly susceptible to images of the grotesque, for children are learning to monitor what is "real" and what is "not real;" what is benign, and what not. The mental experiences of very young children, afterward layered over by time and forgotten, must be a kaleidoscope of sensations, impressions, events, "images" linked with "meanings"—how to make sense of this blooming, buzzing universe? The earliest and most horrific image of my childhood, as deeply embedded in my consciousness as any "real" event (and I lived on a small farm, where the slaughtering of chickens must have been frequent) sprang at me out of a seemingly benign children's book, Lewis Carroll's *Alice's Adventures Through the Looking-Glass.* In the concluding chapter of this generally disturbing book Alice is being crowned Queen at a banquet that begins with promise then rapidly degenerates into anarchy:

"Take care of yourself!" screamed the White Queen, seizing Alice's hair with both hands. "Something's going to happen!"

And then...all sorts of things happened in a moment. The candles all grew up to the ceiling... As to the bottles, they each took a pair of plates, which they hastily fitted as wings, and so, with forks for legs, went fluttering about in all directions...

At this moment Alice heard a hoarse laugh at her side, and turned to see what was the matter with the White Queen, but, instead of the Queen, there was the leg of mutton sitting in a chair. "Here I am!" cried a voice from the soup tureen, and Alice turned again, just in time to see the Queen's broad, good-natured face grinning at her for a moment over the edge of the tureen, before she disappeared into the soup.

There was not a moment to be lost. Already several of the guests were lying down in the dishes, and the soup ladle was walking up toward Alice's chair...

Alice escapes the nightmare prospect of being eaten by waking from her dream as, in her *Wonderland* adventure, she woke from that dream. But what solace, if the memory retains the unspeakable, and the unspeakable can't be reduced to a dream?

Mankind's place in the food chain—is *this* the unspeakable knowledge, the ultimate taboo, that generates the art of the grotesque?—or all art, culture, civilization?

In a more technical sense, art that presents "horror" in aesthetic terms is related to Expressionism and Surrealism in its elevation of interior (and perhaps repressed) states of the soul to exterior status. Even if we were not now, in this Age of Deconstruction, psychologically and anthropologically capable of deciphering seemingly opaque documents, whether fairy tales, legends, works of art or putatively objective histories and scientific reports, we should sense immediately, in the presence of the grotesque, that it is both "real" and "unreal" simultaneoulsy, as states of mind are real enough—emotions, moods, shifting obsessions, beliefs—though immeasurable. The subjectivity that is the essence of the human is also the mystery that divides us irrevocably from one another.

One criterion for horror fiction is that we are compelled to read it swiftly, with a rising sense of dread, and so total a suspension of ordinary skepticism, we inhabit the material without question and virtually as its protagonist; we can see no way out except to go forward. Like fairy tales, the art of the grotesque and horror renders us children again, evoking something primal in the soul. The

outward aspects of horror are variable, multiple, infinite—the inner, inaccessible. What the vision is we might guess, but, inhabiting a brightly populated, sociable, intensely engaging outer world, in which we are defined to one another as social beings with names, professions, roles, public identities, and in which, most of the time, we believe ourselves *at home*—isn't it wisest not to?

First published in Joyce Carol Oates, *Haunted: Tales of the Grotesque*. New York: Dutton, 1994, pp. 303-307.

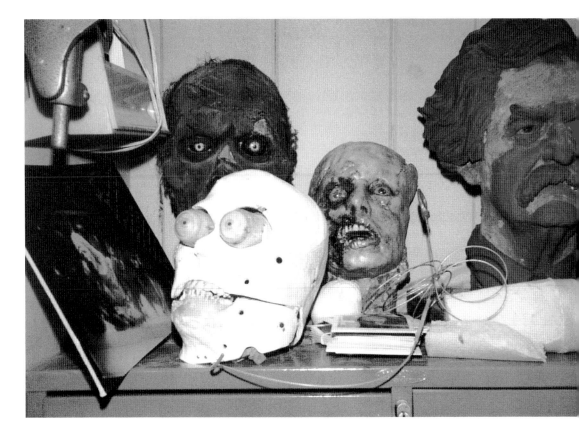

Unsolved Mysteries

1 Derek Jarman, "Black Arts," in *Chroma*. Woodstock, New York: Overlook Press, 1995, p. 139.

2 *The Complete Poetical Works of Percy Bysshe Shelley*. Ed. by George Edward Woodberry. Boston and New York: Houghton Mifflin Company, 1901, p. 370

3 Janet Maslin, "The Years' Memorable Films Paint the World in Light Hues and Dark," *New York Times*, (December 30, 1996), p. C12.

4 Mark Edmundson, "American Gothic," *Civilization: The Magazine of the Library of Congress*, 3 (May/June 1996), p. 48.

5 Judy Halberstam, *Skin Shows: Gothic Horror and the Technology of Monsters*. Durham, North Carolina and London: Duke University Press, 1995, pp. 102-105; Jim Bessman, "Capitol's Melvin Van Peebles issues first album in 20 years," *Billboard*, 107 (March 4, 1995), p. 8; *Time* (April 3, 1995), p. 79; Henry Southworth Allen, *Going Too Far Enough: American Culture at Century's End*. Washington and London: Smithsonian Institution Press, 1994, p. 107; James Wolcott, "Too Much Pulp," *New Yorker*, 72 (January 6, 1997), p. 76; Douglas Martin, "Step Right Up to the Cyberhustle," *New York Times* (January 31, 1997), p. B2; Edmundson, "American Gothic," pp. 48-55; Joyce Carol Oates, "American Gothic," *New Yorker*, 71 (May 8, 1995), pp. 35-36; Justine Elias, "'American Gothic' Settles In on the Dark Side," *New York Times* (October 22, 1995), Section 2, pp. 37, 42.

6 Bradford Morrow and Patrick McGrath, "Introduction," in Bradford Morrow and Patrick McGrath (eds.), *The New Gothic*. New York: Vintage, 1991, p. xiv.

7 Avis Berman, "Antiques Notebook: Gothic Romance. New Interest in an Age-Old Style," *Architectural Digest*, 51 (December 1994), pp. 76-88.

8 Thomas Fisher, "Gothic Revival: Three Gothic Architecture Projects," *Progressive Architecture*, 76 (February 1995), p. 72.

9 Rita Roos, "Death Angels on the Catwalk," *siksi*, 11 (Autumn 1996), p. 10.

10 Wolcott, "Too Much Pulp," pp. 76, 77.

11 Suggestion of *New Yorker* columnist Hayes B. Jacobs in 1963 on how to commonly speak the year 2000. "Warning: New Century Ahead," *New Yorker*, 39 (April 27, 1963), p. 142; as recounted by Hillel Schwartz, *Century's End: A Cultural History of the Fin de Siècle from the 990s through the 1990s*. New York: Doubleday, 1990, p. 290.

12 Daniel Menaker, "End Game," *New Yorker*, 72 (February 10, 1997), p. 86.

13 "To the Ends of the Earth to Ring in 2000," *New York Times* (Sunday, December 29, 1996), Section 5, pp. 1, 8-10. John Yemma, "Countdown to Catastrophe," *Boston Sunday Globe* (December 29, 1996), pp. A1, 16-17.

14 John Updike, "Elusive Evil," *New Yorker*, 72 (July 22, 1996), p. 65.

15 Mark Seltzer, "Serial Killers (I),"*differences: A Journal of Feminist Cultural Studies*, 5 (1993), p. 97.

16 John Perry Barlow quoted in Edmundson, "American Gothic," p. 53.

17 "Agency Reports More Cases of Hair-Eating Dolls," *New York Times* (December 31, 1996), p. A14; Mireya Navarro, "A Monster On Loose? Or is it Fantasy?" *New York Times* (January 10, 1996), p. A10.

18 John Heilemann, "Leapin' Lizards," *New Yorker*, 72 (December 16, 1996), p. 48.

19 Neil Strauss, "Wal-Marts CD Standards are Changing Pop Music," *New York Times* (November 12, 1996), pp. A1, C12.

20 Richard Klein, *Cigarettes are Sublime*. Durham, North Carolina and London: Duke University Press, 1993, p. 3.

21 James Atlas, "The Fall of Fun," *New Yorker*, 72 (November 18, 1996), pp. 65, 70.

22 Mary Wilson Carpenter, "Representing Apocalypse: Sexual Politics and the Violence of Revelation," in Richard Dellamora (ed.), *Postmodern Apocalypse: Theory and Cultural Practice at the End*. Philadelphia: University of Pennsylvania Press, 1995, p. 116.

23 John Waters, Mike Kelley, "The Dirty Boys," *Grand Street* 57, 15 (Summer 1996), p. 15.

24 Rem Koolhaas, "Regrets?" *Grand Street 57*, 15 (Summer 1996), p. 138.

25 Edgar Allan Poe, "The Black Cat," in *Tales*. New York: Dodd, Mead & Company 1979, p. 658.

26 Edmundson, "American Gothic," p. 48.

27 *Grand Street 57*, 15 (Summer 1996), p. 9.

28 Updike, "Elusive Evil," p. 62.

29 Andrew Delbanco, *The Death of Satan: How Americans Have Lost the Sense of Evil*. New York: Farrar, Straus and Giroux, 1995, pp. 16-17.

30 Ibid., pp. 11, 224.

31 Updike, "Elusive Evil," p. 70.

32 Quoted in John Seabrook, "Why is the Force Still With Us?" *New Yorker*, 72 (January 6, 1997), p. 48.

33 Ibid., p. 46.

34 Michael McCoy, "Design and the New Mythology," in Susan Yelavich (ed.), *The Edge of the Millennium*. New York: Whitney Library of Design, 1993, p. 134.

35 Fred Botting, *Gothic*. London and New York: Routledge, 1996, p. 5.

36 Halberstam, *Skin Shows*, p. 106.

37 "Late twentieth-century machines have made thoroughly ambiguous the difference between natural and artificial, mind and body, self-developing and externally designed…. Our machines are disturbingly lively, and we are ourselves frightenly inert." Donna Haraway, "A Manifesto for Cyborgs: Science, Technology, and Socialist Feminism in the 1980s," in Elizabeth Weed (ed.), *Coming to Terms: Feminism, Theory, Politics*. New York: Routledge, 1989, pp. 174, 176.

38 Karl Marx, *Capital. Volume I: Der Produktionsprozess des Kapitals*. Trans. by Eden and Cedar Paul. London and New York: Everyman's Library, 1974, p. 232. For a discussion of the identification of vampires with the aristocracy, capitalist economy, and the anti-Semitic subtext of Bram Stoker's *Dracula* see Halberstam, *Skin Shows*, Chapter 4.

39 Kelly Hurley, "Reading Like an Alien: Posthuman Identity in Ridley Scott's *Alien* and David Cronenberg's *Rabid*," in Judith Halberstam and Ira Livingston (eds.), *Posthuman Bodies*. Bloomington and Indianapolis: Indiana University Press, 1995, p. 208.

40 It also provides us with an image of evil in an industrial and economic system in which "evil has become systematized. The production of it has become technologized, internationalized, multinationalized, and especially in times of war and high zealotry, officially rhapsodized." Lionel Tiger, *The Manufacture of Evil: Ethics, Evolution, and the Industrial System*. New York: Harper & Row, 1987, p. 3.

41 See Christopher P. Tourney, "The Moral Character of Mad Scientists: A Cultural Critique of Science," *Science, Technology, & Human Values*, 17 (Autumn 1992), pp. 411-437.

42 Chris Baldick, "Introduction," in Chris Baldick (ed.), *The Oxford Book of Gothic Tales*. Oxford and New York: Oxford University Press, 1992, p. xix.

43 Wolcott, "Too Much Pulp," p. 76.

44 Quoted in Brendan Hennessy, *The Gothic Novel*. Harlow, Essex: Longman, 1978, p. 10.

45 William H. Pierson, Jr., *American Buildings and Their Architects. Volume 2: Technology and the Picturesque. The Corporate and the Early Gothic Styles*. New York and Oxford: Oxford University Press, pp. 106, 107.

46 Edmund Burke, *A Philosophical Enquiry into the Origin of our Ideas of the Sublime and Beautiful*. (1757) Ed. by James T. Boulton. Oxford: Basil Blackwell, 1987, pp. 57, 72-74, 144-149.

47 Henry James, "The Turn of the Screw," in the Complete Tales of Henry James. Ed. by Leon Edel. Philadelphia and New York: J. B. Lippincott Company, 1964, vol. 10, pp. 36-37.

48 Edgar Allan Poe, "The Fall of the House of Usher," in *Tales*, pp. 158-159.

49 Anthony Vidler, "Introduction," in *The Architectural Uncanny: Essays in the Modern Unhomely*. Cambridge, Massachusetts and London: MIT Press, 1992, p. 3.

50 Sigmund Freud, "The 'Uncanny'," *The Standard Edition of the Complete Psychological Works of Sigmund Freud*. Ed.

and trans. by James Strachey. London: Hogarth Press, 1955, vol. 17, p. 245.

51 Elliot Stein quoted in R. H. W. Dillard, "*Night of the Living Dead*: It's Not Like Just a Wind That's Passing Through," in Gregory A. Waller (ed.), *American Horrors: Essays on the Modern Horror Film*. Urbana and Chicago: University of Illinois Press, 1987, p. 18.

52 Vivian Sobchack, "Bringing It All Back Home: Family Economy and Generic Exchange," in Waller (ed.), *American Horrors*, p. 178.

53 Halberstam, *Skin Shows*, p. 88.

54 Ibid., pp. 89-90.

55 Ty Batirbek, "Marilyn Manson," *Propaganda*, no. 23 (Fall 1996), p. 4.

56 "Girl Says School Violated Her Rights," *Los Angeles Times* (Valley Edition), (February 8, 1992), p. B3. Quoted in Anne Burdick, "Feeding the Monster," *Emigre*, no. 24 (1992), n.p.

57 Burdick, "Feeding the Monster," n.p.

58 Dick Hebdige, *Subculture*. London and New York: Methuen, 1979, p. 96.

59 Ted Polhemus, *Streetstyle: From Sidewalk to Catwalk*. London: Thames and Hudson, 1994, p. 97.

60 Roy Shuker, "From Bodgies to Gothics: pop culture and moral panic in New Zealand," *New Zealand Sociology*, 4 (May 1989), pp. 1-17; Frank Bruni, "Modern Bite of the Occult," *New York Times* (August 10, 1996), p. B1; Carol Lloyd, "Interview with a Vampirette," *New York Times Magazine* (February 9, 1997), p. 17.

61 Mark Blackwell, "Nine Inch Nails," *Raygun*, no. 43 (February 1997), n.p.; Batirbek, "Marilyn Manson," p. 4.

62 Name of a nightclub in the film *Strange Days*, 1995.

63 H. P. Lovecraft, "The Outsider," in Joyce Carol Oates (ed.), *American Gothic Tales*. New York: Plume, 1996, p. 179.

64 John Ruskin, "Classic and Gothic," from *The Art of England*, 1883; "The Nature of Gothic," from *Stones of Venice*, reprinted in *The Lamp of Beauty: Writings of Art by John Ruskin*. Ed. by Joan Evans. London: Phaidon, 1959, pp. 167, 230, 234.

65 Quoted in Carl E. Schorske, *Fin-de-Siècle Vienna: Politics and Culture*. New York: Vintage, 1981, p. xix.

66 Clement Greenberg, *The Collected Essays and Criticism. Volume 2: Arrogant Purpose, 1945-1949*. Ed. by John O'Brian. Chicago and London: University of Chicago Press, 1986, p. 166.

67 Clement Greenberg, *The Collected Essays and Criticism. Volume 1: Perceptions and Judgements, 1939-1944*. Ed. by John O'Brian. Chicago and London: University of Chicago Press, 1986, p. 226. This association was pointed out by Timothy J. Clark, "Jackson Pollock's Abstraction," in Serge Guilbaut (ed.), *Reconstructing Modernism: Art in New York, Paris, and Montreal 1945-1964*. Cambridge, Massachusetts and London: MIT Press, 1990, pp. 178, 185-186.

68 Peter N. Stearns, *American Cool: Constructing a Twentieth-Century Emotional Style*. New York: New York University Press, 1994. Quoted in Atlas, "The Fall of Fun," p. 68

69 David Punter, *The Literature of Terror: A History of Gothic Fictions from 1765 to the Present*. London and New York: Longman, 1996, vol. 2, pp. 183-184.

70 The term was coined by Dave Hickey in his *The Invisible Dragon: Four Essays on Beauty*. Los Angeles: Art Issues, 1993.

71 "For this season, however, the television image is largely a clutter of advocates calling up frightful scenes in hopes of igniting some passion in a nation that can't seem to get very passionate over what used to be Yugoslavia." Walter Goodman, "Horror vs. Hindsight: A War of TV Images," *New York Times* (December 4, 1995), p. C16.

72 Jean Baudrillard, "The Ecstacy of Communication," in Hal Foster (ed.), *The Anti-Aesthetic: Essays on Postmodern Culture*. Seattle, Washington: Bay Press, 1983, p. 131.

73 Roberta Smith, "A Show of Moderns Seeking to Shock," *New York Times* (November 23, 1995), p. C14.

74 Allan Stoekl, "Introduction," George Bataille, *Visions of Excess: Selected Writings, 1927-1939*. Ed. and trans. by Allan Stoekl. Minneapolis: University of Minnesota Press, 1985, p. xii.

75 Jake Chapman quoted in Martin Maloney, "The Chapman Bros.," *Flash Art*, no.186 (January-February 1996), p. 64. See also The Chapman Bros., "When Will I Be Infamous," *Flash Art*, no. 187 (March-April 1996), p. 35.

76 Georges Bataille, *The Tears of Eros*. Trans. by Peter Connor. San Francisco: City Lights Books, 1989, p. 207.

77 Dinos and Jake Chapman quoted in Douglas Fogle, "A Scatological Aesthetic for the Tired of Seeing," in *Chapmanworld*. London: ICA, 1996, n.p.

78 Interview with Robert Gober by Craig Gholson, *Bomb* (Fall 1989), p. 34; quoted in Joan Simon, "Robert Gober and the Extra Ordinary," in *Robert Gober*. Madrid: Museo Nacional Centro de Arte Reina Sofía, 1992, p. 20.

79 "On Fragmentation, Loss and the Studio's Ruin: A Conversation between Jeanne Silverthorne and Jo Anna Isaak," in Judith Tannenbaum, *Jeanne Silverthorne*. Philadelphia: Institute of Contemporary Art, University of Pennsylvania, 1996, p. 16.

80 Jerry Saltz, "Summer Group Show," *Time Out* (New York), no. 44 (July 24, 1996).

81 Julie Becker, "Statement on *Researchers & Residents (a place to rest),*" 1996.

82 Georges Bataille, "Materialism," and "Base Materialism and Gnosticism," in *Visions of Excess*, pp. 15-16, 45-52.

83 Neville Wakefield, "Keith Edmier," *Artforum*, 33 (December 1995), p. 89.

84 The text describes an experiment executed in 1905 by a French scientist, which measured the time a decapitated person responds to being addressed by his name (twenty-five to thirty seconds).

85 For a recent assessment of theories of vision and voyeurism in film see Kate Linker, "Engaging Perspectives: Film, Feminism, Psychoanalysis, and the Problem of Vision," in Russell Ferguson (ed.), *Art and Film Since 1945: Hall of Mirrors*. Los Angeles: Museum of Contemporary Art, 1996, pp. 216-242.

86 Conversation with the artist, November 1995.

87 Michael Cohen, "Mutate/Loving The New Flesh," in *Mutate/Loving The New Flesh*.

New York: Lauren Wittels Gallery, 1996, n.p.

88 Freud, "The 'Uncanny'," p. 226.

89 Ibid., p. 234.

90 "In fetishism, sex abandons the barriers between the organic and inorganic." Walter Benjamin, "Passagen-Werk," in *Gesammelte Schriften*. Ed. by Rolf Tiedemann, Frankfurt am Main: Suhrkamp, vol. V.1, p. 118.

91 Julia Kristeva, *The Powers of Horror: An Essay in Abjection*. New York: Columbia University Press, 1982, pp. 4, 9-10. "If there is a subject of history for the culture of abjection at all, it is not the Worker, the Woman, or the Person of Color, but the Corpse." Hal Foster, "Obscene, Abject, Traumatic," *October*, 78 (Fall 1996), p. 123.

92 *Abject Art: Repulsion and Desire in American Art*. New York: Whitney Museum of American Art, 1993, p. 62.

93 Rosalind Krauss, "*Informe* without Conclusion," *October*, no. 78 (Fall 1996), p. 90.

94 Laura Mulvey, "A Phantasmagoria of the Female Body: The World of Cindy Sherman," *New Left Review*, no. 188 (July/August 1991), p. 146. For a discussion of the "monstrous-feminine" see Barbara Creed, *The Monstrous-Feminine: Film, Feminism, Psychoanalysis*. London and New York: Routledge, 1993.

95 Wilhelm Worringer, *Abstraction and Empathy. A Contribution to the Psychology of Style*. (1908) Trans. By Michael Bullock. New York: International Universities Press, 1953, p. 77.

96 Burke, *Sublime*, p. 39.

97 Vijay Mishra, *The Gothic Sublime*. Albany: State University of New York Press, 1994, p. 227.

Edifying Narratives

1 W. S. Lewis, *The Yale Edition of Horace Walpole's Correspondence*. New Haven: Yale University Press, 1966, vol. 20, p. 381.

2 Robert Blair, "The Grave" (1743). Of this school, only Thomas Grey's "Elegy Written in a Country Churchyard" survives in the canon.

3 Ann Radcliffe, *The Mysteries of Udolpho.* (1794). New York and Oxford: Oxford University Press, 1980, p. 672. All the early Gothic novels mentioned in this essay are available in inexpensive paperback format.

4 Also translated as the "Name of the Father," Lacan's phrase *le nom du père* is a pun in French: the Father's "name" is also his "no." He declares the incest taboo that separates the son from the mother at the moment of the Oedipal crisis. The son implicitly exchanges the father's culture, including his language, for the pre-Oedipal pleasures of infancy (which means "without speech" in Latin). The concept pervades Lacanian theory. See, for instance, *Ecrits: A Selection.* Trans. by Alan Sheridan. New York and London: W. W. Norton, 1977.

5 In a posthumous essay "On the Supernatural in Fiction" (1826), Radcliffe makes the case for this theoretical distinction.

6 See Judith Fetterley's *The Resisting Reader: A Feminist Approach to American Fiction.* Bloomington: Indiana University Press, 1978.

Bela Lugosi's Dead and I Don't Feel So Good Either

1 TK, "TK," *Kerrangg!* 1987.

2 Quoted in Mick Mercer, *Gothic Rock.* Los Angeles: Cleopatra, 1993, p. 37.

3 Jessica Berens, "Portrait: The Masque," *Guardian Weekend Page* (January 14, 1995).

4 Ibid.

5 Mercer, *Gothic Rock,* p. 102.

6 Deborah Curtis, *Touching From a Distance: Ian Curtis and Joy Division.* London: Faber and Faber, 1995, p. xii.

7 Ibid, p. 113.

8 Ibid, p. 5.

"Like Cancer in the System"

1 Nine Inch Nails, "Burn," 1994.

2 For the complete text of Robert Dole's speech, see *Vibe* On-line.

3 Larry Leibstein (with Thomas Rosenstiel), "The Right Takes a Media Giant to Political Task," *Newsweek* (June 12, 1995), p. 30. For C. Dolores Tucker's reaction to NIN's "Big Man With a Gun," see also "Sympathy for the Devil," Eric Weisbard interview with Trent Reznor, *SPIN,* (February, 1996), p. 42.

4 Judith Halberstam, *Skin Shows: Gothic Horror and the Technology of Monsters.* Durham, North Carolina and London: Duke University Press 1995, p. 23.

5 A nascent third wave performing industrial fire noise (e.g. Scot Jenerik from the *23five* collective in San Francisco), experiments with bodily configurations as well as old and new technologies.

6 Dave Thompson, *Industrial Revolution.* Second edition. Los Angeles: Cleopatra, 1994, 45.

7 See Fredric Jameson, *Postmodernism, or, The Cultural Logic of Late Capitalism.* Durham, North Carolina and London: Duke University Press, 1991, and "Reification and Utopia in Mass Culture," *Social Text*, 1 (Winter 1979), pp. 130-148; Henri Lefebvre, *The Production of Space.* Trans. by Donald Nicholson-Smith. Cambridge, Massachusetts: Blackwell, 1992; George Lipsitz, *Dangerous Crossroads: Popular Music, Postmodernism and the Poetics of Place.* New York and London: Verso, 1994; Stuart Hall, "Notes on deconstructing 'the popular'," in Raphael Samuel (ed.), *People's History and Socialist Theory.* London: Routledge, 1981, pp. 227-240; Stuart Hall, "The Toad in the Garden: Thatcherism among the Theorists," in Cary Nelson and Lawrence Grossberg (eds.), *Marxism and the Interpretation of Culture.* Urbana: University of Illinois Press, 1988, pp. 35-37, 58-73; Michel Serres, *The Parasite.* Trans. by Lawrence R. Schehr. Baltimore: Johns Hopkins University Press, 1982; and, most influentially, Jacques Attali, *Noise: The Political Economy of Music.* Trans. by Brian Massumi. Minneapolis: University of Minnesota Press, 1992. See also Jacques Derrida, *The Ear of the Other: Otobiography, Transference, Translation: Text and Discussions with Jacques Derrida.* Ed. by Christie McDonald. Lincoln: University of Nebraska Press, 1985; and Michel Chion, *Audio-Vision: Sound on Screen.* Ed. and trans. by Claudia Gorbman. New York: University of Columbia Press, 1994.

8 Lefebvre, *Production of Space,* p. 52

9 Peggy Phelan, "The Ontology of Performance: Representation without Reproduction," in *Unmarked: The Politics of Performance.* London and New York: Routledge, 1993, p. 149.

10 Ibid., p. 148

11 See Attali, *Noise,* p. 141.

12 Critical Art Ensemble, *The Electronic Disturbance.* New York: Autonomedia, 1994, p. 74.

13 Genesis P-Orridge in Vittore Baroni, *Psychic TV/Genesis P-Orridge: A Coumprehensive Collection Ov Lyrics 1981-90.* Viterbo, Italy: Nouvo Equilibri, n.d., p. 21.

14 Jason Fine, "The Truth about Trent," *OPTION* (July/August, 1994), pp. 34-40. See also Tuck Remington, *Nine Inch Nails.* London and New York: Omnibus Press, 1995.

15 Thus, for instance, reasons for the difficulty of finding NIN videos appear to range from copyright problems (Reznor's feud with his former label TVT) to deliberate release into the "underground economy" of their fans only, to outright censorship: "As far as 'Happiness in Slavery,' I knew when I made that that there was no chance of getting it played." Kim Traub's interview with Trent Reznor, *IndustrialnatioN*, no. 9 (Summer 1994), p. 24.

16 Critical Art Ensemble, *Electronic Disturbance,* p. 52.

17 Halberstam, *Skin Shows,* p. 27; on the vampire's multivalence within postmodernism, ibid., chapters 7 and 8.

18 For a powerful reading of Marx's *Capital* in this light, see Ann Cvetkovich, *Mixed Feelings: Feminism, Mass Culture and Victorian Sensationalism.* New Brunswick: Rutgers University Press, 1992, chapter 7.

19 "Capital is dead labour, which, vampire-like, lives only by sucking living labour, and lives the more, the more labour it sucks," Karl Marx, *Capital. Volume I.* Trans. by Ben Fowkes. New York: Vintage, 1977, p. 342. On other occasions, Marx describes capital as "werewolf-like" (p. 353) and as an "animated monster" (p. 302).

20 Halberstam, *Skin Shows,* p. 27.

21 Nell Tenhaaf, "Of Monitors and Men and Other Unsolved Feminist Mysteries: Video Technology and the Feminine," in Simon Penny (ed.), *Critical Issues in Electronic Media.* Albany: State University of New York Press, 1995, p. 221. This, of course, points back to Michel de Certeau's "The Arts of Dying: Celibatory Machines," in *Heterologies: Discourse on the Other.* Trans. by Brian Massumi. Minneapolis: University of Minnesota Press, 1989, pp. 156-167. I want to thank Maria Fernandez (Department of Art History, University of Connecticut-Storrs) for calling my attention to Nell Tenhaaf's essay.

22 Mark Seltzer, "Serial Killers (I)," *differences: A Journal of Feminist Cultural Studies,* 5 (1993), p. 109 (in italics in the original). See also Seltzer, *Bodies and Machines.* London and New York: Routledge 1992, p. 110.

23 Seltzer, "Serial Killers (I)," p. 110.

24 Ibid., p. 113; and Seltzer, "Serial Killers (II): The Pathological Public Sphere," *Critical Inquiry*, 22 (August, 1995), pp. 122-149. For a Deleuzian reading of serial killing, consult Camilla Griggers, "Phantom and Reel Projections: Lesbians and the (Serial) Killing-Machine," in Judith Halberstam and Ira Livingston (eds.), *Posthuman Bodies.* Bloomington: Indiana University Press, 1995, pp. 162-176.

25 Celeste Olalquiaga, *Megalopolis: Contemporary Cultural Sensibilities.* Minneapolis: University of Minnesota Press, 1992, p. xix.

26 Ibid.

27 Critical Art Ensemble, *Electronic Disturbance,* p. 51.

28 Interview with Genesis P-Orridge in Baroni, *Psychic TV/Genesis P-Orridge,* p. 112.

Shivers

1 Elliot Stein, "Tod Browning," in *Cinema: A Critical Dictionary*. Ed. by Richard Roud, New York: Viking, 1980, p. 163.

2 Carol Clover, *Men, Women, and Chainsaws.* Princeton University Press, 1992, pp. 52-53.

3 Linda Williams, "When the Women Looks," in *Film Theory and Criticism.* Ed. by Gerald Mast, et al. New York: Oxford University Press, 1992, p. 577.

4 Ibid., p. 55

1 Hillel Schwartz, *Century's End: A Cultural History of the Fin de Siècle from the 990s through 1990s.* New York: Doubleday, 1990, p. 9.

2 William Patrick Day, *In the Circles of Fear and Desire: A Study of Gothic Fantasy.* Chicago: University of Chicago Press, 1985, p. 7.

3 Ibid., pp. 10-11

4 Peter Mettler, *Making the Invisible Visible.* Münsterschwarzach Abtei, Germany: Benedikt Press, 1995, pp. 60, 64.

5 Hans-Jürgen Syberberg, Unpublished essay on *The Night*, 1985.

6 Ibid.

7 Adda B. Bozeman, "Decline of the West? Spengler Reconsidered," *The Virginia Quarterly Review,* 59 (Spring 1983), p. 194.

8 Aleksander I. Solzhenitsyn, *A World Split Apart.* New York: Harper & Row, 1978, pp. 59, 61.

9 Oswald Spengler, *Aphorisms.* Chicago: H. Regenery Co., 1967, p. 39.

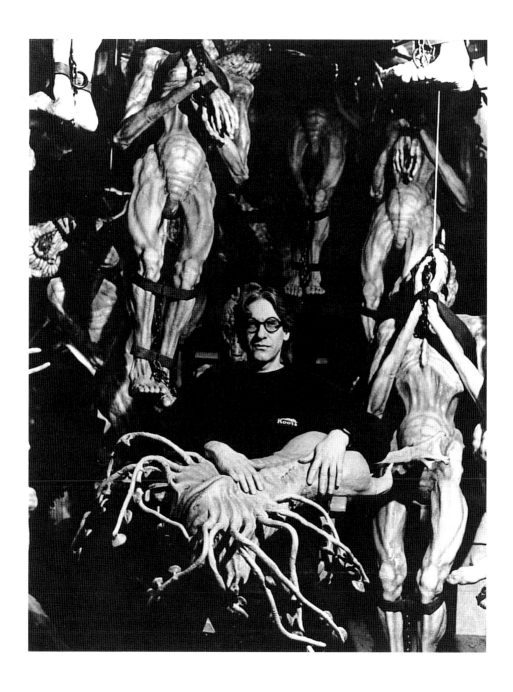

Director David Cronenberg in the prop
room on the set of *Naked Lunch*,
Canada/Great Britain, 1991
Courtesy Fern Bayer, Toronto

Film and Video Series

Films

Nosferatu, 1921 (Germany)
Directed by F.W. Murnau
35mm, 63 min., b/w and color, silent

Freaks, 1931 (USA)
Directed by Tod Browning
35mm, 64 min., b/w

Haunting, 1963 (USA)
Directed by Robert Wise
35mm, 112 min., b/w

Onibaba, 1964 (Japan)
Directed by Keneto Shindo
35mm, 103 min., b/w

Ganja and Hess, 1970 (USA)
Directed by Bill Gunn
16mm, 110 min., color

Shivers, (US title: *They Came from Within*),
1974 (Canada)
Directed by David Cronenberg
35mm, 87 min., color

Heart of Glass, 1976 (West Germany)
Directed by Werner Herzog
35mm, 94 min., color

Possession, 1981 (France/West Germany)
Directed by Andrzej Zulawski
35mm, 81 min., color

The Last of England, 1988 (UK)
Directed by Derek Jarman
35mm, 88 min., color

Daddy, Father Frost is Dead, 1991 (Russia)
Directed by Yevgeni Yufit
35mm, 74 min., color

Whispering Pages, 1993 (Russia)
Directed by Aleksander Sokhurov
35mm, 87 min., color

Cronos, 1994 (Mexico)
Directed by Guillermo del Toro
35mm, 92 min., color

Fate, 1994 (Germany)
Directed by Fred Kelemen
16mm, 80 min., color

Faust, 1994 (Czech Republic/UK)
Directed by Jan Svankmajer
35mm, 97 min., color

Safe, 1995 (USA)
Directed by Todd Haynes
35mm, 80 min., color

Nadja, 1995 (USA)
Directed by Michael Almereyda
35mm, 100 min., b/w

The Addiction, 1995 (USA)
Directed by Abel Ferrara
35mm, 84 min., color

The Kingdom, 1995 (Denmark)
Directed by Lars von Trier
35mm, 280 min., color

Short films and videos

Kenneth Anger (USA)
Lucifer Rising, 1977
16mm, 30 min., color

Cerith Wyn Evans (UK)
Have You Seen Orphee Recently, 1981
Super 8, 20 min., color
Courtesy Jay Jopling, London

Steven Chivers (UK)
Prima Dilettante, 1984
16mm, 12 min., color

Luther Price (USA)
Sodom, 1989
Super 8, 18 min., color
Courtesy of the Artist, Cambridge,
Massachusetts

Jeri Cain Rossi (USA)
Black Hearts Bleed Red, 1992
16mm, 15 min., b/w
Courtesy of the Artist, New Orleans

Peggy Ahwesh (USA)
The Color of Love, 1994
Super 8, 10 min., color
Courtesy of the Artist, New York

John Brattin (USA)
Funeral, 1995
Super 8 on video, 8 min., b/w
Courtesy of the Artist, New York

Jane and Louise Wilson (UK)
Crawl Space, 1995
16mm/video transfer, 9 min., color
Courtesy of the Artists, London

Ellen Cantor (USA)
Within Heaven and Hell, 1996
Film/video, 16 min., color
Courtesy XL/Xavier LaBoulbenne, New York

Jake Mahaffy (USA)
Egypt Hollow, 1996
16mm, 25 min., b/w

Selected by John Gianvito, Branka Bogdanov,
Christoph Grunenberg and Lia Gangitano

Jane and Louise Wilson
Crawl Space, (UK)1995
Courtesy Galleria S.A.L.E.S., Rome

Aguirre, Manuel. *The Closed Space: Horror Literature and Western Symbolism*. Manchester: Manchester University Press, 1990.

Allen, Henry Southworth. *Going Too Far Enough: American Culture at Century's End*. Washington, D.C.: Smithsonian Institution Press, 1994.

Andriano, Joseph. *Our Ladies of Darkness: Feminine Daemonology in Male Gothic Fiction*. University Park: Pennsylvania State University Press, 1993.

Armstrong, Nancy and Leonard Tennenhouse, eds. *The Violence of Representation: Literature and the History of Violence*. New York: Routledge, 1989.

Attali, Jacques. *Millennium: Winners and Losers in the Coming World Order*. Leila Conners and Nathan Gardels, trans. New York: Times Books, 1991.

Baldick, Chris. *In Frankenstein's Shadow: Myth, Monstrosity and Nineteenth-Century Writing*. Oxford: Clarendon, 1987.

Baldick, Chris, ed. *The Oxford Book of Gothic Tales*. Oxford: Oxford University Press, 1992.

Bataille, Georges. *Literature and Evil*. (1957) Alastair Hamilton, trans. New York: Marion Boyars, 1985.

_____. *The Tears of Eros*. (1961) Peter Connor, trans. San Francisco: City Lights Books, 1989.

_____. *Visions of Excess: Selected Writings, 1927-1939*. Allan Stoekl, ed. Allan Stoekl, Carl R. Lovitt and Donald M. Leslie, Jr., trans. Minneapolis: University of Minnesota Press, 1985.

Baudrillard, Jean. *The Transparency of Evil*. James Benedict, trans. London: Verso, 1993.

Bayer-Berenbaum, Linda. *The Gothic Imagination: Expansion in Gothic Literature and Art*. London: Associated University Presses, 1982.

La Belle et La Bête. Un Choix de Jeunes Americains. Paris: Musée d'Art Moderne de la Ville de Paris, 1995.

Benezra, Neal and Olga M. Viso. *Distemper: Dissonant Themes in the Art of the 1990s*.

Washington, D.C.: Hirshhorn Museum and Sculpture Garden, 1996.

Berenstein, Rhona J. *Attack of the Leading Ladies: Gender Sexuality and Spectatorship in Classic Horror Cinema*. New York: Columbia University Press, 1996.

Botting, Fred. *Gothic*. London: Routledge, 1996.

Brea, José Luis, ed. *The Last Days*. Seville: Pabellon de Espana, 1992.

Bronfen, Elisabeth. *Over Her Dead Body: Death, Femininity, and the Aesthetic*. Manchester: Manchester University Press, 1992.

Carroll, Noël. *The Philosophy of Horror: Or, Paradoxes of the Heart*. New York: Routledge, 1990.

Carter, Margaret L., ed. *Dracula: The Vampire and the Critics*. Ann Arbor, Michigan: U.M.I. Research Press, 1988.

_____. *Specter or Delusion? The Supernatural in Gothic Fiction*. Ann Arbor, Michigan: U.M.I. Research Press, 1987.

Chamberlin, J. Edward and Sander L. Gilman, eds. *Degeneration: The Dark Side of Progress*. New York: Columbia University Press, 1985.

Cixous, Hélène and Catherine Clément. *The Newly Born Women*. Betsy Wing, trans. Minneapolis: University of Minnesota Press, 1986.

Clark, Kenneth. *The Gothic Revival: An Essay in the History of Taste*. (1928) London: John Murray, 1962.

Clover, Carol. *Men, Women, and Chain Saws: Gender in the Modern Horror Film*. Princeton, New Jersey: Princeton University Press, 1992.

Colomina, Beatriz, ed. *Sexuality and Space*. New York: Princeton Architectural Press, 1992.

Copjec, Joan. *Read My Desire: Lacan Against the Historicists*. Cambridge, Massachusetts: MIT Press, 1994.

Cornwell, Neil. *The Literary Fantastic: From Gothic to Postmodernism*. New York: Harvester Wheatsheaf, 1990.

Corrin, Lisa G. and Joaneath Spicer, eds. *Going for Baroque*. Baltimore: The Contemporary and Walters Art Gallery, 1995.

Creed, Barbara. *The Monstrous-Feminine: Film, Feminism, Psychoanalysis.* London: Routledge, 1993.

Curiger, Bice. *Signs and Wonders: Nikos Pirosmani (1862-1918) and Recent Art.* Zurich: Kunsthaus, 1995.

Day, William Patrick. *In the Circles of Fear and Desire: A Study of Gothic Fantasy.* Chicago: University of Chicago Press, 1985.

Deitch, Jeffrey. *Post Human.* New York: Distributed Art Publishers, 1992.

DeLamotte, Eugenia C. *Perils of the Night: A Feminist Study of Nineteenth-Century Gothic.* New York: Oxford University Press, 1990.

Delbanco, Andrew. *The Death of Satan: How Americans Have Lost the Sense of Evil.* New York: Farrar, Straus and Giroux, 1995.

Deleuze, Gilles and Félix Guattari. *A Thousand Plateaus: Capitalism and Schizophrenia.* Brian Massumi, trans. Minneapolis: University of Minnesota Press, 1987.

Dellamora, Richard, ed. *Postmodern Apocalypse.* Philadelphia: University of Pennsylvania Press, 1995.

Dijkstra, Bram. *Idols of Perversity: Fantasies of Feminine Evil in Fin-de-Siècle Culture.* New York: Oxford University Press, 1986.

Doty, Robert. *Human Concern/Personal Torment: The Grotesque in American Art Revisited.* New York: Phyllis Kind Gallery, 1989.

Ellis, Kate Ferguson. *The Contested Castle: Gothic Novels and the Subversion of Domestic Ideology.* Urbana: University of Illinois Press, 1989.

Fleenor, Juliann E., ed. *The Female Gothic.* Montreal: Eden Press, 1983.

Foucault, Michel. *Power/Knowledge.* Colin Gordon, et al., trans. Brighton: Harvester, 1980.

Frank, Frederick S. *Guide to the Gothic: An Annotated Bibliography of Criticism.* Metuchen, New Jersey: Scarecrow Press, 1984.

Frayling, Christopher. *Vampyres: Lord Byron to Count Dracula.* London: Faber and Faber, 1991.

Geary, Robert F. *The Supernatural in Gothic Fiction: Horror, Belief, and Literary Change.* Lewiston, New York: Edwin Mellen Press, 1992.

Gilbert, Sandra and Susan Gubar. *The Madwoman in the Attic: The Woman Writer and the Nineteenth-Century Literary Imagination.* New Haven, Connecticut: Yale University Press, 1979.

Graham, Kenneth W., ed. *Gothic Fictions: Prohibition/Transgressions.* New York: AMS Press, 1989.

Grant, Barry Keith, ed. *Planks of Reason: Essays on the Horror Film.* Metuchen, New Jersey: Scarecrow Press, 1984.

Grixti, Joseph. *Terrors of Uncertainty: The Cultural Contexts of Horror Fiction.* London: Routledge, 1989.

Gross, Louis S. *Redefining the American Gothic: From Wieland to Day of the Dead.* Ann Arbor, Michigan: U.M.I. Research Press, 1989.

Gudis, Catherine, ed. *Helter Skelter: L.A. Art in the 1990s.* Los Angeles: Museum of Contemporary Art, 1992.

Haggerty, George E. *Gothic Fiction/Gothic Form.* University Park, Pennsylvania: Pennsylvania State University Press, 1989.

Halberstam, Judith. *Skin Shows: Gothic Horror and the Technology of Monsters.* Durham, North Carolina: Duke University Press, 1995.

Halberstam, Judith and Ira Livingston, ed. *Posthuman Bodies.* Bloomington: Indiana University Press, 1995.

Harpham, Geoffrey Galt. *On the Grotesque: Strategies of Contradiction in Art and Literature.* Princeton, New Jersey: Princeton University Press, 1982.

Heller, Terry. *The Delights of Terror: An Aesthetics of the Tale of Terror.* Urbana: University of Illinois Press, 1987.

Hirsch, Foster. *Film Noir: The Dark Side of the Screen.* New York: Da Capo, 1981.

Houser, Craig, et al., eds. *Abject Art: Repulsion and Desire in American Art.* New York: Whitney Independent Study Program, 1993.

Huet, Marie-Hélène. *Monstrous Imagination.* Cambridge, Massachusetts: Harvard University Press, 1993.

Irigaray, Luce. *Speculum of the Other Woman.* Gillian C. Gill, trans. Ithaca, New York: Cornell University Press, 1985.

Jones, Ernest. *On the Nightmare.* (1931) New York: Liveright, 1951.

Kaplan, E. Ann. *Women in Film Noir.* London: British Film Institute, 1980.

Kayser, Wolfgang. *The Grotesque in Art and Literature.* Ulrich Weisstein, trans. Bloomington: Indiana University Press, 1963.

Kelley, Mike. *The Uncanny.* Arnhem, The Netherlands: Sonsbeek 93, 1993.

Krafft-Ebing, Richard von. *Psychopathia Sexualis: A Medico-Forensic Study.* (1886) New York: G. P. Putnam's, 1965.

Kristeva, Julia. *Powers of Horror: An Essay in Abjection.* Leon S. Roudiez, trans. New York: Columbia University Press, 1982.

Levine, George and U. C. Knoepflmacher. *The Endurance of Frankenstein: Essays on Mary Shelley's Novel.* Berkeley: University of California Press, 1979.

Lovell, Terry. *Consuming Fiction.* London: Verso, 1987.

MacAndrew, Elizabeth. *The Gothic Tradition in Fiction.* New York: Columbia University Press, 1979.

Malin, Irving. *New American Gothic.* Carbondale: Southern Illinois University Press, 1962.

Massé, Michelle A. *In the Name of Love: Women, Masochism, and the Gothic.* Ithaca, New York: Cornell University Press, 1992.

McCarty, John. *Splatter Movies: Breaking the Last Taboo of the Screen.* New York: St. Martin's Press, 1984.

McElroy, Bernard. *Fiction of the Modern Grotesque.* Basingstoke, Hampshire: Macmillan, 1989.

Mercer, Mick. *Gothic Rock Black Book.* London: Omnibus Press, 1988.

Miles, Robert. *Gothic Writing 1750-1820: A Genealogy.* London: Routledge, 1993.

Mishra, Vijay. *The Gothic Sublime.* Albany: State University of New York Press, 1994.

Moers, Ellen. *Literary Women.* Garden City, New York: Doubleday, 1976.

Morrow, Bradford and Patrick McGrath. *The New Gothic.* New York: Vintage, 1991.

Moss, Karen, ed. *Altered Egos.* Santa Monica, California: Santa Monica Museum of Art, 1994.

Napier, Elizabeth. *The Failure of Gothic: Problems of Disjunction in an Eighteenth-Century Literary Form.* Oxford University Press, 1987.

Newman, Kim. *Nightmare Movies: A Critical History of the Horror Film.* London: Bloomsbury, 1988.

Oates, Joyce Carol, ed. *American Gothic Tales.* New York: Plume, 1996.

Olalquiaga, Celeste. *Megalopolis: Contemporary Cultural Sensibilities.* Minneapolis: University of Minnesota Press, 1992.

Prawer, S. S. *Caligari's Children: The Film as Tale of Terror.* Oxford: Oxford University Press, 1980.

Polhemus, Ted. *Streetstyle: From Sidewalk to Catwalk.* London: Thames and Hudson, 1994.

Praz, Mario. *The Romantic Agony.* (1930) Angus Davidson, trans. London: Oxford University Press, 1970.

Punter, David. *The Literature of Terror: A History of Gothic Fictions from 1765 to the Present Day.* London: Longman, 1996.

Raschke, Carl A. *Painted Black: From Drug Killings to Heavy Metal—The Alarming True Story of How Satanism is Terrorizing Our Communities.* San Francisco: Harper and Row, 1990.

Rockett, Will H. *Devouring Whirlwind: Terror and Transcendence in the Cinema of Cruelty.* New York: Greenwood, 1988.

Rugoff, Ralph. *Transformers.* New York: Independent Curators Incorporated, 1994.

Sage, Victor. *Horror Fiction in the Protestant Tradition.* New York: St. Martin's Press, 1988.

Sage, Victor and A. Lloyd Smith, eds. *Gothick Origins and Innovations.* Amsterdam: Rodopi, 1994.

Sappington, Rodney and Tyler Stallings, eds. *Uncontrollable Bodies: Testimonies of Identity and Culture.* Seattle: Bay Press, 1994.

Scarry, Elaine. *The Body in Pain: The Making and Unmaking of the World*. New York: Oxford University Press, 1985.

Schwartz, Hillel. *Century's End: A Cultural History of the Fin de Siècle from the 990s through the 1990s*. New York: Doubleday, 1990.

Sedgwick, Eve Kosofsky. *The Coherence of Gothic Conventions*. New York: Methuen, 1986.

Seltzer, Mark. *Bodies and Machines*. London: Routledge, 1992.

Showalter, Elaine. *Sexual Anarchy: Gender and Culture at the Fin de Siècle*. New York: Viking, 1990.

Skal, David J. *Hollywood Gothic*. New York: W. W. Norton & Company, 1990.

Steele, Valerie. *Fetish: Fashion, Sex and Power*. New York: Oxford University Press, 1996.

Stearns, Peter N. *Millennium III, Century XXI: A Retrospective on the Future*. Boulder, Colorado: Westview Press, 1996.

Steiner, Wendy. *The Scandal of Pleasure: Art in an Age of Fundamentalism*. Chicago: University of Chicago Press, 1995.

Stivers, Richard. *The Culture of Cynicism: American Morality in Decline*. Oxford: Blackwell, 1994.

Thompson, Dave. *Industrial Revolution*. Los Angeles: Cleopatra, 1994.

Tracy, Ann Blaisdell. *Patterns of Fear in the Gothic Novel, 1790-1830*. New York: Arno Press, 1980.

_____. *The Gothic Novel 1790-1830: Plot Summaries and Index to Motifs*. Lexington: University of Kentucky Press, 1981.

Tropp, Martin. *Images of Fear: How Horror Stories Helped Shape Modern Culture (1818-1918)*. Jefferson, North Carolina: McFarland and Company, 1990.

Tudor, Andrew. *Monsters and Mad Scientists: A Cultural History of the Horror Movie*. Oxford: Blackwell, 1989.

Twitchell, James B. *Dreadful Pleasures: An Anatomy of Modern Horror*. New York: Oxford University Press, 1985.

Vidler, Anthony. *The Architectural Uncanny: Essays in the Modern Unhomely*. Cambridge, Massachusetts: MIT Press, 1992.

Waller, Gregory A., ed. *American Horrors: Essays on the Modern American Horror Film*. Urbana: University of Illinois Press, 1987.

_____. *The Living and the Undead: From Stoker's Dracula to Romero's Dawn of the Dead*. Urbana: University of Illinois Press, 1986.

Whitebook, Joel. *Perversion and Utopia: A Study in Psychoanalysis and Critical Theory*. Cambridge, Massachusetts: MIT Press, 1995.

Williams, Anne. *Art of Darkness: A Poetics of Gothic*. Chicago: University of Chicago Press, 1995.

Wilt, Judith. *Ghosts of the Gothic: Austen, Eliot, and Lawrence*. Princeton: Princeton University Press, 1980.

Winter, Kari J. *Subjects of Slavery, Agents of Change: Women and Power in Gothic Novels and Slave Narratives 1790-1865*. Athens: University of Georgia Press, 1992.

Wolstenholme, Susan. *Gothic (Re)Visions: Writing Women as Readers*. Albany: State University of New York Press, 1993.

Yelavich, Susan, ed. *The Edge of the Millennium: An International Critique of Architecture, Urban Planning, Product and Communication Design*. New York: Whitney Library of Design, 1993.

Zizek, Slavoj. *The Sublime Object of Ideology*. London: Verso, 1989.

Compiled by Thomas Conley Rollins, Jr.

Julie Becker

Born 1972 in Los Angeles
Lives and works in Los Angeles

Solo Exhibitions:

1997 Regen Projects, Los Angeles

Researchers, Residence, A Place to Rest,
Kunsthalle Zurich

Group Exhibitions:

1997 *New Works: Drawings Today,* San
Francisco Museum of Modern Art

Hot Coffee, Artists Space, New York

1996 *Universalis,* Bienal Internacional São
Paulo

Greene Naftali Inc., New York

Monica Carocci

Born 1966 in Rome
Lives and works in Turin

Solo Exhibitions:

1997 Galleria S.A.L.E.S., Rome

1996 Galleria Guido Carbone, Turin

1995 Galleria Guido Carbone, Turin

1994 Galleria Sergio Tossi, Prato, Italy

Galleria S.A.L.E.S., Rome

1993 Galleria Guido Carbone, Turin

1992 Galleria Guido Carbone, Turin

1991 *Biennale di Fotografia,* Zenit deposito
d'arte, Turin

1990 Galleria Guido Carbone, Turin

Selected Group Exhibitions:

1996 Quadriennale di Roma

Periscopio, La Mandria, Venaria Reale,
Italy

Electronic-Art Café, Lingotto, Turin

Fuzzy Logic, The Institute of
Contemporary Art, Boston (video pro-
gram)

Carte Italiane, Istituto Italiano di Cultura,
Athens

NowHere, Louisiana Museum,
Humlebaek, Denmark

Collezionismo a Torino, Castello di Rivoli,
Museo d'Arte Contemporanea Rivoli,
Turin

Transfer, Galleria d'Arte Moderna,
Bologna

1995 *Fake I.D.,* 88 Room, Boston

Proposte X, Galleria S. Filippo Neri,
Regione Piemonte, Turin

1994 *Prima Linea,* Trevi Flash Art Museum,
Trevi, Italy

1991 *FIAR International Prize,* Milan, Rome,
Paris, London, New York, Los Angeles

Arte neobarocca, Palazzo Zerace, Geneva

1990 *Italia '90. Ipotesi arte giovane,* Fabbrica
del Vapore, Milan

Studio Corrado Levi, Milan

Dinos and Jake Chapman

Born 1962 in London and 1966 in Chelmsford,
England
Live and work in London

Solo Exhibitions:

1997 Gagosian Gallery, New York

1996 *Zero Principle,* Galleria Gió Marconi,
Milan

Chapmanworld, ICA, London; Grazer
Kunstverein, Graz, Austria; Kunst-Werke,
Berlin

P-House, Tokyo

1995 *Five Easy Pissers,* Andréhn Schiptjenko
Gallery, Stockholm

*Zygotic acceleration, biogenetic, de-subli-
mated libidinal model (enlarged x 1000),*
Victoria Miro Gallery, London

Bring me the head of Franco Toselli!,
Ridinghouse Editions, London

Gavin Brown's Enterprise, New York

1994 *Mummy & Daddy,* Galleria Franco Toselli,
Milan

Great Deeds Against the Dead, Victoria
Miro Gallery, London

1993 *The Disasters of War,* Victoria Miro
Gallery, London

1992 *We Are Artists,* Hales Gallery, London

Selected Group Exhibitions:

1997 *Full House,* Kunstmuseum Wolfsburg,
Germany

Sensation, Royal Academy, London

1996 *Life/Live,* Musée d'Art Moderne de la
Ville de Paris; Centro Cultural Belem,
Lisbon

Campo 6, Fondazione Sandretto Re Rebandengo per l'Arte, Turin; Bonnefanten Museum, Maastricht, The Netherlands

1995 *General Release: Young British Artists*, Biennale di Venezia, Venice

Brilliant! New Art From London, Walker Art Center, Minneapolis; Contemporary Arts Museum, Houston

1994 *Watt*, With de Witte and Kunsthal Rotterdam

Gregory Crewdson

Born 1962 in Brooklyn, New York
Lives and works in Brooklyn, New York

Solo Exhibitions:
1997 Luhring Augustine, New York
1996 Ginza Artspace, Shiseido Co., Tokyo
1995 Luhring Augustine, New York

Ruth Bloom Gallery, Los Angeles

Jay Jopling/White Cube, London

Galerie Samia Saouma, Paris

Gallerie Charlotte Lund, Stockholm

Les Images du Plaisir, Frac des Pays de la Loire, Galerie des Carmes, La Fleche, France

1994 Palm Beach Community College Museum of Art, Palm Beach, Florida
1993 Feigen Gallery, Chicago
1992 Houston Center for Photography, Houston

Ruth Bloom Gallery, Los Angeles

1991 Portland School of Art, Portland, Maine

BlumHelman Warehouse, New York

1988 Yale University, New Haven, Connecticut

Selected Group Exhibitions:
1997 *American Art Today: The Garden*, Art Museum at Florida International University, Miami

Galerie Barbara Farber, Amsterdam

1996 *Everything That's Interesting Is New: The Dakis Joannou Collection*, Athens School of Fine Arts

Digital Gardens, Power Plant, Toronto

1995 *La Belle et La Bête*, Musée d'Art Moderne de la Ville de Paris

Nature Studies: Gregory Crewdson, Adam Fuss, Hiroshi Sugimoto, Johnson County Community College, Overland Park, Kansas

1994 *Close Encounters*, Ikon Gallery, Birmingham, England

New Work, New Directions 2, Los Angeles County Museum of Art

Keith Edmier

Born 1967 in Chicago
Lives and works in New York

Solo Exhibitions:
1997 Metro Pictures, New York

Shoshana Wayne Gallery, Santa Monica, California

Galerie Paul Andriesse, Amsterdam

University of South Florida Art Museum, Tampa, Florida

1995 Friedrich Petzel Gallery, New York

Neugerriemschneider Galerie, Berlin

1993 Petzel/Borgmann Gallery, New York

Selected Group Exhibitions:
1996 *Mutate/Loving the New Flesh*, Lauren Wittels Gallery, New York
1995 *Human/Nature*, New Museum of Contemporary Art, New York

Narcissistic Disturbance, Otis College of Art and Design, Otis Gallery, Los Angeles

1993 *Ghost-Limb*, Basilico Fine Arts, New York

James Elaine

Born 1950 in Dallas, Texas
Lives and works in Brooklyn, New York

Solo Exhibitions:
1995 *Reflecting Pool*, One Main Sculpture Space, Brooklyn, New York

Objects From the Dying Salon, Thread Waxing Space, New York

1993 *Fragrance*, Maranushi Lederman, New York
1986 *Medals*, Casas Toledo Oosterom, New York
1985 White Columns, New York
1983 University Art Gallery, University of North Texas, Denton, Texas
1981 Dana Reich Gallery, San Francisco
1980 Dana Reich Gallery, San Francisco

Selected Group Exhibitions:

1995 *Works for a Funhouse*, E. S. Vandam, New York

Centro Cultural Ricardo Rojas, University of Buenos Aires

1994 *Life/Boat*, Rotunda Gallery, Brooklyn, New York

Cultus, Plasma Space, New York

1993 *Obsessive Collective*, Art in General, New York

1992 BlumHelman Gallery, New York

1991 *N.Y., N.Y.*, San Francisco Museum of Modern Art

1990 White Columns, New York

1988 Massachusetts College of Art, Boston

1987 Hallwalls, Buffalo, New York

1986 *10 From the Drawing Center*, Paine Webber Gallery, New York

1984 New Museum of Contemporary Art, New York

1977 Fort Worth Art Museum, Texas

Robert Gober

Born 1954 in Wallingford, Connecticut
Lives and works in New York

Selected Solo Exhibitions:

1997 Museum of Contemporary Art, Los Angeles

1996 Max Hetzler Galerie, Berlin

1995 Museum für Gegenwartskunst, Basel, Switzerland

1994 Paula Cooper Gallery, New York

1993 Serpentine Gallery, London; Tate Gallery, Liverpool

1992 DIA Center for the Arts, New York

1991 Galerie Nationale du Jeu de Paume, Paris; Museo Nacional Centro de Arte Reina Sofía, Madrid

1990 Museum Boymans-van Beuningen, Rotterdam; Kunsthalle Bern, Switzerland

1989 Paula Cooper Gallery, New York

1988 Art Institute of Chicago

Galerie Max Hetzler, Cologne

1987 Paula Cooper Gallery, New York

1986 Daniel Weinberg Gallery, Los Angeles

1985 Daniel Weinberg Gallery, Los Angeles

Robert Gober Dessins, Galerie Samia Saouma, Paris

1984 *Slides of a Changing Painting*, Paula Cooper Gallery, New York

Selected Group Exhibitions:

1997 *De-Genderism*, Setagaya Art Museum, Tokyo

1996 *Views from Abroad 2: European Perspectives on American Art*, Whitney Museum of American Art, New York

Distemper: Dissonant Themes in the Art of the 1990s, Hirshhorn Museum and Sculpture Garden, Washington, D.C.

Everything That's Interesting Is New: The Dakis Joannou Collection, Athens School of Fine Arts

1995 *Carnegie International*, Carnegie Museum of Art, Pittsburgh, Pennsylvania

Signs and Wonders, Kunsthaus Zurich

Feminin/masculin: le sexe de l'art?, Centre Georges Pompidou, Paris

Rites of Passage: Art for the End of the Century, Tate Gallery, London

1993 *The Sublime Void: An Exhibition on the Memory of the Imagination*, Royal Museum of Fine Arts, Antwerp, Belgium

Abject Art: Repulsion and Desire in American Art, Whitney Independent Study Program, Whitney Museum of American Art, New York

American Art in the 20th Century, Martin Gropius Bau, Berlin; Royal Academy of Arts, London

1992 *TransForm*, Kunstmuseum and Kunsthalle Basel, Switzerland

Post Human, FAE Musée d'Art Contemporain, Pully/Lausanne, Switzerland; Castello di Rivoli, Museo d'Arte Contemporanea Rivoli, Turin; Deste Foundation for Contemporary Art, Athens; Deichtorhallen, Hamburg; Israel Museum, Jerusalem

Documenta IX, Kassel, Germany

Doubletake: Collective Memory and Current Art, Hayward Gallery, London

1991 *Metropolis*, Martin Gropius Bau, Berlin

1990 *The Readymade Boomerang: Certain Relations in 20th Century Art*, Biennale of Sydney 1990, Art Gallery of New South Wales, Sydney

Culture and Commentary: An Eighties Perspective, Hirshhorn Museum and Sculpture Garden, Washington, D.C.

1989 *Einleuchten: Will, Vorstel, und Simul in HH*, Deichtorhallen, Hamburg

The Play of the Unsayable: Ludwig Wittgenstein and the Art of the 20th Century, Wiener Secession, Vienna; Palais des Beaux Arts, Brussels

Biennial Exhibition, Whitney Museum of American Art, New York

Horn of Plenty, Stedelijk Museum, Amsterdam

1988 *The BiNational: American Art of the Late 80's*, The Institute of Contemporary Art and Museum of Fine Arts, Boston; Städtische Kunsthalle, Kunstsammlung Nordrhein-Westfalen, Kunstverein für die Rheinlande und Westfalen, Düsseldorf; Kunsthalle Bremen; Württembergischer Kunstverein, Stuttgart

Art at the End of the Social, Rooseum, Malmö, Sweden

XLIII Biennale di Venezia, Venice

New York Art Now: The Saatchi Collection (Part II), Saatchi Collection, London

Utopia Post Utopia, The Institute of Contemporary Art, Boston

1987 *New York Art Now: The Saatchi Collection (Part I)*, Saatchi Collection, London

Avant-Garde in the Eighties, Los Angeles County Museum of Art

Art and Its Double: Recent Developments in New York Art, Fundacio Caixa de Pensiones, Madrid

1986 *New Sculpture: Robert Gober, Jeff Koons, Haim Steinbach*, Renaissance Society, University of Chicago

1979 112 Greene Street, New York

Douglas Gordon

Born 1966 in Glasgow
Lives and works in Glasgow

Solo Exhibitions:

1997 Micheline Szwajcer, Antwerp, Belgium

Galerie Mot & Van den Boogaard, Brussels, Belgium

1996 *Douglas Gordon & Rirkrit Tiravanija*, FRAC Languedoc-Roussillion, Montpellier, France

24 Hour Psycho, Akademie der bildenden Künste, Vienna

...head, Uppsala Konstmuseum, Sweden

Galleria Bonomo, Rome

Canberra Contemporary Art Space, Australia

Museum für Gegenwartskunst, Zurich

Galerie Walchenturm, Zurich

The Turner Prize, Tate Gallery, London

1995 Centre Georges Pompidou, Paris

Rooseum, Malmö, Sweden

Bad Faith, Künstlerhaus, Stuttgart

The End, Jack Tilton Gallery, New York

Jukebox (in collaboration with Graham Gussin), The Agency, London

Entr' Acte 3, Van Abbe Museum, Eindhoven, The Netherlands

1994 Lisson Gallery

1993 *24 Hour Psycho*, Tramway, Glasgow; Kunstwerke, Berlin

Migrateur, L'ARC Musée d'Art Moderne de la Ville de Paris

Selected Group Exhibitions:

1997 *The Magic of Numbers*, Staatsgalerie Stuttgart

Skupturen Projekte, Münster, Germany

1996 *Art and Film Since 1945: Hall of Mirrors*, Museum of Contemporary Art, Los Angeles; Wexner Center for the Arts, Colombus, Ohio; Palazzo delle Esposizioni, Rome; Museum of Contemporary Art, Chicago

1995 *Shift*, De Appel, Amsterdam

General Release: Young British Artists, Biennale di Venezia, Venice

Take me (I'm yours), Serpentine Gallery, London; Kunsthalle Nuremberg

1994 *Watt*, Witte de With and Kunsthal, Rotterdam

1993 *Prospekt '93*, Kunstverein Frankfurt

1992 *Speaker Project*, ICA, London

Wolfgang Amadeus Hansbauer

Born 1967 in Neustadt an der Waldnaab, Germany
Lives and works in Düsseldorf and Etzenricht, Germany

Solo Exhibitions:

1997 Jablonka Galerie, Cologne

1995 Jablonka Galerie, Cologne

Lindenau Museum, Altenburg, Germany

Jim Hodges

Born 1957 in Spokane, Washington
Lives and works in New York

Solo Exhibitions:

1997 Galerie Ghislaine Hussenot, Paris

Site Sante Fe, Santa Fe, New Mexico

1996 *yes*, Marc Foxx, Santa Monica, California

States, Fabric Workshop & Museum, Philadelphia

1995 CRG Gallery, New York

Center for Curatorial Studies, Bard College, Annandale-on-Hudson, New York

1994 *Everything For You*, Interim Art, London

A Diary of Flowers, CRG Gallery, New York

1992 *New Aids Drug*, Het Apollohuis, Eindhoven, The Netherlands

1991 *White Room*, White Columns, New York

1989 *Historia Abscondita*, Gonzaga University Gallery, Spokane, Washington

1986 *Master of Fine Arts Thesis Exhibition*, Pratt Institute, New York

Selected Group Exhibitions:

1997 *9 Artists of the Nineties*, San Francisco Museum of Modern Art

Poetics of Obsession, Linda Kirkland Gallery, New York

1996 *Just Past: The Contemporary in MOCA's Permanent Collection 1975-1996*, Museum of Contemporary Art, Los Angeles

Universalis, Bienal Internacional São Paulo

1995 *Avant-Garde Walk a Venezia*, Biennale di Venezia, Venice

1993 *Our Perfect World*, Grey Art Gallery, New York University, New York

1992 *Healing*, Rena Bransten Gallery, San Francisco

Cameron Jamie

Born 1969 in Los Angeles
Lives and works in Los Angeles

Solo Exhibitions:

1997 Galerie du Triangle, Bordeaux, France

1993 Robert Berman Gallery, Santa Monica, California

Selected Group Exhibitions:

1997 *Hotel California*, Arlington Museum of Art, Texas

Anomalies: Jim Shaw, Cameron Jamie, Jeffrey Vallance, Contemporary Art Collective, Las Vegas

1995 *Neotoma*, Otis College of Art and Design, Los Angeles

A Tribute to Mr. Showmanship, Liberace Museum, Las Vegas

1994 *Elvis & Marylin: 2x Immortal*, The Institute of Contemporary Art, Boston; Contemporary Arts Museum, Houston; Cleveland Museum of Art, Ohio; Tennessee State Museum, Nashville; San José Museum of Art

1993 *Exhibition*, California Institute of the Arts, Valencia

Mike Kelley

Born 1954 in Detroit
Lives and works in Los Angeles

Selected Solo Exhibitions:

1997 Museu d' Art Contemporain, Barcelona; Center for Contemporary Art, Malmö, Sweden; Stedelijk Van Abbemuseum, Eindhoven, The Netherlands

1995 *The Thirteen Seasons (Heavy On the Winter)*, Jablonka Galerie, Cologne

Missing Time: Works on Paper 1974-1976 Reconsidered, Kestner-Gesellschaft, Hanover, Germany

Toward a Utopian Arts Complex, Metro Pictures, New York

1994 Rosamund Felsen Gallery, Los Angeles

1993 Whitney Museum of American Art, New York; Los Angeles County Museum; Haus der Kunst, Munich; Moderna Museet, Stockholm

1992 Kunsthalle Basel, Switzerland; Portikus, Frankfurt; ICA, London; capcMusée d'art contemporain de Bordeaux, France

1991 *Mike Kelley: 'Half a Man'*, Hirshhorn Museum and Sculpture Garden, Washington, D.C.

1990 Galerie Ghislaine Hussenot, Paris

1989 *Why I Got Into Art: Vaseline Muses*, Jablonka Galerie, Cologne

Pansy Metal/Clovered Hoof, Metro Pictures, New York; University Art Museum, University of California, Berkeley; Robbin Lockett Gallery, Chicago

1988 Renaissance Society, University of Chicago

1987 *Vintage Works: 1979-1986*, Rosamund Felsen Gallery, Los Angeles

1986 Metro Pictures, New York

1985 Rosamund Felsen Gallery, Los Angeles

1984 Metro Pictures, New York

1983 Rosamund Felsen Gallery, Los Angeles

1982 Metro Pictures, New York

1981 Mizuno Gallery, Los Angeles

Selected Group Exhibitions:

1996 *a/drift: Scenes From the Penetrable Culture*, Bard College, Annandale-on-Hudson, New York

Distemper: Dissonant Themes in the Art of the 1990s, Hirshhorn Museum and Sculpture Garden, Washington, D.C.

L'Informe: Le Modernisme a Rebours, Centre Georges Pompidou, Paris

1995 *Feminin/masculin: le sexe de l'art?*, Centre Georges Pompidou, Paris

Signs and Wonders, Kunsthaus Zurich

1994 *World-Morality*, Kunsthalle Basel, Switzerland

1993 *The Uncanny*, Gemeentemuseum, Arnhem, The Netherlands

Abject Art: Repulsion and Desire in American Art, Whitney Independent Study Program, Whitney Museum of American Art, New York

American Art in the 20th Century, Martin Gropius Bau, Berlin; Royal Academy of Arts, London

1992 *Post Human*, FAE Musée d'Art Contemporain, Pully/Lausanne, Switzerland; Castello di Rivoli, Museo d'Arte Contemporanea Rivoli, Turin; Deste Foundation for Contemporary Art, Athens; Deichtorhallen, Hamburg; Israel Museum, Jerusalem

Doubletake: Collective Memory and Current Art, Hayward Gallery, London

Documenta IX, Kassel, Germany

Helter Skelter: L.A. Art in the 90s, Museum of Contemporary Art, Los Angeles

1991 *Metropolis*, Martin Gropius Bau, Berlin

1989 *A Forest of Signs: Art in the Crisis of Representation*, Museum of Contemporary Art, Los Angeles

1988 *Aperto '88*, Biennale di Venezia, Venice

The BiNational: American Art of the Late 80's, The Institute of Contemporary Art and Museum of Fine Arts, Boston; Städtische Kunsthalle, Kunstsammlung Nordrhein-Westfalen, Kunstverein für die Rheinlande und Westfalen, Düsseldorf; Kunsthalle Bremen; Württembergischer Kunstverein, Stuttgart

1986 *Individuals: A Selected History of Contemporary Art, 1945-1986*, Museum of Contemporary Art, Los Angeles

1985 *Biennial Exhibition*, Whitney Museum of American Art, New York

1984 *Private Symbol: Social Metaphor*, Fifth Biennale of Sydney, Art Gallery of New South Wales, Sydney

1979 *The Poltergeist*, Foundation for Art Resources, Los Angeles

Abigail Lane

Born 1967 in Penzance, England
Lives and works in London

Solo Exhibitions:

1997 Andréhn Schiptjenko Gallery, Stockholm

Galerie Chantal Crousel, Paris

1995 *Skin of the Teeth*, ICA, London

1994 Emi Fontana, Milan

1992 *Abigail Lane: Making History*, Karsten Schubert Ltd., London

Selected Group Exhibitions:

1997 *Full House*, Kunstmuseum Wolfsburg, Germany

L'Empreinte, Centre Georges Pompidou, Paris

1996 *Painting: The Extended Field*, Magasin 3 Stockholm Konsthall, Stockholm and Rooseum, Malmö

1995 *4th International Istanbul Biennial*, Istanbul

Brilliant! New Art From London, Walker Art Center, Minneapolis; Contemporary Arts Museum, Houston

Here and Now, Serpentine Gallery, London

1994 *Some Went Mad, Some Ran Away...*, Serpentine Gallery, London; Nordic Arts Centre, Helsinki; Kunstverein Hanover, Germany; Museum of Contemporary Art, Chicago; Portalen, Copenhagen

1990 *Modern Medicine*, Building One, London

1989 *The New Contemporaries*, ICA, London

1988 *Freeze*, Surrey Docks, London

Zoe Leonard

Born 1961 in Liberty, New York
Lives and works in New York

Solo exhibitions:

1997 Kunstalle Basel

Wiener Secession, Vienna

Museum of Contemporary Art, Miami

1995 Le Case d'Arte, Milan

Paula Cooper Gallery, New York

Galerie Jennifer Flay, Paris

Galerjia Dante Marino Cettina, Umag, Croatia

1993 Renaissance Society, University of Chicago

1992 Paula Cooper Gallery, New York

1991 Luhring Augustine Hetzler, Los Angeles

University Art Museum and Pacific Film Archive, University of California, Berkeley

Trans-Avant-Garde Gallery, San Francisco

Richard Foncke Gallery, Ghent

Galerie Gisela Capitain, Cologne

1990 Galerie Gisela Capitain, Cologne

1985 Greathouse, New York

1983 Hogarth Gallery, Sydney, Australia

1979 Fourth Street Photo Gallery, New York

Selected Group Exhibitions:

1997 *Biennial Exhibition*, Whitney Museum of American Art, New York

Fashion Moda, Cleveland Center for Contemporary Art

1996 *Black and Blue: Eight American Photographers*, Groninger Museum, The Netherlands

Art at Home: Ideal Standard Life, Spiral Garden, Tokyo, Japan

L'Evidence, Centre d'Art Conremporain, Geneva

1995 *In a Different Light*, University Art Museum and Pacific Film Archive, University of California, Berkeley

Feminin/masculin: le sexe de l'art?, Centre Georges Pompidou, Paris

1993 *Biennial Exhibition,* Whitney Museum of American Art, New York; National Museum of Contemporary Art, Seoul, Korea

Dissent, Difference and the Body Politic, Otis Gallery, Otis School of Art and Design, Los Angeles

1993 *The Uncanny*, Gemeentemuseum, Arnhem, The Netherlands

Abject Art: Repulsion and Desire in American Art, Whitney Independent Study Program, Whitney Museum of American Art, New York

1992 *Documenta IX*, Kassel, Germany

1989 *Strange Attractors: Signs of Chaos*, New Museum of Contemporary Art, New York

AIDS Timeline: An Installation by Group Material, University Art Museum/Pacific Film Archive, University of California, Berkeley

1982 *Times Square Show*, Times Square, New York

Tony Oursler

Born 1957 in New York
Lives and works in New York

Selected Solo Exhibitions:

1997 *Judy*, Institute of Contemporary Art, Philadelphia

1996 Museum of Contemporary Art, San Diego

Kasseler Kunstverein, Kassel, Germany

Lisson Gallery, London

Metro Pictures, New York

1995 *Tony Oursler: Video Installations, Objects, Watercolors*, Musée des Arts Modernes et Contemporains, Strasbourg, France

Wiener Secession, Vienna

1994 Lisson Gallery, London

System for Dramatic Feedback, Portikus, Frankfurt

Tony Oursler: Recent Video Works, Contemporary Museum, Honolulu, Hawaii

1993 *White Trash and Phobic*, Centre d' Art Contemporain, Geneva; Kunstwerke, Berlin

Dummies, Dolls, and Poison Candy, Ikon Gallery, Birmingham; Bluecoat Gallery, Liverpool

1992 *F/X Plotter, 2 Way*, Kijkhuis, The Hague, The Netherlands

1991 *Dummies, Hex Signs, Watercolors*, The Living Room, San Francisco

1990 Hallwalls, Buffalo, New York

1989 Folkwang Museum, Essen, Germany

Museum für Gegenwartskunst, Basel, Switzerland

1988 *Constellation: Intermission*, Diane Brown Gallery, New York

1987 The Kitchen, New York

1986 *Spheres of Influence*, Centre Georges Pompidou, Paris

1985 Kijkhuis, The Hague, The Netherlands

The American Center, Paris

1984 *L-7, L-5*, The Kitchen, New York

1982 The Walker Art Center, Minneapolis

Complete Works, The Kitchen, New York

Boston Film/Video Foundation, Boston

1981 *Video Viewpoints*, Museum of Modern Art, New York

Selected Group Exhibitions:

1997 Centre Georges Pompidou, Paris

1996 *Scream & Scream Again*, Museum of Modern Art, Oxford; Irish Museum of Modern Art

Young Americans: New American Art in the Saatchi Collection, Saatchi Collection, London

1995 *Carnegie International*, Carnegie Museum of Art, Pittsburgh

Signs and Wonders, Kunsthaus Zurich

1994 *Tony Ousler and John Kessler*, Kunstverein Salzburg, Austria

1992 *Documenta IX*, Kassel, Germany

1989 *Biennial Exhibition*, Whitney Museum of American Art, New York

1988 *The BiNational: American Art of the Late 80's*, The Institute of Contemporary Art and Museum of Fine Arts, Boston; Städtische Kunsthalle, Kunstsammlung Nordrhein-Westfalen, Kunstverein für die Rheinlande und Westfalen, Düsseldorf; Kunsthalle Bremen; Württembergischer Kunstverein, Stuttgart

1987 *Documenta VIII*, Kassel, Germany

L'epoque, la mode, la morale, la passion, Centre Georges Pompidou, Paris

Sheila Pepe

Born 1959 in Morristown, New Jersey
Lives and works in Boston

Solo Exhibitions:

1997 *Fix, Fles, Reflux*, Judy Ann Goldman Fine Art, Boston

1996 *Part and Parcel*, Simmons College, Boston

Exquisite Corpse for One: The Many Betweens, Mobius, Boston

1995 *Fake I.D.*, 88 Room, Boston

1994 *Work from the Doppelgänger Series*, 88 Room, Boston

1991 *DISclosures/DIScomforts*, Center for the Arts, Northampton, Massachusetts

Selected Group Exhibitions:

1996 *The Lois Foster Exhibition of Boston Area Artists*, Rose Art Museum, Brandeis University, Waltham, Massachusetts

Fictions, Galleria Guido Carbone, Turin

1995 *Way Cool*, Exit Art/The First World, New York

1992 *Diversity and Vision*, Blue Mountain Gallery, New York

Alexis Rockman

Born 1962 in New York
Lives and works in New York

Solo Exhibitions:

1997 Contemporary Arts Museum, Houston

Jay Gorney Modern Art, New York

1996 London Projects, London

Alexis Rockman: Zoology A-Z, Wildlife Interpretive Gallery, Detroit Zoo

Cranbrook Art Museum, Bloomfield Hills, Michigan

1995 *Neblina*, Koyanagi Gallery, Tokyo

Alexis Rockman: Second Nature, Portland Art Museum, Portland, Oregon; University Galleries, Illinois State University, Normal, Illinois; Cincinnati Art Museum, Cincinnati, Ohio; Tweed Museum of Art, Duluth, Minnesota

Guyana Paintings, Tom Solomon's Garage, Los Angeles

Works on Paper: Guyana, Jay Gorney Modern Art, New York

Guyana Paintings, Studio Guenzani, Milan

1994 *Biosphere: The Ocean*, Gian Enzo Sperone, Rome

1993 *Biosphere*, Jay Gorney Modern Art, New York

1992 Carnegie Museum of Art, Pittsburgh, Pennsylvania

Evolution, Sperone Westwater Gallery, New York

Tom Solomon's Garage, Los Angeles

Jay Gorney Modern Art, New York

1991 John Post Lee Gallery, New York

Galerie Thaddaeus Ropac, Salzburg, Austria

1990 Jay Gorney Modern Art, New York

1989 Fawbush Gallery, New York

Jay Gorney Modern Art, New York

1988 Michael Kohn Gallery, Los Angeles

The Institute of Contemporary Art, Boston

1987 McNeil Gallery, Philadelphia

Jay Gorney Modern Art, New York

1986 Jay Gorney Modern Art, New York

Michael Kohn Gallery, Los Angeles

1985 Patrick Fox Gallery, New York

Selected Group Exhibitions:

1997 *Animal: The Lost Ark*, Centre for Contemporary Arts, Glasgow

1996 *Screen*, Friedrich Petzel Gallery, New York

1994 *Some Went Mad, Some Ran Away...*, Serpentine Gallery, London; Nordic Arts Centre, Helsinki; Kunstverein Hanover, Germany; Museum of Contemporary Art, Chicago; Portalen, Copenhagen

1993 *The Return of the Cadavre Exquis*, Drawing Center, New York

Aperto '93, Biennale di Venezia, Venice

1990 *Not So Simple Pleasures: Content and Contentment in Contemporary Art*, MIT List Visual Arts Center, Cambridge, Massachusetts

The (Un)Making of Nature, Whitney Museum of American Art, New York

1989 *The Silent Baroque*, Galerie Thaddeus Ropac, Salzburg, Austria

Roarrr! The Pre-historic in Contemporary Art, New York State Museum, Albany

1985 Jay Gorney Modern Art, New York

Aura Rosenberg

Born in New York
Lives and works in New York and Berlin

Solo Exhibitions:

1997 Richard Telles Fine Arts, Los Angeles

1996 Gallerie Moussion, Paris

Wooster Gardens, New York

Art & Public, Geneva

1994 Galerie Martina Detterer, Frankfurt

1993 Kunstwerke Berlin

Kunsthalle St. Gallen, Switzerland

1992 I.D. Galerie, Düsseldorf

1989 White Room, White Columns, New York

1986 TKL Gallery, Costa Mesa, California

Selected Group Exhibitions:

1997 *Someone Else With My Fingerprints*, David Zwirner Gallery, New York; Galerie Hauser & Wirth, Zurich; August Sander Archiv, Cologne; Kunstverein Munich; Kunsthaus Hamburg

1995 *In Search for a Storehouse*, Kunstverein Nuremberg

Club Berlin, Biennale di Venezia, Venice

Pittura/Immedia, Neue Galerie, Graz, Austria; Muscarnoc, Palace of Art, Budapest

Aura Rosenberg/John Miller, Künstlerhaus Bethanien, Berlin

1994 *Real*, Salzburger Kunstverein, Austria

1985 *Art Quest*, New Museum of Contemporary Art, New York

Pieter Schoolwerth

Born 1970 in St. Louis, Missouri
Lives and works in Brooklyn, New York

Solo Exhibitons:

1996 Greene Naftali Inc., New York

1994 *Astrid's Secret Banana*, Thread Waxing Space, New York

Selected Group Exhibitions:

1996 *Offerings*, Thread Waxing Space, New York

Departure Lounge, Clocktower Gallery at P.S. 1 Museum, New York

1994 Anthony Reynolds Gallery, London

Cindy Sherman

Born 1954 in Glen Ridge, New Jersey
Lives and works in New York

Selected Solo Exhibitions:

1996 Museum of Modern Art, Shiga, Japan; Museum of Contemporary Art, Tokyo

Museum Boymans-van Beuningen, Rotterdam; Museo Nacional Centro de Arte Reina Sofía, Madrid; Sala de Exposiciones REKALDE, Bilbao, Spain; Staatliche Kunsthalle, Baden-Baden, Germany

1995 *Cindy Sherman: The Self Which Is Not One*, Museu de Arte Moderna de São Paulo

Deichtorhallen, Hamburg; Malmö Kunsthall, Sweden; Kunstmuseum Luzern, Switzerland

Directions: Cindy Sherman - Film Stills, Hirshhorn Museum and Sculpture Garden, Washington, D.C.

1994 *Cindy Sherman: Possession*, Manchester City Art Gallery; Offshore Gallery, East Hampton, New York

From Beyond the Pale: Cindy Sherman Photographs, 1977-1993, Irish Museum of Modern Art, Dublin

1993 Tel Aviv Museum of Art

1992 Museo de Monterrey, Mexico

1991 Saatchi Collection, London

Milwaukee Art Museum; Center for the Fine Arts, Miami; Walker Art Center, Minneapolis

Kunsthalle Basel, Switzerland; Staatsgalerie Moderner Kunst, Munich; Whitechapel Art Gallery, London

1990 University Art Museum, University of California, Berkeley

1989 National Art Gallery, Wellington, New Zealand; Waikato Museum of Art and History, New Zealand

Wiener Secession, Vienna

1987 Whitney Museum of American Art, New York; The Institute of Contemporary Art, Boston; Dallas Museum of Art

1986 Portland Art Museum, Portland, Oregon

Aldrich Museum of Contemporary Art, Ridgefield, Connecticut

1985 Westfälischer Kunstverein, Münster, Germany

1984 Seibu Gallery of Contemporary Art, Tokyo

Akron Art Museum; Institute of Contemporary Art, Philadelphia; Museum of Art, Carnegie Institute, Pittsburgh; Baltimore Museum of Art

1983 Musée d'Art et d'Industrie, Saint-Etienne, France

St. Louis Art Museum

1982 Stedelijk Museum, Amsterdam; Gewad, Ghent, Belgium; Watershed Gallery, Bristol, England; Palais Stutterheim, Erlangen, West Germany; Haus am Waldsee, West Berlin; Centre d'Art Contemporain, Geneva; Sonja Henie-Niels Onstadt Foundation, Copenhagen; Louisiana Museum, Humlebaek, Denmark

1981 Metro Pictures, New York

1980 Contemporary Arts Museum, Houston

The Kitchen, New York

1979 Hallwalls, Buffalo, New York

Selected Group Exhibitions:

1996 *L'Informe: Le Modernisme a Rebours*, Centre Georges Pompidou, Paris

1995 *Feminin/masculin: le sexe de l'art?*, Centre Georges Pompidou, Paris

Signs and Wonders, Kunsthaus Zurich

1994 *World Morality*, Kunsthalle Basel, Switzerland

1993 *The Uncanny*, Gemeentemuseum, Arnhem, The Netherlands

American Art in the 20th Century, Martin Gropius Bau, Berlin; Royal Academy of Arts, London

1992 *Post Human*, FAE Musée d'Art Contemporain, Pully/Lausanne, Switzerland; Castello di Rivoli, Museo d'Arte Contemporanea, Rivoli, Turin; Deste Foundation for Contemporary Art, Athens; Deichtorhallen, Hamburg; Israel Museum, Jerusalem

1991 *Metropolis*, Martin Gropius Bau, Berlin

1990 *Energies*, Stedelijk Museum, Amsterdam

Culture and Commentary: An Eighties Perspective, Hirshhorn Museum and Sculpture Garden, Washington, D.C.

1989 *Image World: Art and Media Culture*, Whitney Museum of American Art, New York

A Forest of Signs: Art in the Crisis of Representation, Museum of Contemporary Art, Los Angeles

1987 *L'Epoque, la mode, la morale, la passion*, Centre Georges Pompidou, Paris

1986 *Individuals: A Selected History of Contemporary Art, 1945-1986*, Museum of Contemporary Art, Los Angeles

Art and Its Double: A New York Perspective, Fundacio Caixa de Pensions, Barcelona and La Caixa de Pensions, Madrid

1985 *Carnegie International*, Museum of Art, Carnegie Institute, Pittsburgh

1983 *Biennial Exhibition*, Whitney Museum of American Art, New York

1982 *XL Biennale di Venezia*, Venice

Documenta 7, Kassel, Germany

1976 *Hallwalls*, Artists Space, New York

Jeanne Silverthorne

Born 1950 in Philadelphia
Lives and works in New York

Solo Exhibitions

1997 David McKee Gallery, New York

1996 Institute of Contemporary Art, Philadelphia

Rocca Paolina, Perugia, Italy

1995 Gallery Paule Anglim, San Francisco

Studio la Città, Verona, Italy

1994 David McKee Gallery, New York

Galerie Nathalie Obadia, Paris

1993 Amelie A. Wallace Gallery, Old Westbury, New York

1990 Hobart-William Smith Colleges, Geneva, New York

Christine Burgin Gallery, New York

1982 P.S. 1, Institute for Contemporary Art, Long Island City, New York

1981 Nexus Gallery, Philadelphia

1980 Nexus Gallery, Philadelphia

Selected Group Exhibitions:

1996 *Women's Work*, Greene Naftali Inc., New York

1995 *Laughter Ten Years After*, Ezra and Cecile Zikha Gallery, Center for The Arts, Wesleyan University, Middletown, Connecticut; Houghton House Gallery, Hoart and William Smith College, Geneva, New York; Beaver College Art Gallery, Glenside, Pennsylvania

1991 *Social Studies*, Allen Memorial Art Museum, Oberlin, Ohio

1990 *Fragments, Parts and Wholes*, White Columns, New York

1987 *Standing Ground*, Contemporary Arts Center, Cincinnati, Ohio

1986 *Momento Mori*, Centro Cultural Arte Contemporaneo, Mexico

1983 *Sophia's House*, Pennsylvania Academy of Fine Arts, Philadelphia

Gary Simmons

Born 1964 in New York
Lives and works in New York

Solo Exhibitions:

1997 *Gary Simmons: Gazebo*, Museum of Contemporary Art, San Diego, California

1996 Metro Pictures, New York

Boom, Bang!, Galerie Philippe Rizzo, Paris

1995 Fabric Workshop & Museum, Philadelphia

Metro Pictures, New York

The Contemporary, New York

Gary Simmons: Erasure Drawings, Lannan Foundation, Los Angeles

1994 *Directions: Gary Simmons*, Hirshhorn Museum and Sculpture Garden, Washington, D.C.

1993 Gallerie Philippe Rizzo, Paris

Metro Pictures, New York

1992 Roy Boyd Gallery, Santa Monica, California

Jason Rubell Gallery, Miami, Florida

The Garden of Hate, Whitney Museum at Philip Morris, New York

1991 Roy Boyd Gallery, Santa Monica, California

Simon Watson Gallery, New York

1990 White Columns, New York

1989 Roy Boyd Gallery, Santa Monica, California

Selected Group Exhibitions:

1997 *in/SITE*, San Diego, California/Tijuana, Mexico

New Works: Drawings Today, San Francisco Museum of Modern Art

1996 *a/drift: Scenes From the Penetrable Culture*, Bard College, Annandale-on-Hudson, New York

Defining the 90's: Consensus Making in New York, Los Angeles and Miami, Museum of Contemporary Art, Miami

1994 *Black Male: Representations of Masculinity in Contemporary American Art*, Whitney Museum of American Art, New York; Armand Hammer Museum, University of California at Los Angeles

1993 *Biennial Exhibition*, Whitney Museum of American Art, New York

1991 *Interrogating Identity: The Question of Black Art*, Grey Art Gallery, New York University, New York; Museum of Fine Arts, Boston; Walker Art Center, Minneapolis; Madison Art Center, Madison, Wisconsin; Center for Fine Arts, Miami; Allen Memorial Art Museum, Oberlin, Ohio; Duke University Museum of Art, Durham, North Carolina

1990 *Spent: Currency, Security and Art on Deposit*, New Museum of Contemporary Art at Marine Midland Bank, New York

Selected Biographies compiled by Martina Pachmanová

Dennis Cooper

Dennis Cooper is a Los Angeles-based novelist, contributing editor to *Spin* magazine, and regular contributor to *Artforum*. His novels include *Closer* (1989), *Frisk* (1991), *Try* (1994), and *Guide* (1997). *Horror Hospital Unplugged*, a graphic novel he created with artist Keith Mayerson, was published this winter. He is also the author of several collections of poems, including *The Dream Police: Selected Poems 1969-1993* (1995).

John Gianvito

John Gianvito is a filmmaker, professor and critic. He currently is Guest Curator at the Harvard Film Archive, Cambridge, Massachusetts. He has taught at the Rhode Island School of Design in Providence and the University of Massachusetts, Boston, where he is Assistant Professor of film. His essays on film have appeared in a number of publications, including *The Boston Review* and *Visions*.

Christoph Grunenberg

Christoph Grunenberg is Curator at The Institute of Contemporary Art in Boston. He previously worked at the Kunsthalle Basel, Switzerland and National Gallery of Art, Washington, D.C. His exhibitions and publications include *Rachel Whiteread* (Kunsthalle Basel; ICA Philadelphia; ICA Boston); *World-Morality* and *Marie José Burki: Sans Attribut* (both Kunsthalle Basel).

James Hannaham

James Hannaham is a New York-based writer and cultural critic whose work has appeared in the *Village Voice*, *Spin*, *American Theatre*, and *Ersatz*. He has recently contributed an essay on Kara Walker for the exhibition catalogue *New Histories* (The Institute of Contemporary Art, Boston).

Patrick McGrath

Patrick McGrath is the author of a collection of short stories (*Blood and Water and Other Tales*) and several novels including *The Grotesque*, *Spider*, and *Dr. Haggard's Disease*. His latest novel, *Asylum*, was published this year by Random House. He has also co-published, with Bradford Marrow, a collection of "New Gothic" writing (*The New Gothic*, New York, 1991). He lives in New York and London.

Joyce Carol Oates

Joyce Carol Oates is the author of numerous novels, short stories, and critical essays, including *You Must Remember This*, *them*, *Raven's Wing*, *Bellefleur*, and *Because It Is My Heart*. Recently she has published a collection of stories, *Haunted: Tales of the Grotesque* (1994), and *First Love: A Gothic Tale* (1996), and edited a collection of *American Gothic Tales* (1996). She is Roger S. Berlind Professor in the Humanities at Princeton University.

Shawn Rosenheim

Shawn Rosenheim is Associate Professor of English at Williams College. A founding member of the Media Technologies Research Group, he writes widely on film, literature, and technology. His most recent book is *The Cryptographic Imagination: Secret Writings from Edgar Allan Poe to the Internet* (Johns Hopkins University Press, 1996).

Csaba Toth

Csaba Toth is Associate Professor and Chair of the Department of History at Carlow College, Pittsburgh. He has published widely in utopian studies and on nineteenth and twentieth century American history and culture. He is the author of *The World of Nathaniel Hawthorne* (Budapest, 1982), which won Europa Publishing Company's Award for Best Biography. Recently Toth has concentrated on music, noise, performance, and cultural production in postindustrial societies.

Anne Williams

Anne Williams is Professor of English at the University of Georgia and author of *Prophetic Strain* and *Art of Darkness: A Poetics of Gothic* (both University of Chicago Press).

Julie Becker

Postersize Copy Machine, 1996
Mixed media
36 x 48 x 51½ inches
Collection of Eileen and Michael Cohen, New
York

Interior Corner #1, 1993
C-print
35 x 27½ inches
Courtesy Regen Projects, Los Angeles

Interior Corner #7, 1993
C-print
35 x 27½ inches
Private Collection, Courtesy Thea Westreich,
Art Advisory Services, New York

Interior Corner #8, 1993
C-print
35 x 27½ inches
Private Collection, Courtesy Thea Westreich,
Art Advisory Services, New York

Interior Corner #10, 1993
C-print
35 x 27½ inches
Collection of Nina and Frank Moore, New York

Monica Carocci

Untitled, 1995
Black and white photograph
78¾ x 47 inches
Courtesy Galleria Guido Carbone, Turin

Untitled, 1995
Black and white photograph
78¾ x 47 inches
Courtesy Galleria Guido Carbone, Turin

Untitled, 1995
Black and white photograph
78¾ x 47 inches
Courtesy Galleria Guido Carbone, Turin

Untitled, 1995
Black and white photograph
70⅞ x 47¼ inches
Courtesy Galleria Guido Carbone, Turin

Dinos and Jake Chapman

Nazissuss by the Pool, 1997
Fiberglass, resin, paint
54 x 49 x 102 inches
Courtesy Victoria Miro Gallery, London

Gregory Crewdson

Untitled, 1993
C-print
30 x 40 inches
Courtesy of the Artist and Luhring Augustine
Gallery, New York

Untitled, 1994
C-print
40 x 30 inches
Courtesy of the Artist and Luhring Augustine
Gallery, New York

Untitled, 1994
C-print
30 x 40 inches
Courtesy of the Artist and Luhring Augustine
Gallery, New York

Untitled, 1994
C-print
40 x 50 inches
Courtesy of the Artist and Luhring Augustine
Gallery, New York

Untitled, 1995
C-print
40 x 50 inches
Courtesy of the Artist and Luhring Augustine
Gallery, New York

Untitled, 1996
C-print
40 x 50 inches
Courtesy of the Artist and Luhring Augustine
Gallery, New York

Keith Edmier

Nowhere (Insideout), 1995
Resin
81½ x 68½ x 22 inches
Courtesy Friedrich Petzel Gallery, New York

Blister, 1995
Acrylic polyvinyl, wax
79 x 46 x 46 inches and 18 x 8 x 8 inches
Collection Friedrich Petzel Gallery, New York

James Elaine

Reflecting Pool, 1994
Ribbon mahogany wood, collected alarm clocks
80 x 90 inches
Courtesy of the Artist, New York

Swan Lake, 1995
Steel, decorative iron work, glass, anti-freeze,
freeze-dried calf rib cages
120 x 80 inches
Courtesy of the Artist, New York

Sign for the Dying Salon, 1995
Steel, decorative iron work, stained glass
33 x 45 x 14 inches
Courtesy of the Artist, New York

Robert Gober

Untitled (Closet), 1989
Wood, plaster, enamel paint
92 x 52 x 32 inches
Collection of Selma and Josef Vandermolen,
Ghent, Belgium

Douglas Gordon

Monster, 1995
Color photograph
Lifesize
Courtesy of the Artist, Glasgow

30 Seconds Text, 1996
Timer, lightbulb and vinyl lettering
Dimensions variable
Courtesy Lisson Gallery, London

Wolfgang Amadeus Hansbauer

Friendly Fire, 1996
Acrylic on canvas
105¼ x 196½ inches
Courtesy Jablonka Galerie, Cologne

Jim Hodges

Blurring, 1997
White brass chain
36 x 36 x 6 inches
Courtesy of the Artist and CRG Gallery,
New York

Mike Kelley and Cameron Jamie

Monday's Goth, 1997
Black and white photograph
24 x 20 inches
Courtesy Patrick Painter Editions, Vancouver

Tuesday's Goth, 1997
Black and white photograph
24 x 20 inches
Courtesy Patrick Painter Editions, Vancouver

Wednesday's Goth, 1997
Black and white photograph
24 x 20 inches
Courtesy Patrick Painter Editions, Vancouver

Thursday's Goth, 1997
Black and white photograph
24 x 20 inches
Courtesy Patrick Painter Editions, Vancouver

Friday's Goth, 1997
Black and white photograph
24 x 20 inches
Courtesy Patrick Painter Editions, Vancouver

Saturday's Goth, 1997
Black and white photograph
24 x 20 inches
Courtesy Patrick Painter Editions, Vancouver

Sunday's Goth, 1997
Black and white photograph
24 x 20 inches
Courtesy Patrick Painter Editions, Vancouver

Abigail Lane

The Incident Room, 1993
Table, chair, mirror, earth, photographic lights,
wax body, newspaper
The Artist, Courtesy Victoria Miro Gallery,
London

Zoe Leonard

Preserved Head of Bearded Woman, Musée Orfila, 1991
Five gelatin silver prints
33 x 22¼ inches
21⅝ x 14⅜ inches
28⅝ x 19 inches
33¼ x 22½ inches
24⅝ x 16⅝ inches
Courtesy Paula Cooper Gallery, New York

Tony Oursler

4, 1997
Video installation with LCD video
Courtesy Metro Pictures, New York

Sheila Pepe

Untitled, 1997
From the series *Doppelgänger*
Objects, light, shadow, wall drawing
Dimensions variable
Courtesy Judy Ann Goldman Fine Art, Boston

Aura Rosenberg

Mike Kelley/Carmen Rosenberg Miller, 1996
From the series *Who am I, What am I, Where am I?*
C-print
40 x 30 inches
Courtesy Wooster Gardens, New York

Alexis Rockman

The Beach: Demerara River Delta, 1994-96
Oil, sand polymer, lacquer, mixed objects on wood
96 x 64 inches
Collection of Gian Enzo Sperone, New York

Pieter Schoolwerth

Thee 83 Altered States ov Americka: Chapters 1 & 2, 1995-96
Colored pencil and paint pen on paper
42 x 30 inches
Courtesy Greene Naftali Gallery, New York

Thee 83 Altered States ov Americka: Chapters 3 & 4, 1995-96
Colored pencil and paint pen on paper
49 x 49 inches
Courtesy Greene Naftali Gallery, New York

Thee 83 Altered States ov Americka: Chapter 7,
1995-96
Colored pencil and paint pen on paper
49 x 49 inches
Courtesy Greene Naftali Gallery, New York

Thee 83 Altered States ov Americka: Chapter 11, 1996
Colored pencil and paint pen on paper
49 x 49 inches
Collection of Vicki and Kent Logan, San Francisco

Thee 83 Altered States ov Americka: Chapter 12, 1995-96
Colored pencil and paint pen on paper
72 x 39½ inches
Collection of Tim Nye, New York

Cindy Sherman

Untitled (# 307), 1994
Cibachrome
79 x 42½ inches (framed)
Courtesy of the Artist and Metro Pictures, New York

Untitled (# 308), 1994
Cibachrome
69½ x 47 inches (framed)
Courtesy of the Artist and Metro Pictures, New York

Untitled (# 311), 1994
Cibachrome
76 x 51 inches (framed)
Courtesy of the Artist and Metro Pictures, New York

Untitled (# 319), 1995
Cibachrome
58¼ x 39½ inches (framed)
Courtesy of the Artist and Metro Pictures, New York

Untitled (#322), 1996
Cibachrome
39¾ x 58½ inches (framed)
Courtesy of the Artist and Metro Pictures, New York

Jeanne Silverthorne

This Day in the Studio: 4/1/97, 1997
Rubber
Dimensions variable
Courtesy McKee Gallery, New York

Gary Simmons

Land's End, 1996-97
Paint and chalk on wall
328 x 144 inches
Courtesy of the Artist and Metro Pictures, New York

ICA Staff

Milena Kalinovska, James Sachs Plaut Director

Naomi Arin, Grantwriter
Joanne Barrett, Public Relations Consultant
Marcella Beccaria, Curatorial Assistant
Branka Bogdanov, Video Curator/Producer
Laura Brown, Education Coordinator
Rosemary Clarke, Controller
Lia Gangitano, Registrar/Assistant Curator
Christoph Grunenberg, Curator
Kara Keller, Director of Operations
Patricia Kramer, Director of Development &
 Communications
June Mattioli, Special Events Coordinator
Christine McCarthy, Executive Assistant
Tim Obetz, Exhibitions & Facilities Manager
Lobsang Paljor, Custodian
Nicola Rinne, Membership & Marketing
 Coordinator
Kate Shamon, Functions Coordinator

Gallery Staff

Tammy Bonn
David Bryson
Bill Crump
Brian Cummings
Tara Eckert
Ivelisse Estrada
Christen Goguen
Mara Kampe, Gallery Supervisor
Jeffrey Mumford
Levin Pfuefer
Isabella Rossi, Gallery Supervisor
Tia Scalcione
Scott Sinclair
Alice Spirito
Kelly Sturhahn
Melissa Zambelis, Gallery Supervisor

Installers

Winston Braman
James Buni
James Hull
Vincent Marasa
Mark McElhiney
Erica Moody
Kanishka Raja

DocentTeens

Alain Alexander
Khalid Brickhouse
Zakia Dottin Carter

Patrice Cort
James Jackson
Monique Kilgore
Tenyka Lassiter
James Thomas
Kevin Ward

Volunteers

Teny Gross
Rick Miskiv
Tamara Schillin
Vernon "Faith" Woodroffe
Melissa Zambelis

Interns

Amira Antar, Education
Tara Ecker, Public Realtions
Elizabeth Essner, Public Relations
Chad Forsyth, Education
Emily Haroldson, Education
Felix Krämer, Curatorial
Monica LaStaiti
Viviane Le Courtois-Mitchell, Curatorial
Aleksandar Lekic, Video
Nicole Noseworthy, Curatorial
Emily O'Shea, Curatorial
Martina Pachmanová, Curatorial
Cristina Pimentel, Archives
Athena Robles, Curatorial
Thomas Conley Rollins, Jr., Curatorial
Laura Isabel Serna, Public Relations
Ulrike Unfug, Curatorial
Kerry Zucker, Video

Photo Credits

Matt Anker (p. 113)

The Art Institute of Chicago and VAGA, New York (p. 206)

Boris Becker, Cologne (p.203)

British Film Institute Stills, Posters and Designs, London (p. 211)

Philippe Carty (p. 94)

Country Life Picture Library, London (p.194)

Joseph Cultice (p. 171)

© D. James Dee (p. 144)

Attila Dory (p. 25)

© 1995, Paul Elledge, New York (p. 87)

Film Still Archive, The Museum of Modern Art, New York (p. 201; 200; 199; 198; 197; 196; 195; 170; 63; 62; 61; 59; 58; 57; 56; 55; 54)

Petra Gall, Berlin (p. 85)

International Film Circuit Inc., New York (p. 47)

© Russel Kaye (back cover)

Heidi Kosaniuk, Glasgow (p. 65)

Foto Marburg/Art Resource, New York (p. 193)

Chris Mills (p. 93)

© 1997, The Museum of Modern Art, New York (p. 169)

Photofest, New York (front cover)

Neal Preston/Retna Ltd. (p. 83)

Rosenbach Museum & Library, Philadelphia (p. 157)

© Oren Slor, New York (p. 108)

© Dan Soper (p. 111; 110)

© Stills/Retna Ltd. (p. 81)

TMS Film-GmbH, Munich (p. 46; 43)

© 1990, Jack Vartoogian, New York (p. 117)

© Stephen White (p. 185)

Joe Ziolkowski (p. 99)